INDIANAPOLIS

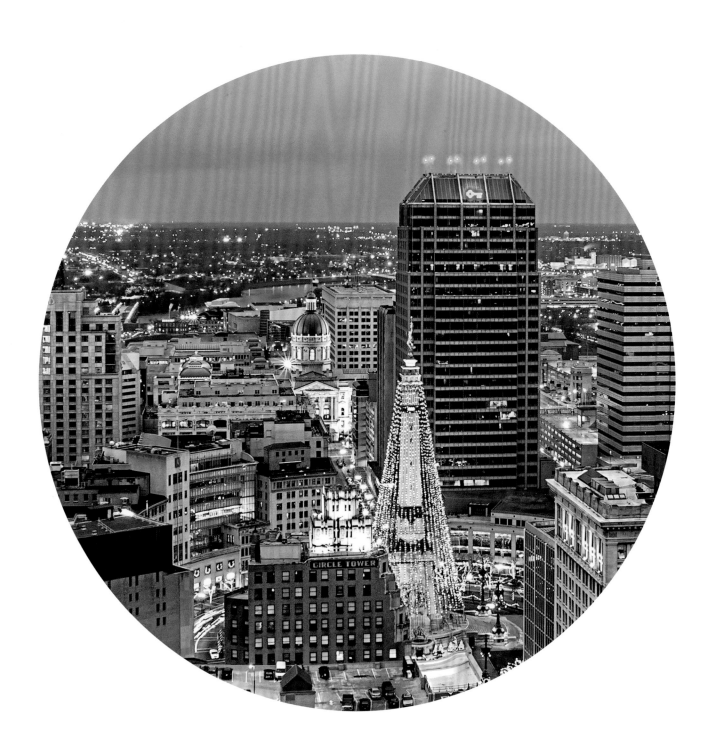

INDIANAPOLIS

The Circle City

———○———

LEE MANDRELL

FOREWORD BY *Matthew Tully*

An imprint of
INDIANA UNIVERSITY PRESS
Bloomington & Indianapolis

This book is a publication of

Quarry Books

an imprint of

INDIANA UNIVERSITY PRESS
Office of Scholarly Publishing
Herman B Wells Library 350
1320 East 10th Street
Bloomington, Indiana 47405 USA

iupress.indiana.edu

Manufactured in China

Library of Congress Cataloging-in-Publication Data

Names: Mandrell, Lee, photographer.
Title: Indianapolis: the Circle City / Lee Mandrell; foreword by Matthew Tully.
Description: Bloomington: Indiana University Press, 2016. | Includes index.
Identifiers: LCCN 2015048275 | ISBN 9780253021618 (cloth) | ISBN 9780253021694 (ebook)
Subjects: LCSH: Indianapolis (Ind.)—Pictorial works. | Indianapolis (Ind.)—Buildings, structures, etc.—Pictorial works.
Classification: LCC F534.I343 M36 2016 | DDC 977.2/52—dc23 LC record available at http://lccn.loc.gov/2015048275

1 2 3 4 5 21 20 19 18 17 16

CONTENTS

———o———

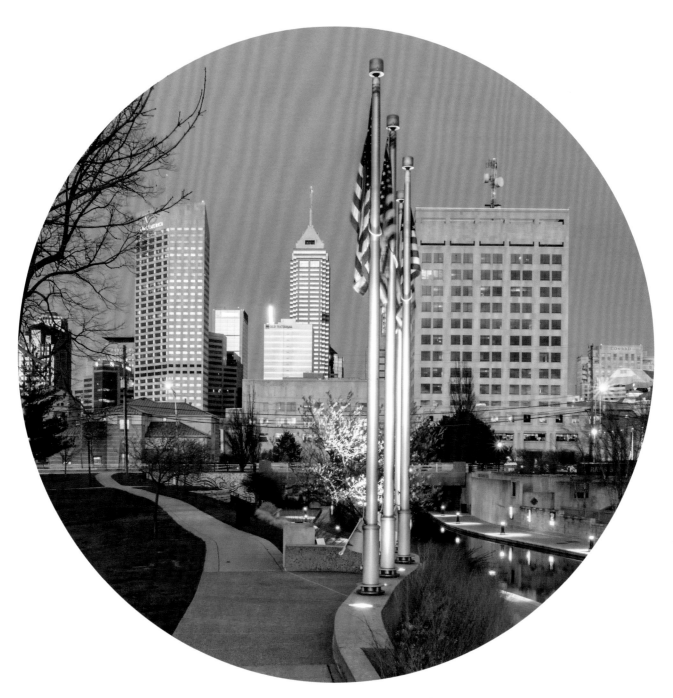

Indianapolis as Seen from the Central Canal

For me as a writer it is always humbling to work with great photographers, and I've been fortunate enough over the years to work with many of them. No matter what I've written, no matter how good I might think a piece of work is, time and again I've found that a photographer with a sharp eye and a passion for the job can help an ink-stained newspaper columnist like me reach people in a way that words alone rarely can.

And a great photo, a great series of photos, can help you understand an issue, a person, or even a city better than you thought possible.

Some of the best photos capture moments so fleeting that most of us would have missed them. Others take us into worlds we didn't know existed. And some photographs—and this might actually be the most challenging task of all—tackle subjects that we have seen hundreds or thousands of times before. They show us subjects so familiar to us, so much a part of our lives, yet they offer a perspective or a slice of beauty and color that we have never seen.

Foreword

BY *Matthew Tully*

In this stunning book of photography, Lee Mandrell offers scores of beautiful and vibrant photos of Indianapolis, the city I've lived in and around most of my adult life. He has captured public buildings, museums, parks, and monuments that hold deep and important memories for me and so many other Hoosiers. This book showcases the Statehouse, the downtown canal, Monument Circle, the zoo, and so many other locations that feel almost like second homes.

But here's the amazing part: Lee so often does this while allowing us to see these places and our hometown in entirely new ways. The triumph of this book is that Lee has created fresh images of the places and buildings we know so well.

Perhaps Lee's photos of the Indiana Statehouse struck me most. This building means the world to me. An early assignment there, an assignment granted to a green and unpolished reporter who'd only recently broken into the newspaper business, provided me with a path to a wonderful career in writing and reporting. And, on a much more important note, I care about the building because it's where I met my wife twenty years ago. I've spent countless hours in the statehouse, not always loving the politics unfolding inside it but always appreciating the craft and architecture that went into creating it so long ago. I've studied and photographed it many times, struck by its beauty and history.

Still, as well as I know the building, I found myself staring for minutes at Lee's photos of it, noticing for the first time the way the lights nearby on Market Street and in the offices below complemented the capitol dome. Lee was able to make the world around the building—the cars and the streetlights—pop in a way that only a great photographer can.

I am not a photography expert, and I cannot intelligently discuss the techniques used by those who make their living making pictures. As much as I love great photography, I often find it hard to explain why a picture sticks with me, why it resonates with me. I agree with what Ansel Adams once said: "There are no rules for good photographs, there are only good photographs." And this book is filled with good photographs. Well, actually, it is filled with great photographs.

Anyone who has worked in newspapers or any similar field will tell you that hard work is the difference between good writing and bad writing, or between good writing and great writing. The editing and rewriting process is not fun—working over the same words time and again, going back for more information, ripping up some of what you've written in hopes of finding a sentence or a paragraph that makes the piece sing a little more. But that's what writers must do.

I think many people don't understand that great photographers do the same type of thing. A great eye and a lot of talent are critical. But so is old-fashioned hard work. Lee, for instance, told me that for some of his photos he went back to the scene time after time, hoping to catch a better ray of light or a different angle, desperate to see the subjects in new and different ways. "The shots are there," he said. "You just have to go find them."

Photos of the monuments and buildings that we know so well particularly require that approach. In this book, Lee has captured Indy's familiar places in unfamiliar, vibrant ways, and that's what impressed me most.

At the zoo, his photos from underneath the dolphin pool glimmer with light. In the wonderful Fountain Square neighborhood, a blue-green fountain in the foreground helps the main subject of the work, a colorful marquee, look even more interesting than it has the hundreds of times I've passed by.

I can only imagine how many photography books have been published about cities such as New York and Chicago—cities known globally for their architecture and style. Those cities deserve those books. But it is also important to appreciate the life, vibrancy, and beauty that exist in cities such as Indiana's beloved capital. That can be easy to overlook in the bustle of our busy lives. Fortunately, Lee Mandrell's book forces us to remember.

I wish to thank some people for their help, encouragement, and support. Without it, much of this would probably have been impossible and my life as I know it would have likely had a much different path. First, my parents, who have always made sacrifices and have never thought of themselves first. The contributions they have made along the way, throughout the years, have never gone unappreciated. I know that it was a challenge for them to buy me a real camera all those years ago, and I have never forgotten it. My inspiration for art and photography comes from these two people. My dad was a decent artist in his youth, so I picked that up from him. My mom enjoyed telling me about how much she loved photography and darkroom work during her years at school. Their accounts definitely got my curiosity and imagination going at an early age. I couldn't wait to learn more about art and pho-

Acknowledgments

tography and what it was that also inspired my parents. It has evolved into a lifelong journey and an ongoing education. The curiosity, wonder, and amazement, as well as my continued education in these areas, have never stopped. I truly believe that this is my life's purpose and that my parents were there to get me on the right course as early as possible in life, even if they didn't realize it. Thank you both.

My wife, DeeDee, who is always positive, uplifting, and sees the good in everything. You are a ray of sunshine to me, a constant source of inspiration and motivation, and a great companion for everything we do and everywhere we go. Thank you for always being willing to travel, even when it's long before the sun comes up, even when it's windy, rainy, cold, frozen, or too hot to be out shooting, even sometimes right smack in the middle of the night, and even when we simply don't feel up to it. We just never know when or where we will end up, and on a moment's notice. I have never once heard a complaint from you about taking photographs, but rather just the opposite. Thanks for being there for me, thanks for being there for us, and thanks for making us a real team and always being together as one. I appreciate that we have so much in common and get to share our life's passions together. What an amazing wife! I am truly blessed.

Ashlee, my daughter, who is always seeing random things with wonder and amazement, things that I might miss. It still amazes me that we can be in the exact same location yet our shots look miles apart. It is with her help that I can work on this area of my photography. I find myself wandering over to see what she is shooting, or what holds her interest. Sometimes I can see it right away, but sometimes I need her to point it out to me. As parents we get to see the world not only through our own eyes, but also those of our children. Thank you for who you are and allowing me to share in your experiences. The wonder never ceases.

Indiana University Press for their endless patience and willingness to always answer any questions I have had, particularly Sarah Jacobi. I told her early on she has the patience of a saint, and as the book evolved and obstacles came up, I am more convinced of that now. The press's help, guidance, and experience throughout the process have been invaluable to me. Thank you for the belief in my work and the chance for us to work together. Hopefully there will be more opportunities. I know that this project was a giant leap of faith. It means more than I can ever express.

Everyone who has been willing to help educate me in some way, willing to work with me and give me that first chance. I very much appreciate all of the willingness to collaborate with others in this field. All of you whom I reached out to for help or advice—some of the photos wouldn't have been possible without the understanding and cooperation of so many people. Over the years, the network of colleagues has grown, and still continues to grow. I look forward to all of the people I have yet to meet in upcoming years and possibly work with.

To all of the people who live in the great city of Indianapolis: it is also to each of you that this collection of work is dedicated. I hope it is enjoyed by everyone, and for years to come. I hope you can explore some of these locations first hand and experience the sights and wonders for yourselves.

INDIANAPOLIS

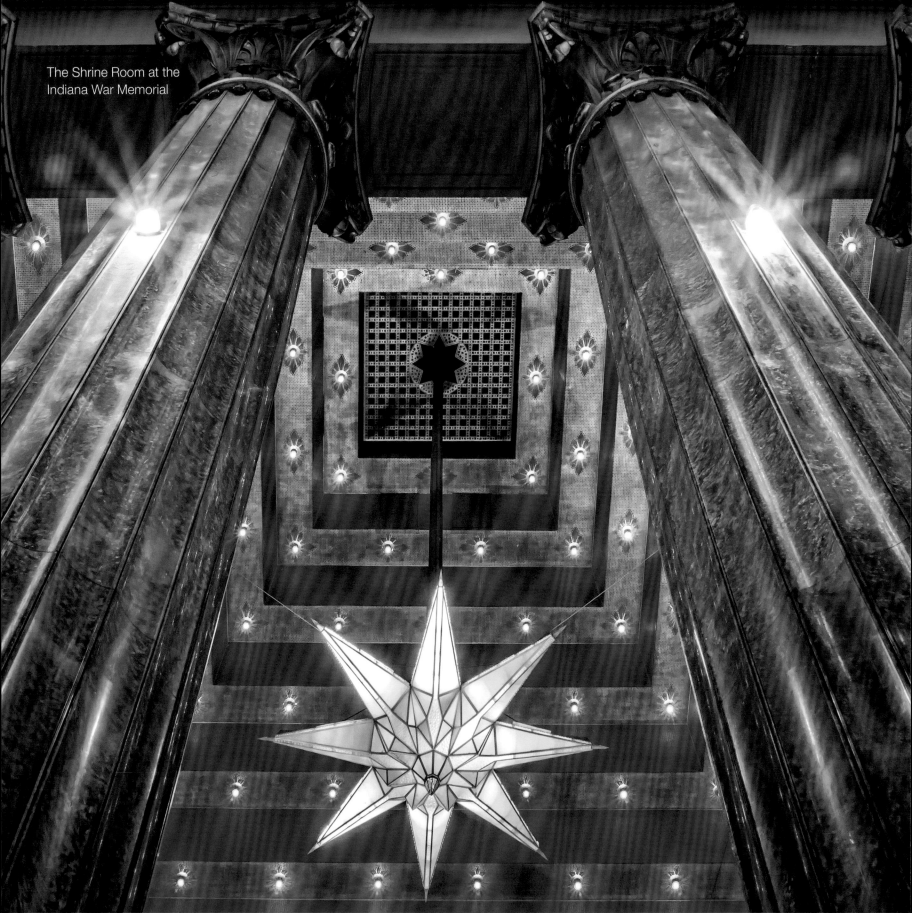

The Shrine Room at the
Indiana War Memorial

Gallery

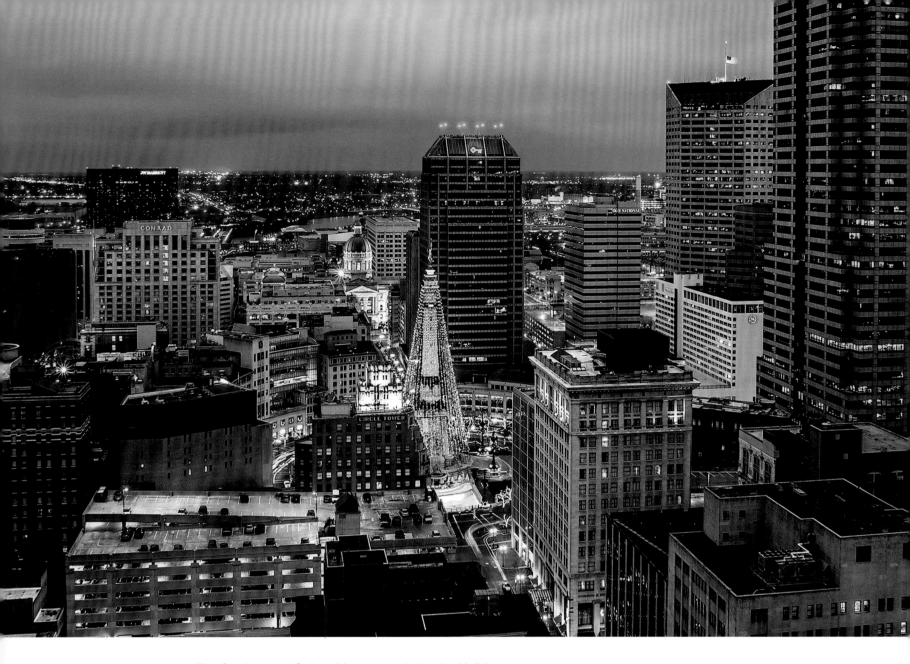

The Soldiers and Sailors Monument during the Holidays

(Facing) The Corridor at the Indiana Government Center

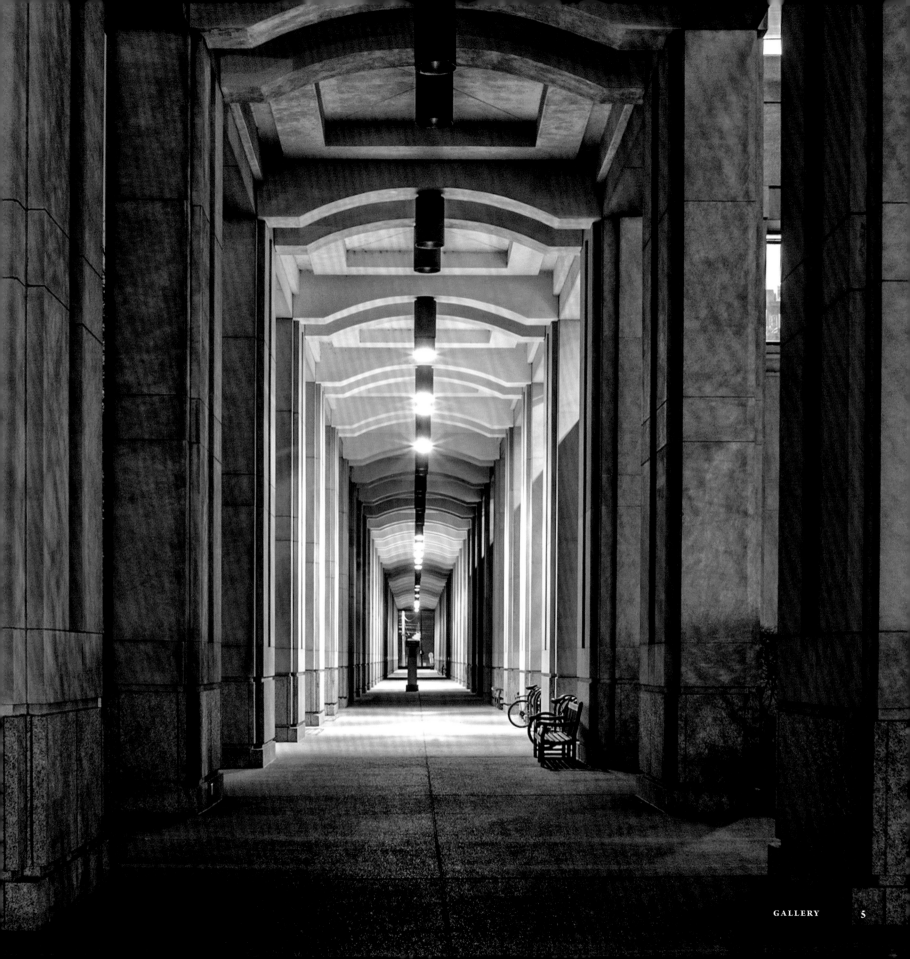

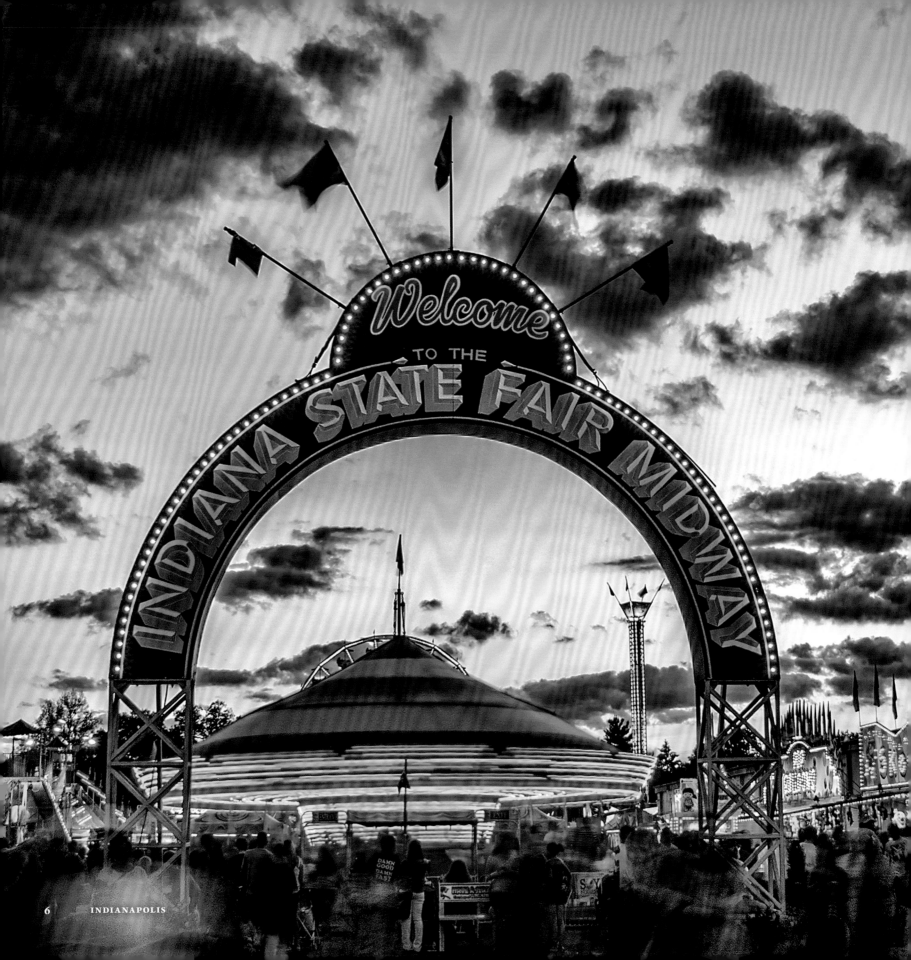

Welcome TO THE INDIANA STATE FAIR MIDWAY

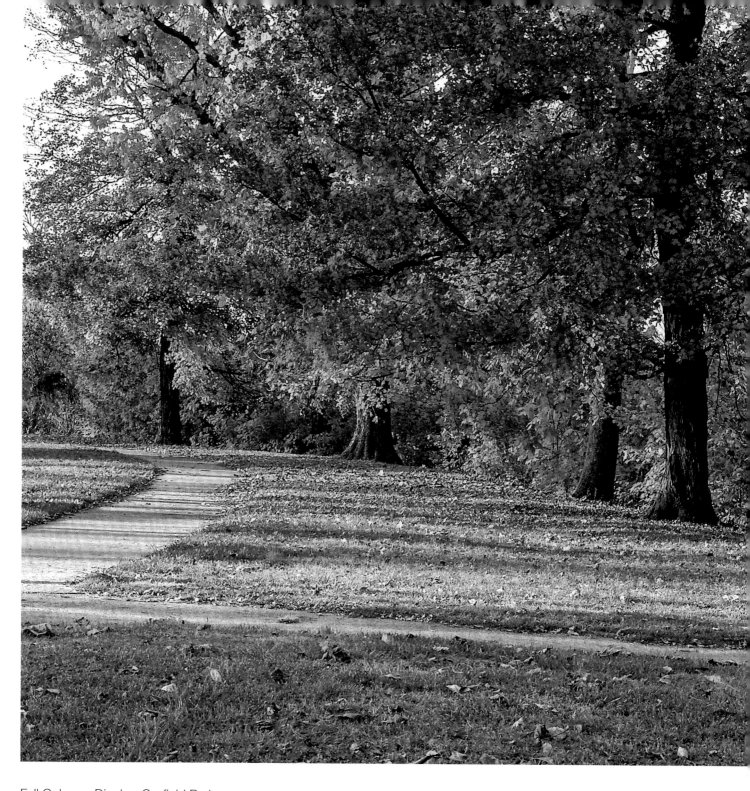

Fall Color on Display, Garfield Park

(Facing) The Indiana State Fair Midway

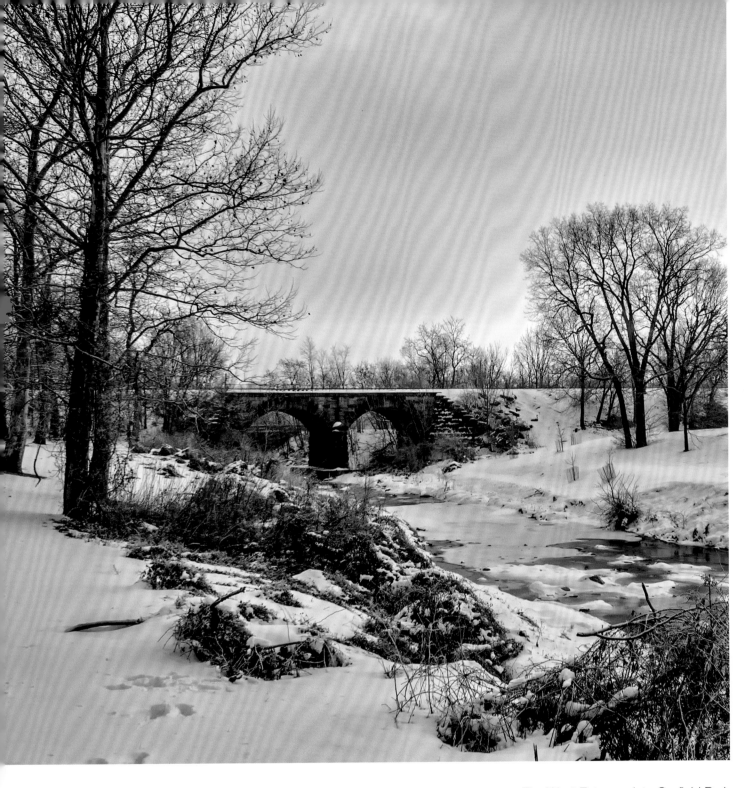

The West Entrance into Garfield Park

(Facing) The Indiana State Capitol Building

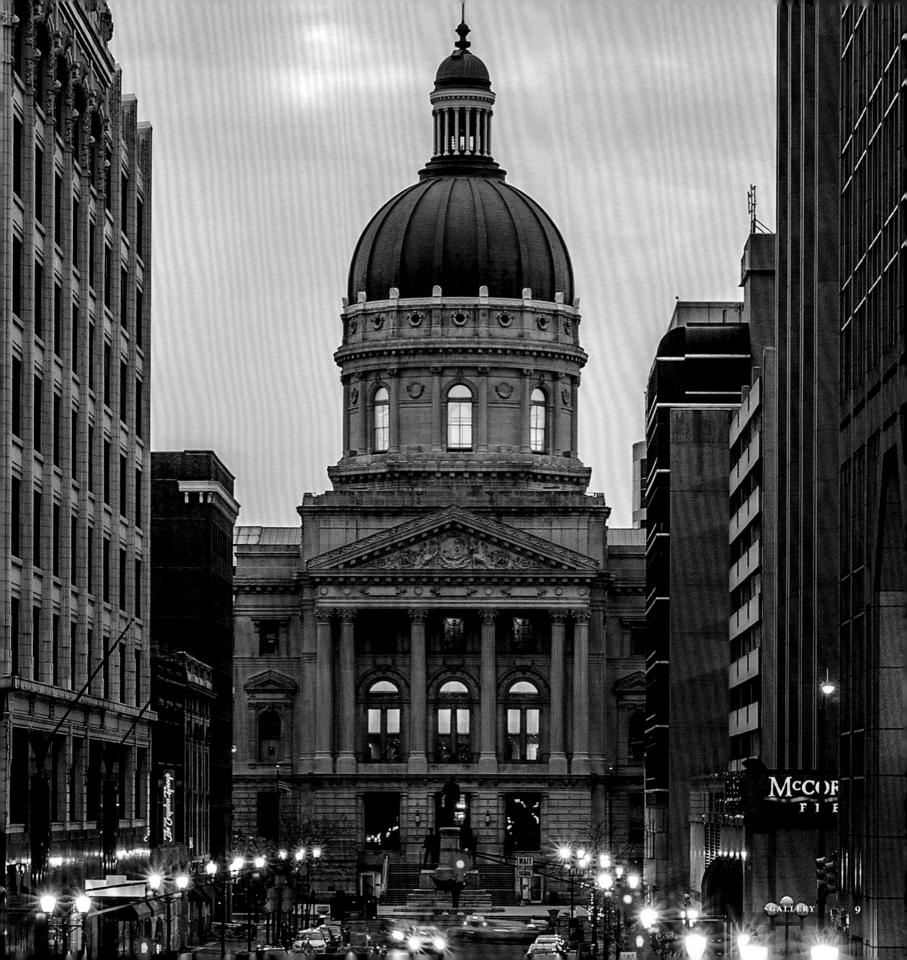

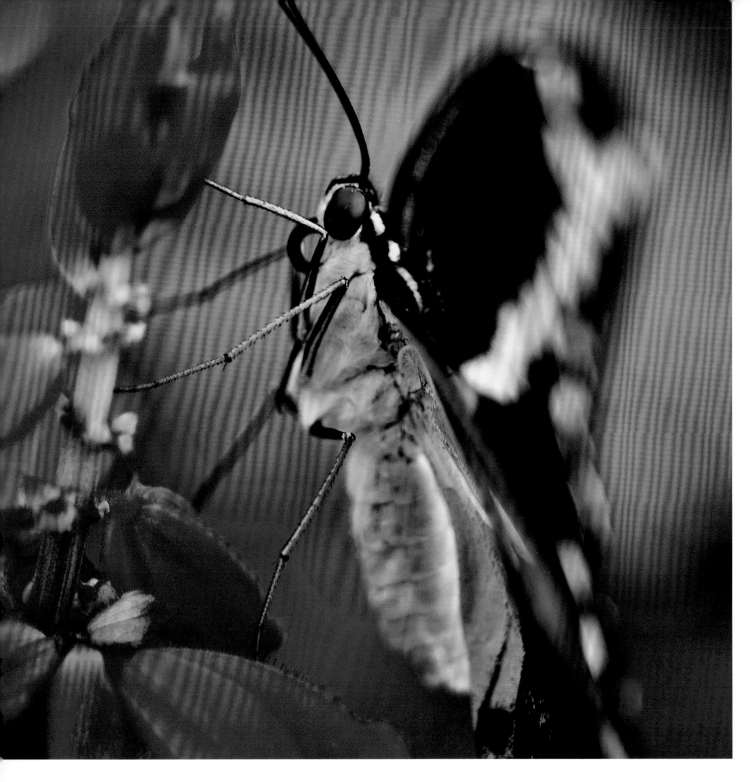

The Garfield Park Conservatory Butterfly Exhibit

(Facing) Spring, White River Gardens

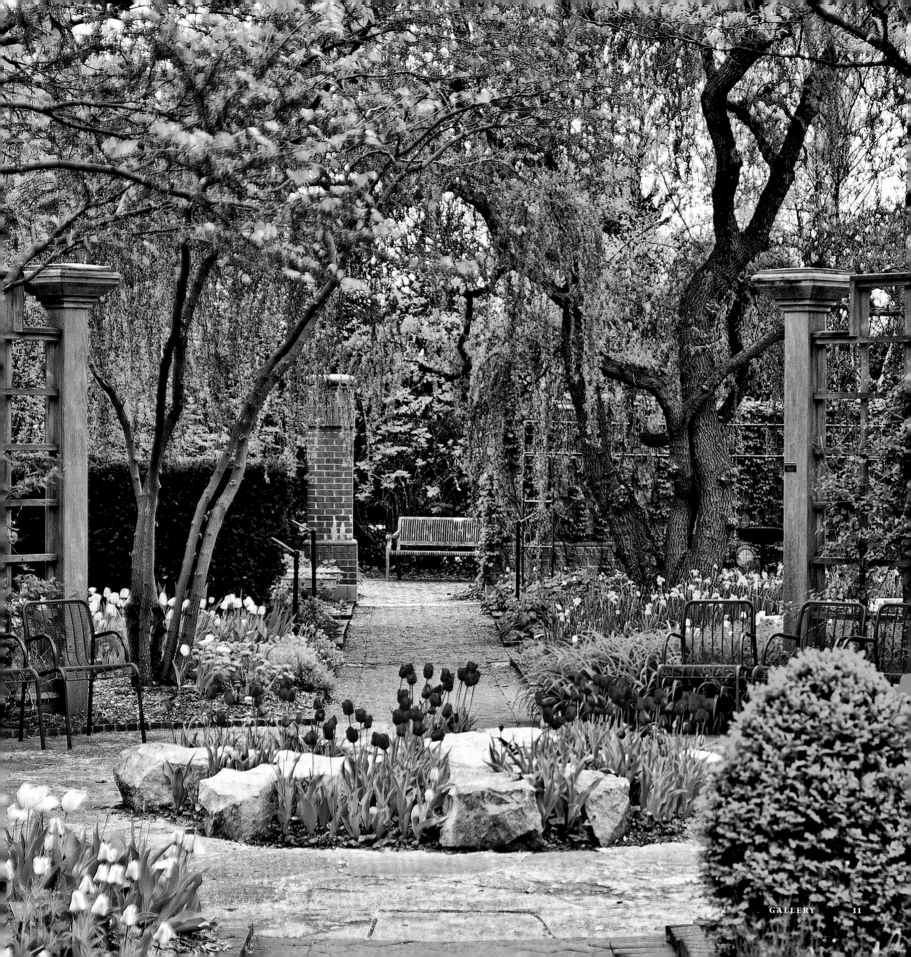

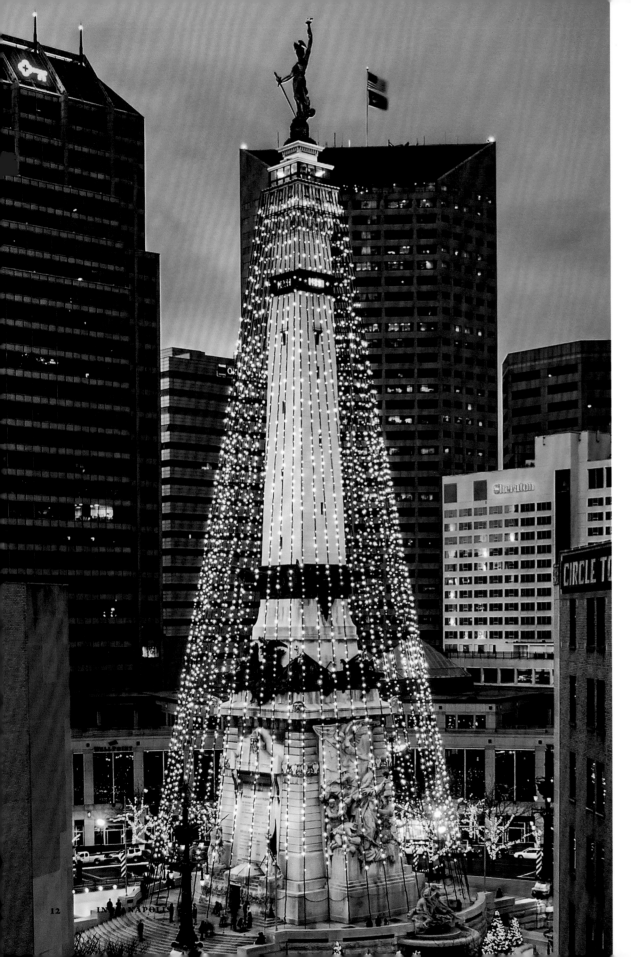

The Soldiers and Sailors Monument during the Holidays

(Facing) The Covered Bridge at the Indiana State Fairgrounds

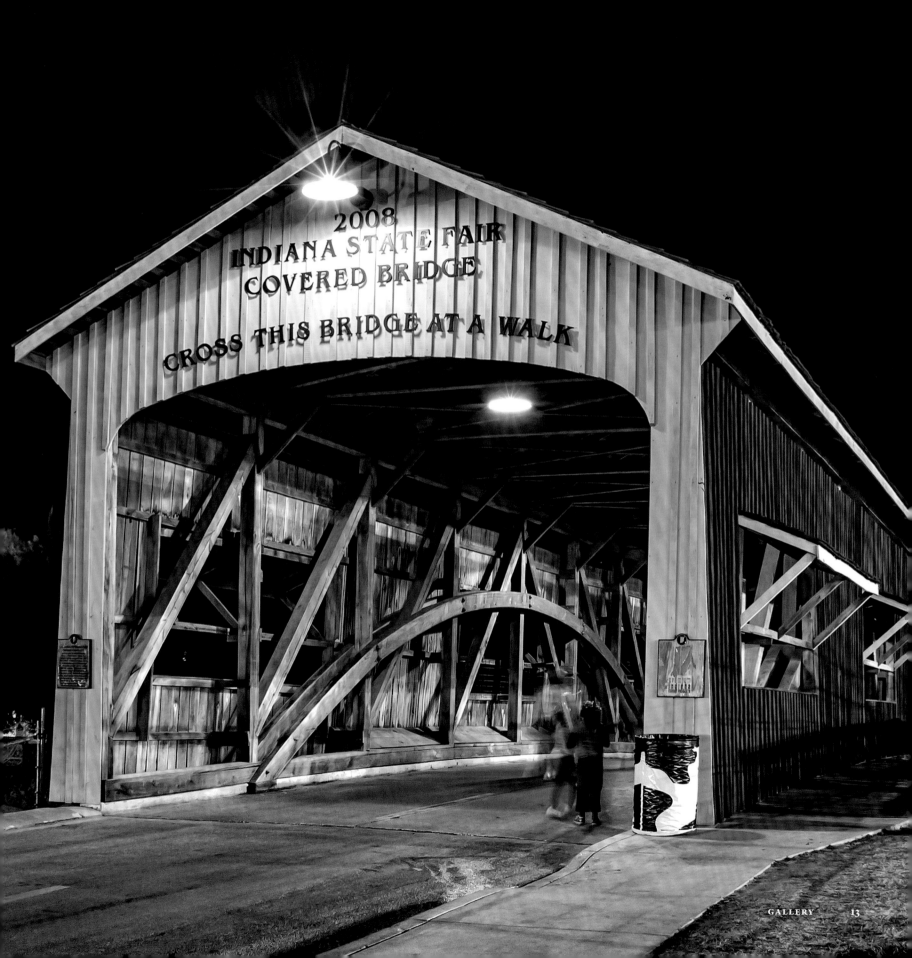

2008
INDIANA STATE FAIR
COVERED BRIDGE

CROSS THIS BRIDGE AT A WALK

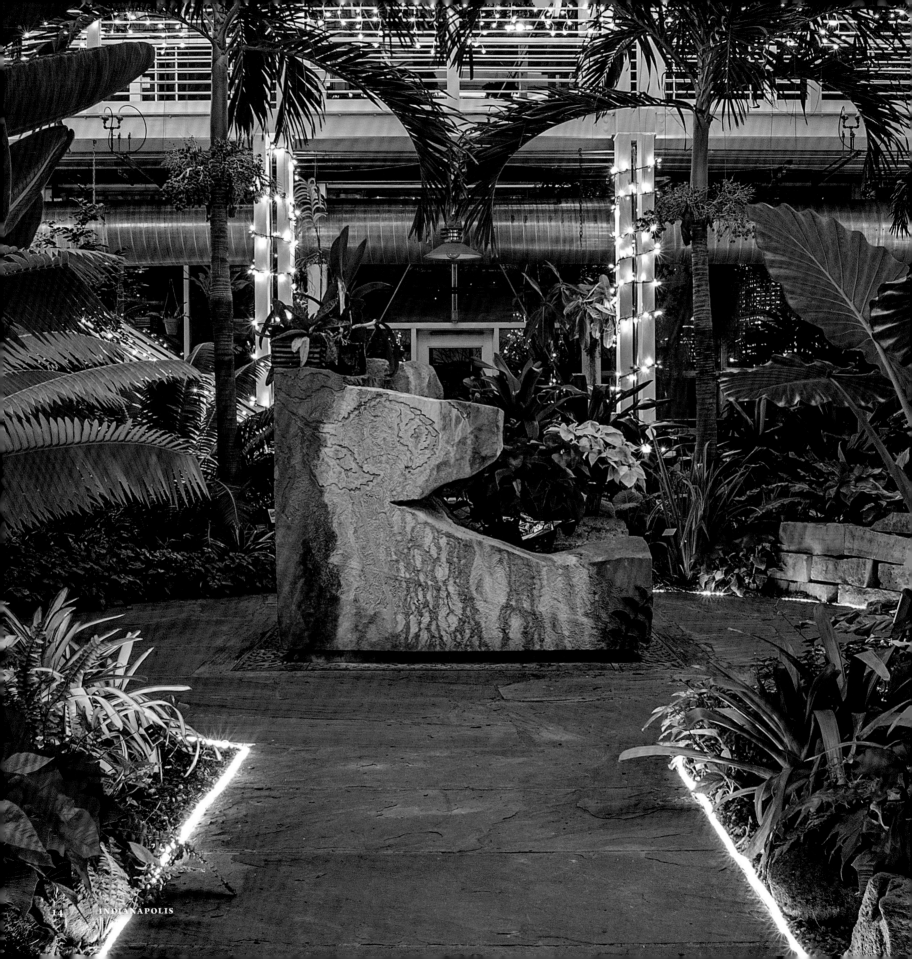

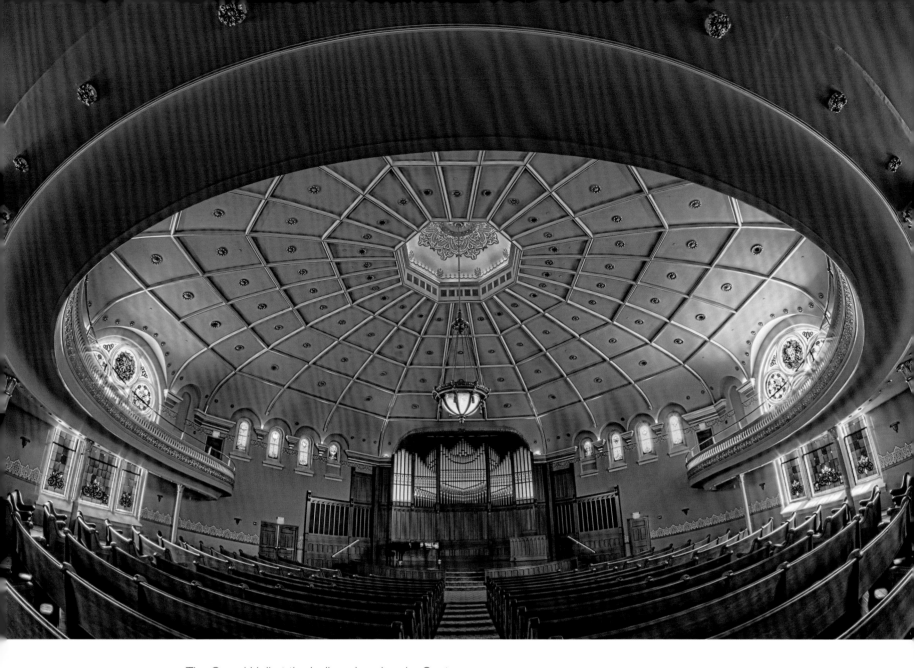

The Grand Hall at the Indiana Landmarks Center

(Facing) White River Gardens during the Holiday Season

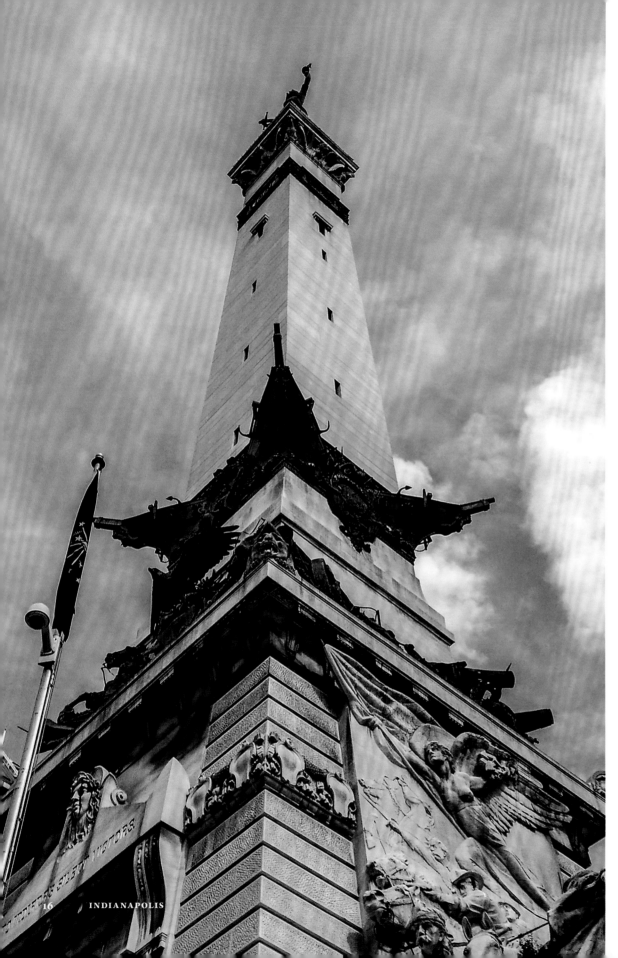

The Soldiers and Sailors Monument

(Facing) The Sunken Garden at Garfield Park

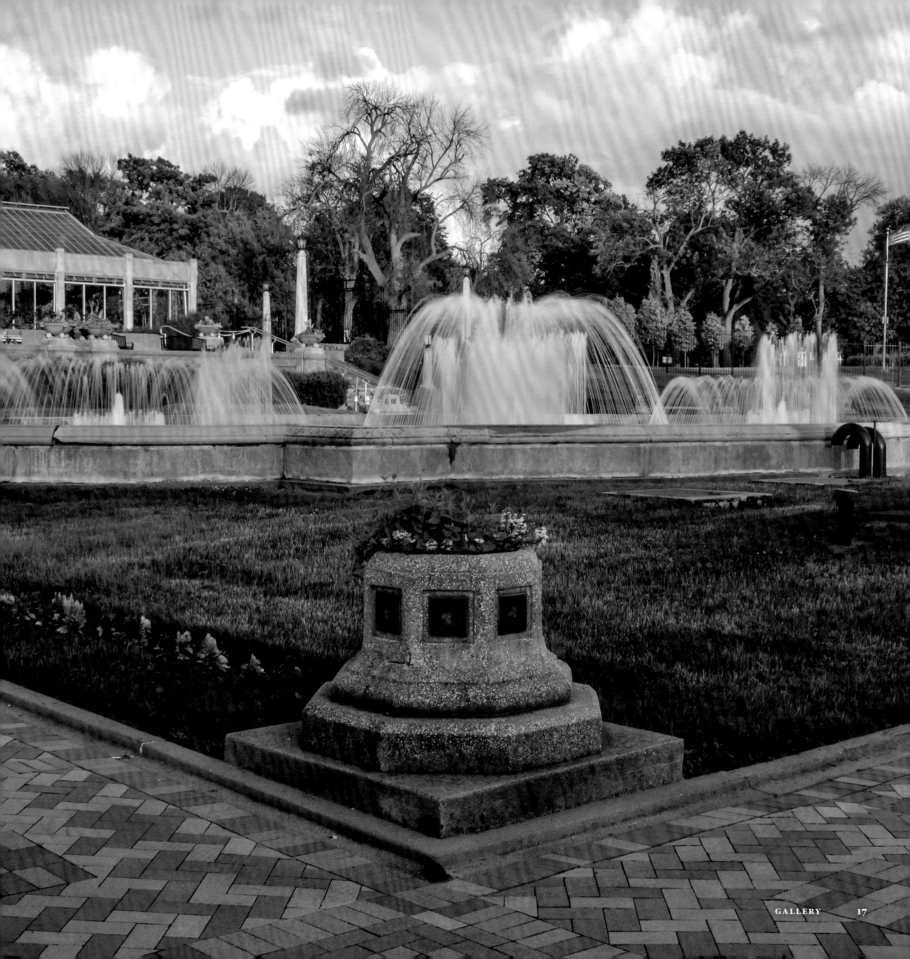

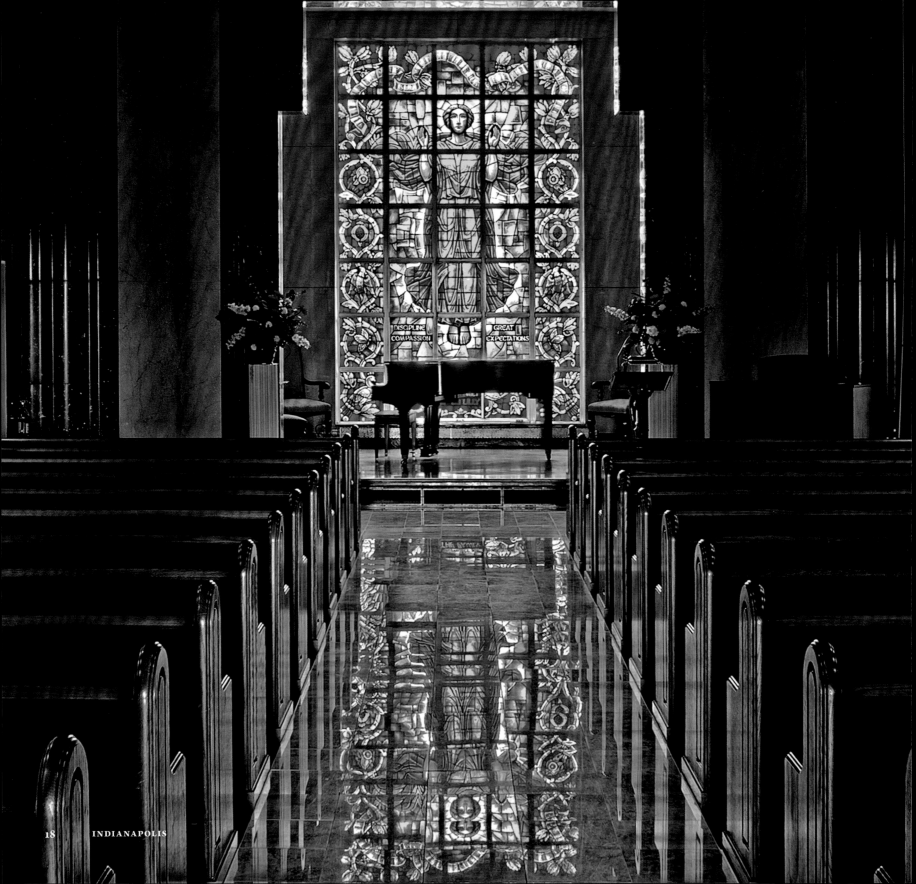

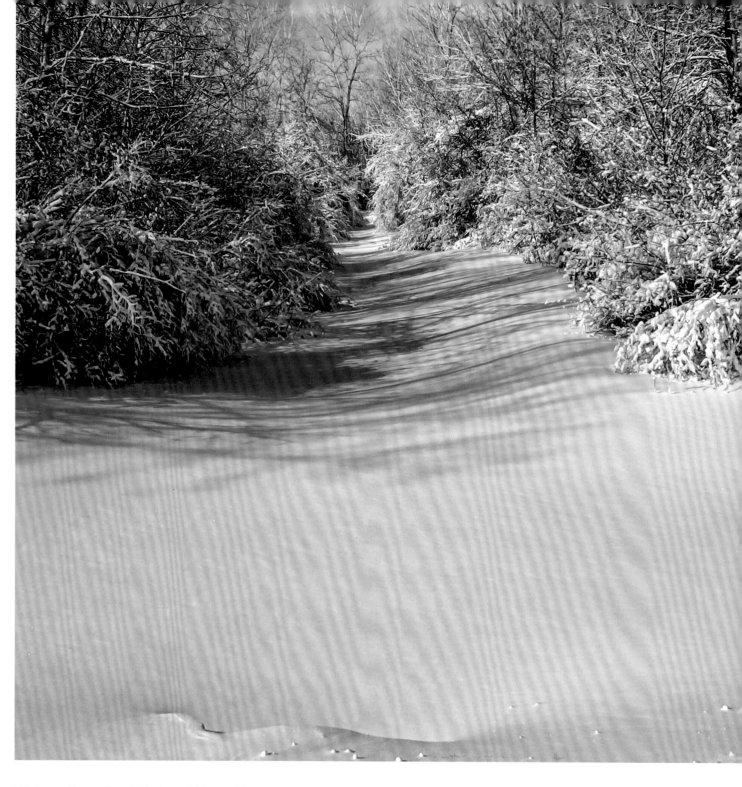

Winter at Eagle Creek Park and Nature Preserve

(Facing) The Eli Lilly Memorial at the Peace Chapel, Crown Hill Community Mausoleum

The City-County Building

(Facing) Hook's Drug Store Museum

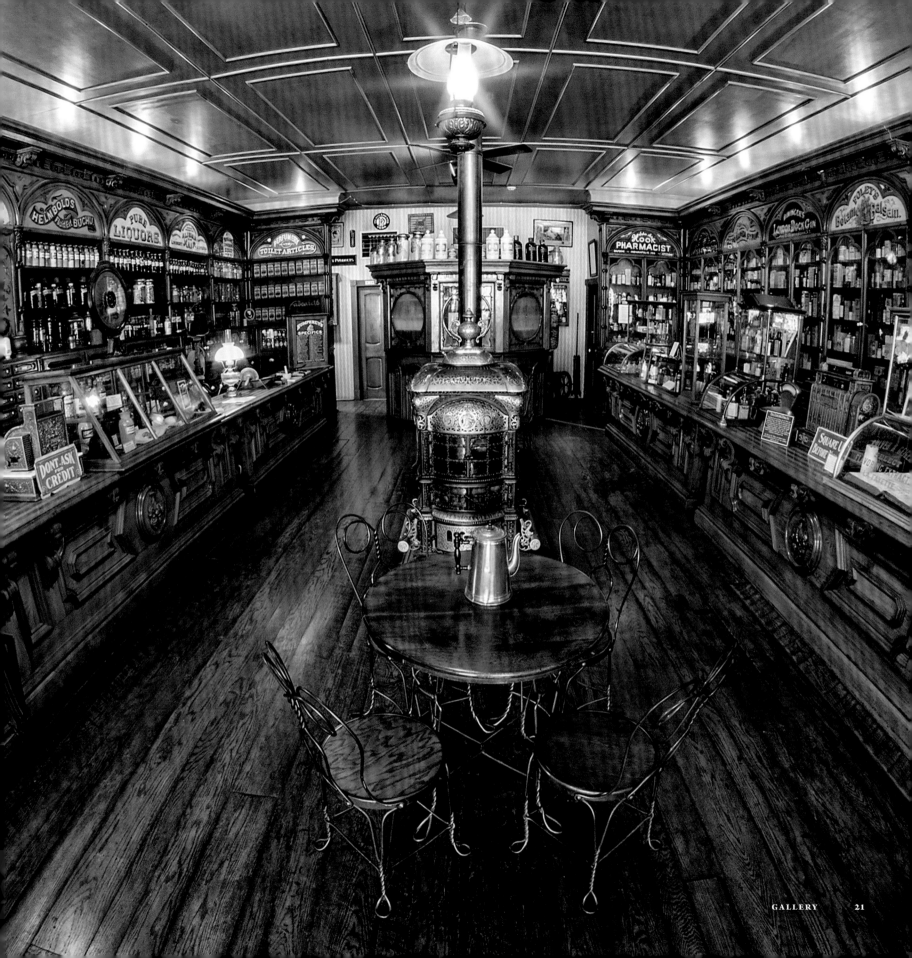

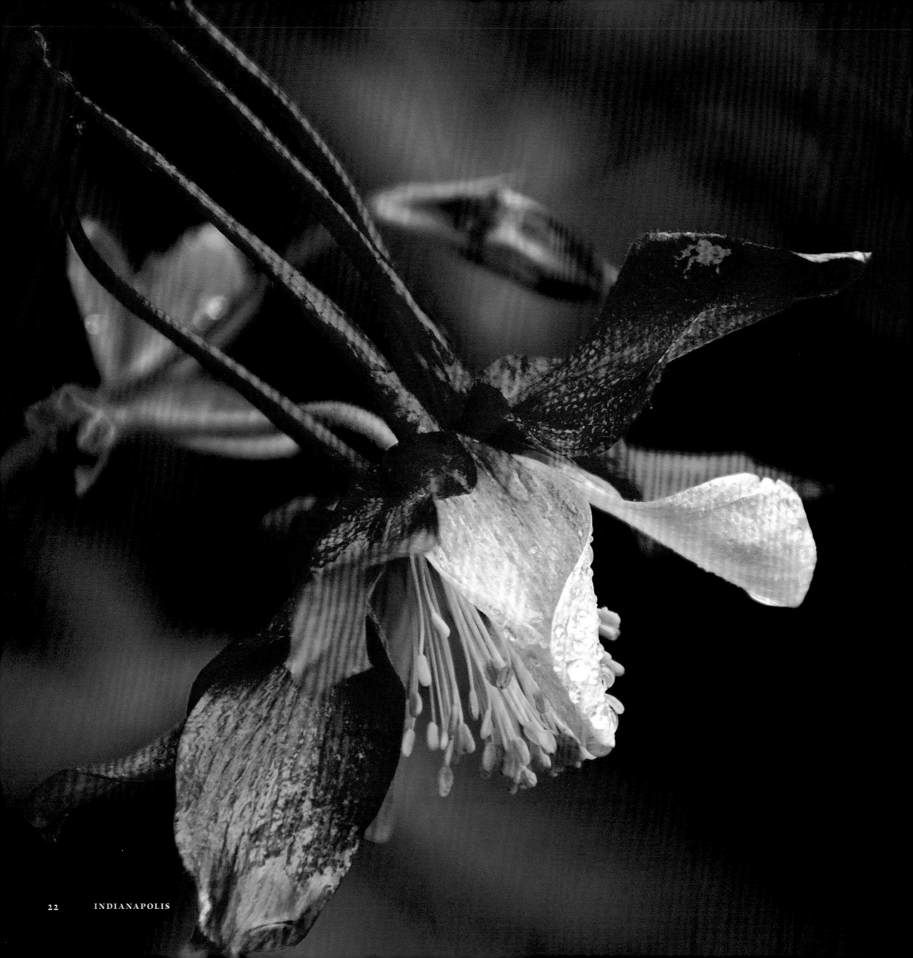

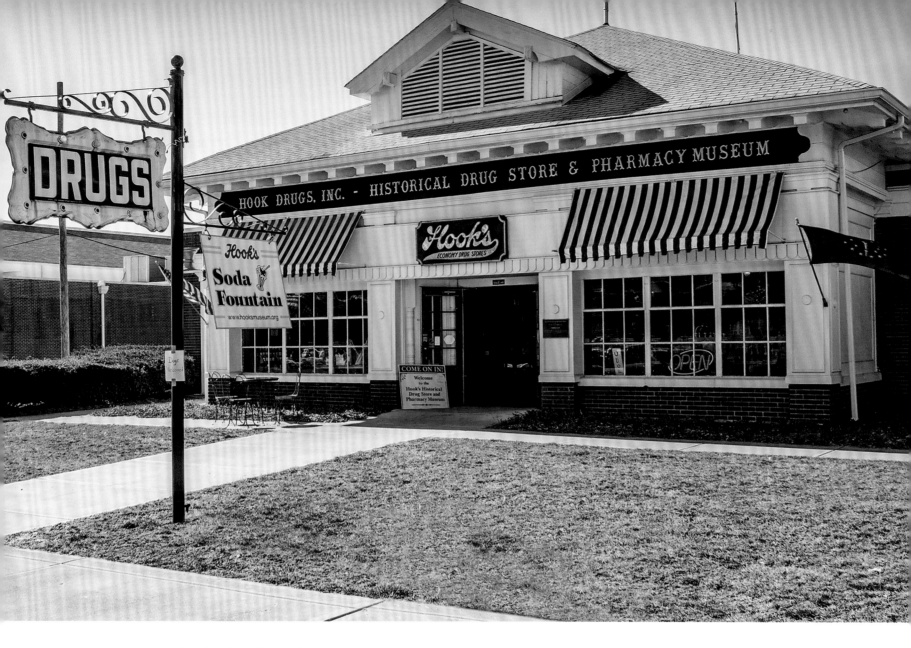

Hook's Drug Store Museum

(Facing) Columbine at White River Gardens

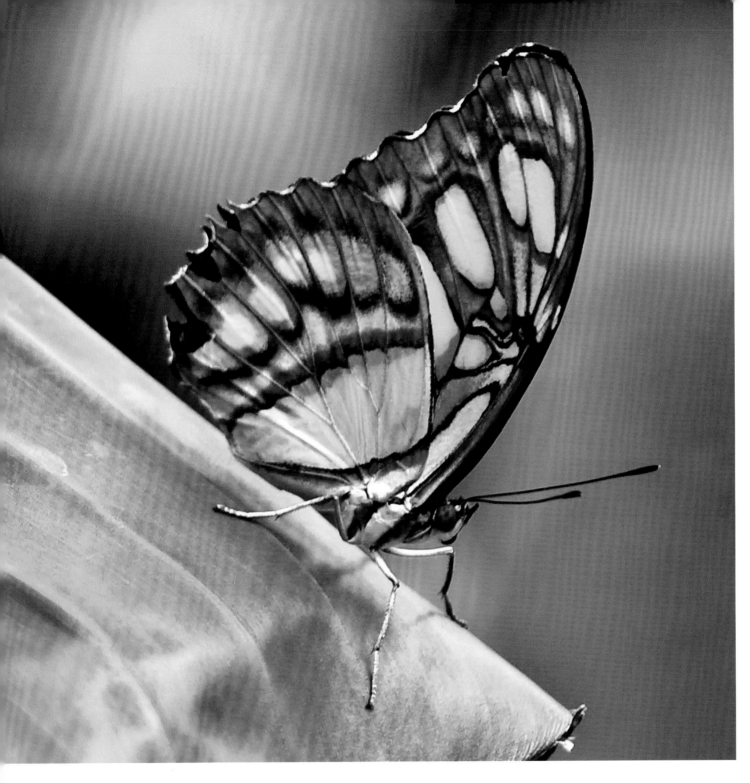

The Butterfly Exhibit, White River Gardens

(Facing) Carriage Ride at the Soldiers and Sailors Monument

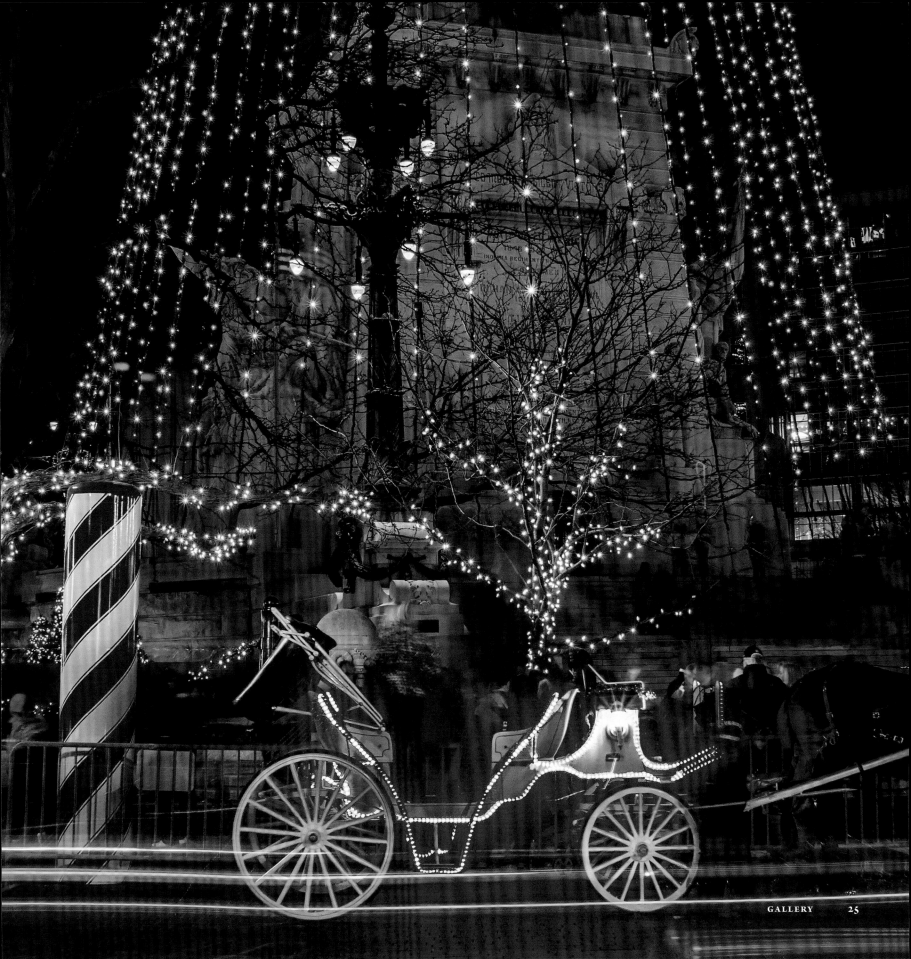

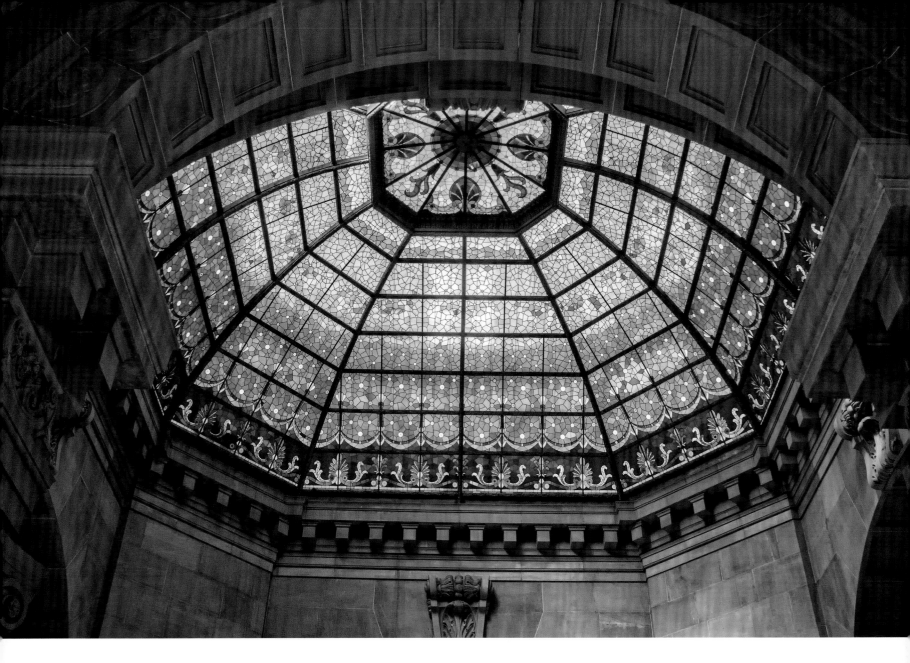

The Dome at the Indiana State Capitol Building

(Facing) The Indiana State Capitol Building

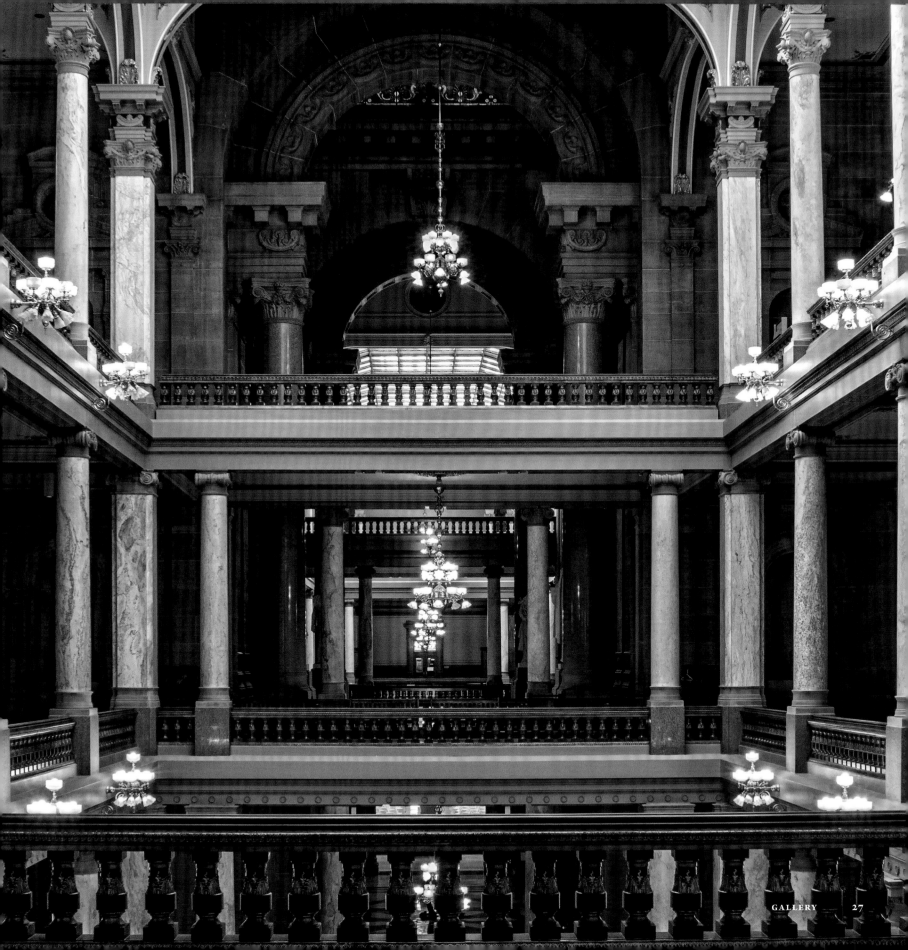

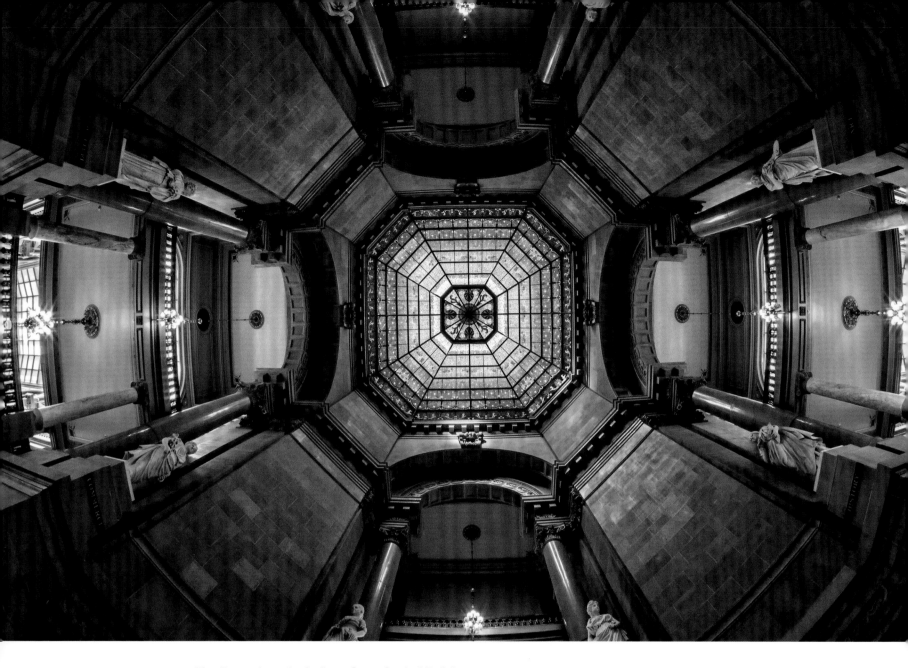

The Rotunda at the Indiana State Capitol Building

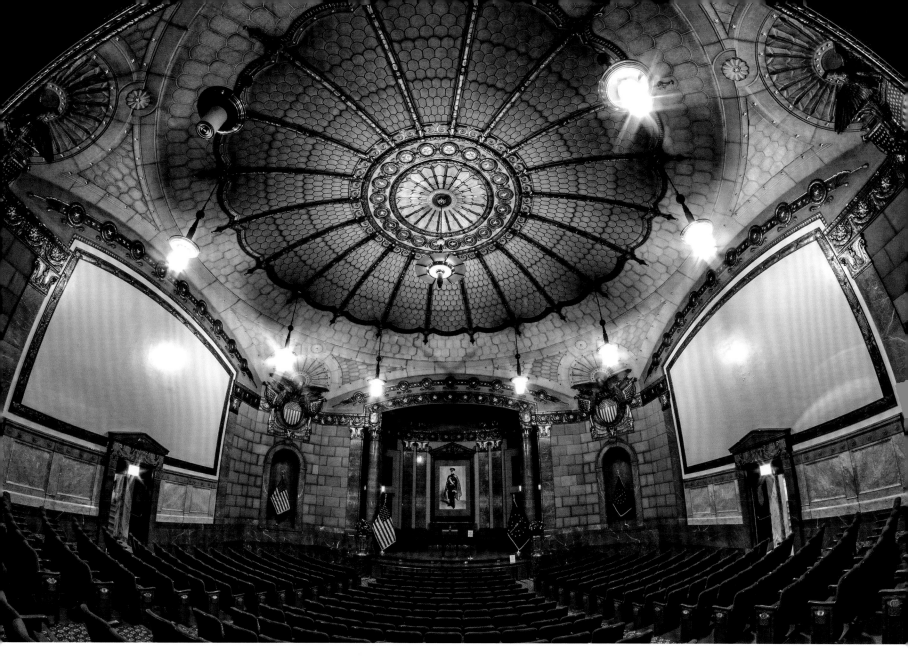

Pershing Auditorium inside the Indiana War Memorial

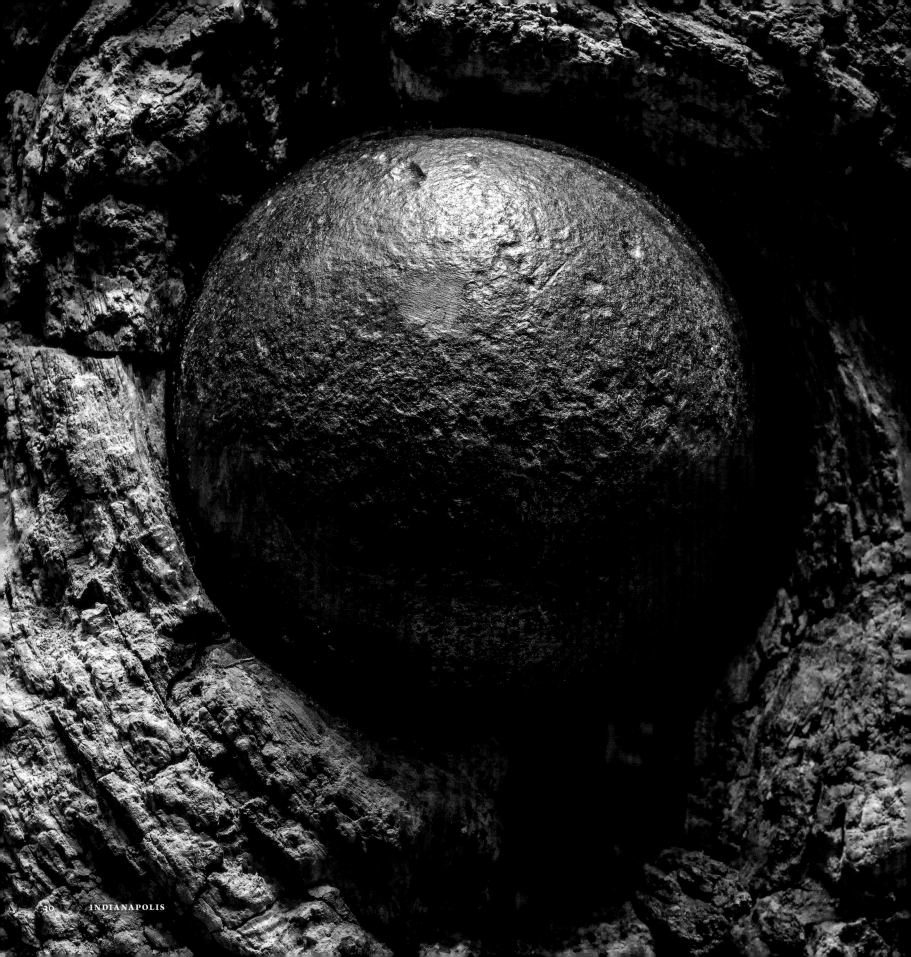

The Covered Bridge Inside the
Colonel Eli Lilly Civil War Museum

(Facing) A Relic of Gettysburg,
Colonel Eli Lilly Civil War Museum

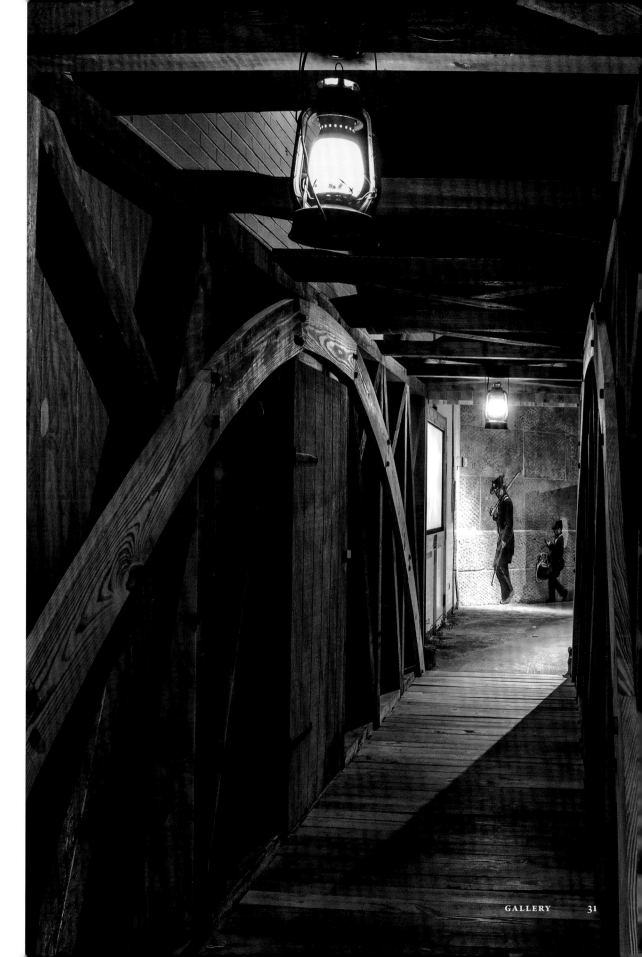

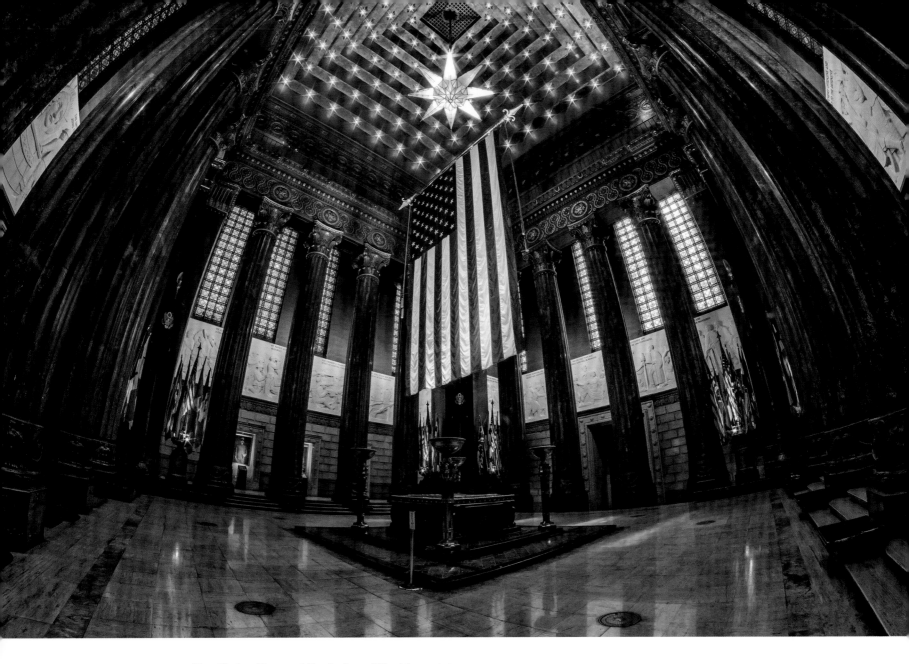

The Shrine Room at the Indiana War Memorial

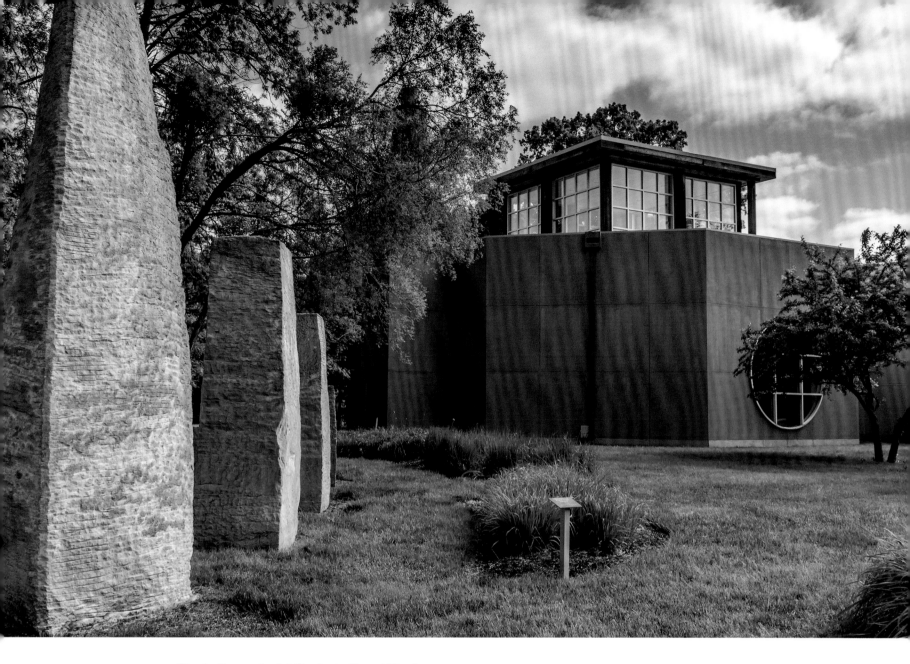

The Indianapolis Art Center in Broad Ripple

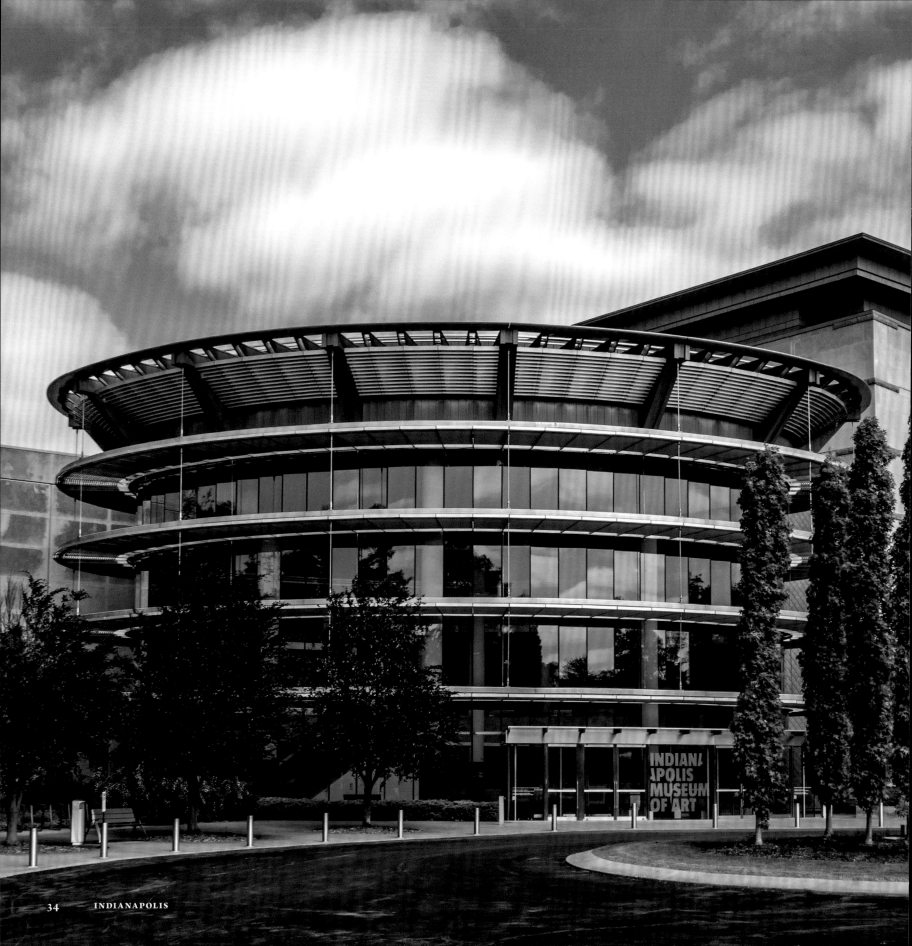

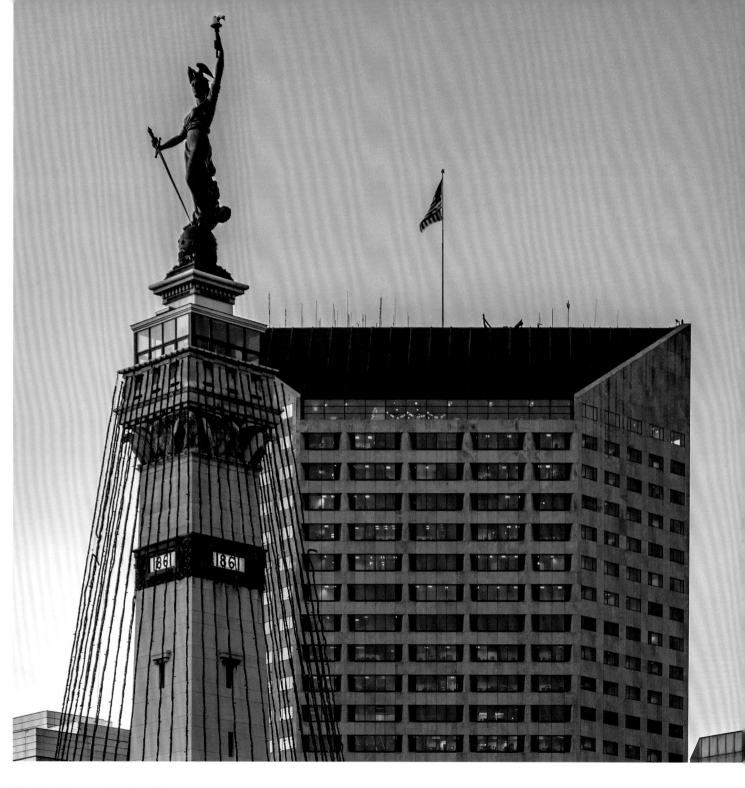

The Soldiers and Sailors Monument

(Facing) The Indianapolis Museum of Art

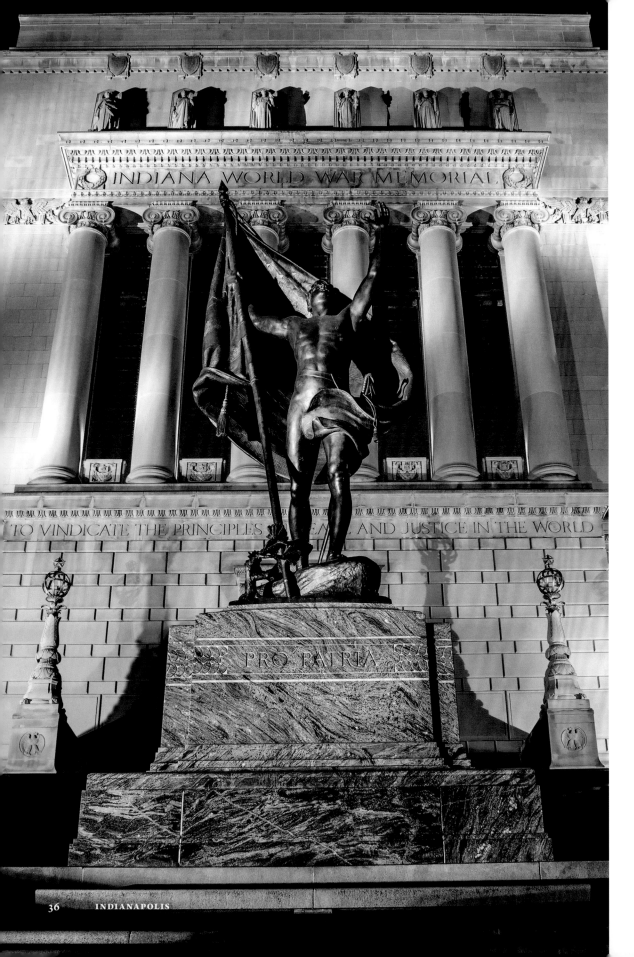

The Pro Patria Statue at the
Indiana War Memorial

(Facing) The Central Canal,
Downtown

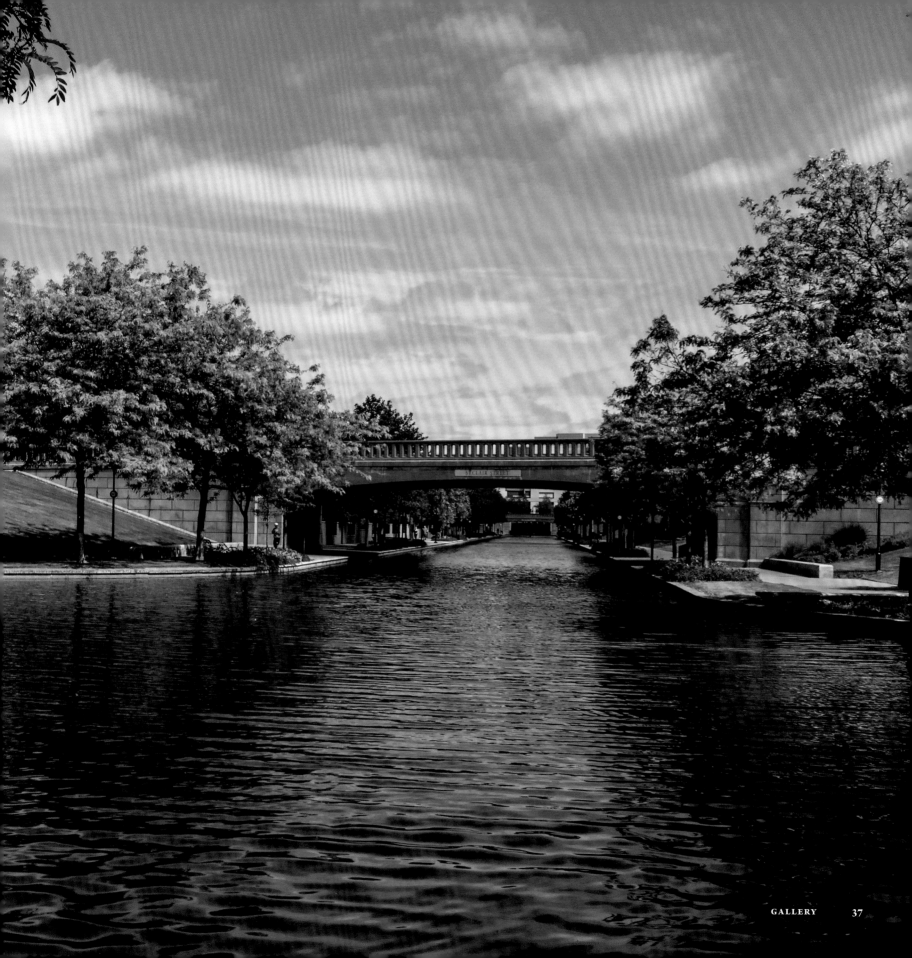

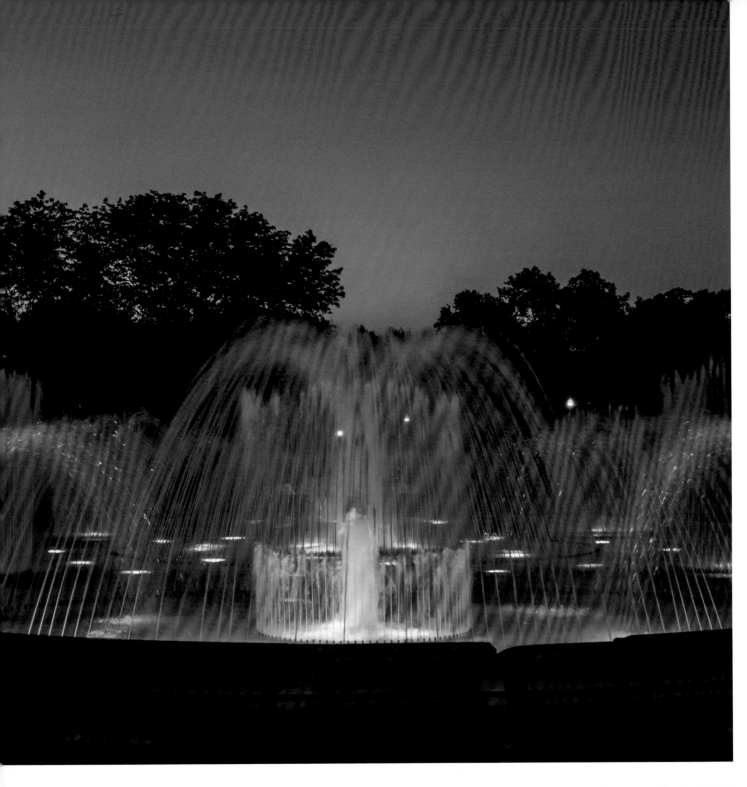

The Sunken Garden at Garfield Park

(Facing) The Chase Circle Building as Seen from Monument Circle

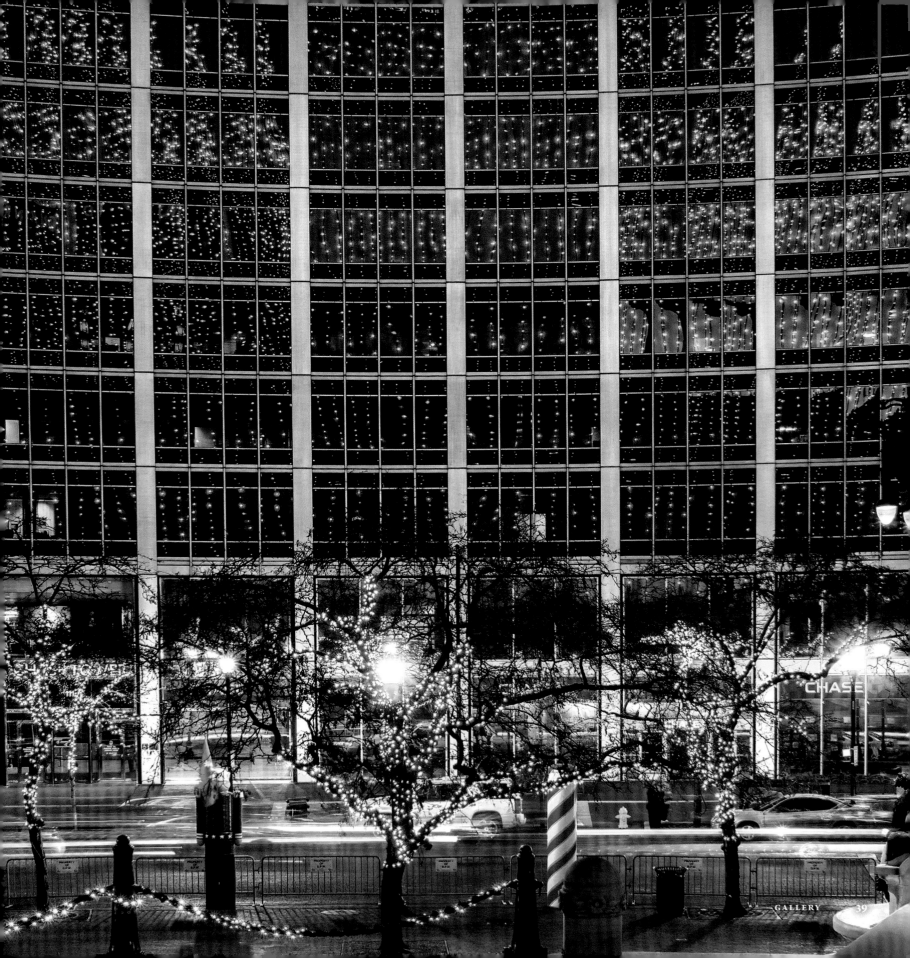

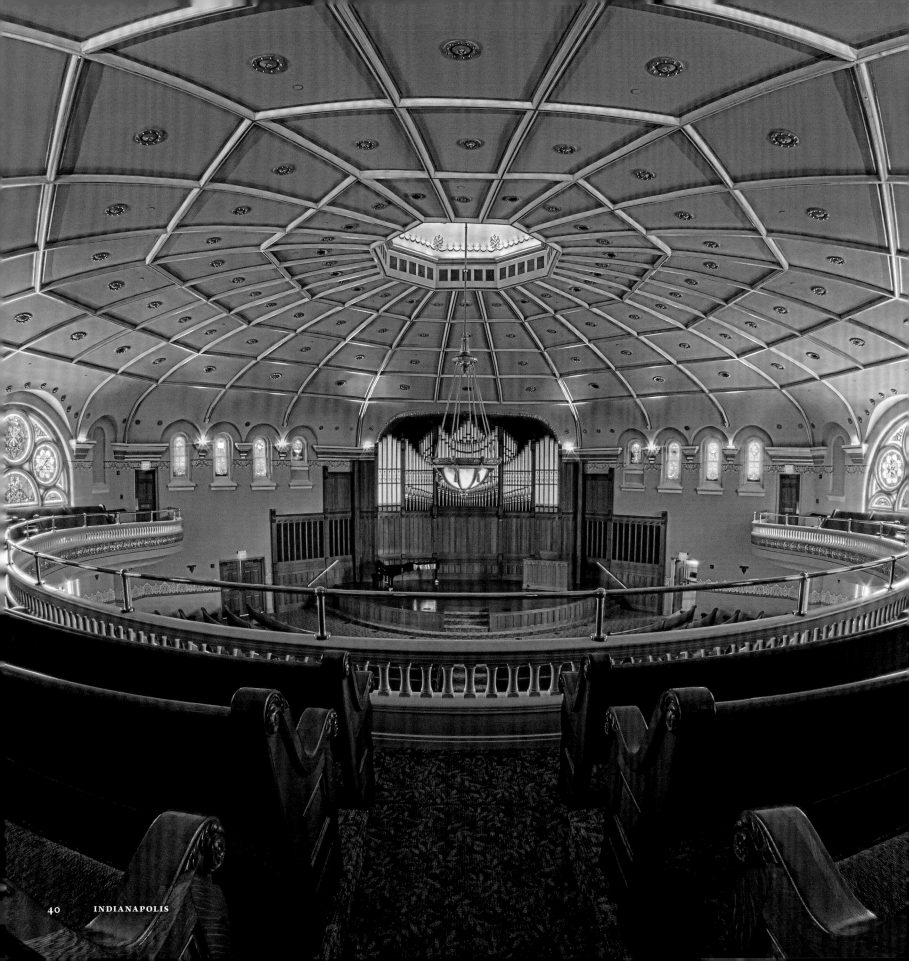

(This page and facing)
The Grand Hall at the
Indiana Landmarks Center

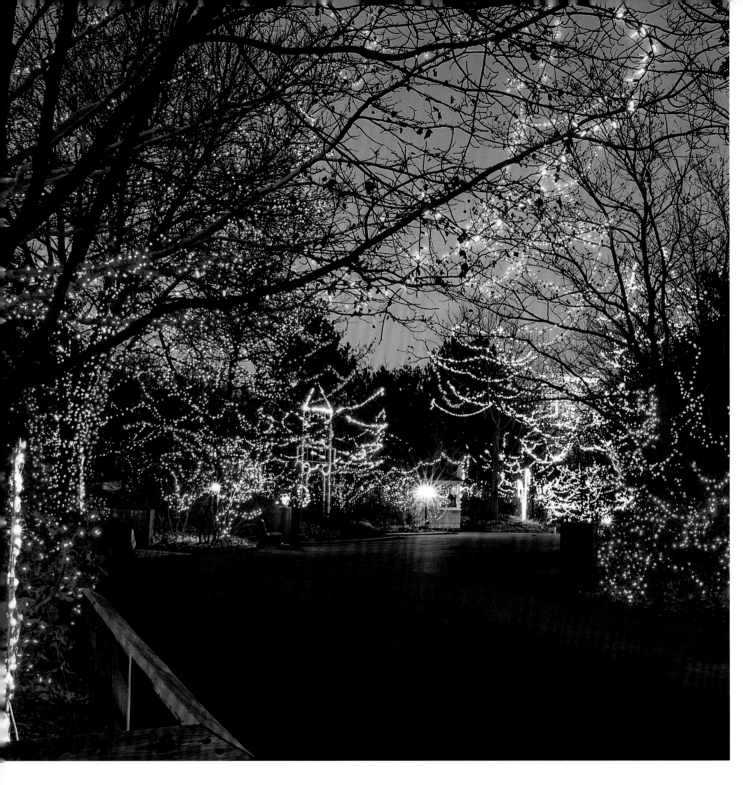

Christmas at the Zoo

(Facing) The Central Library

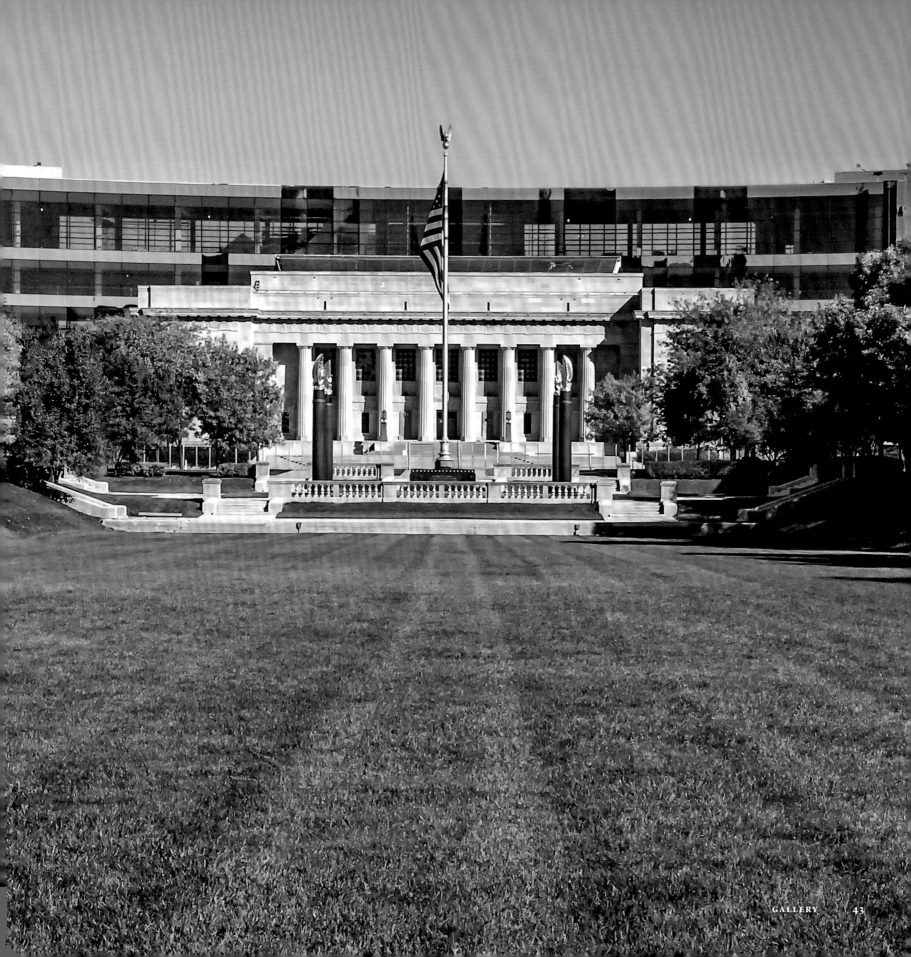

Sunrise at the West Entrance, Garfield Park

(Facing) Water Lily at White River Gardens

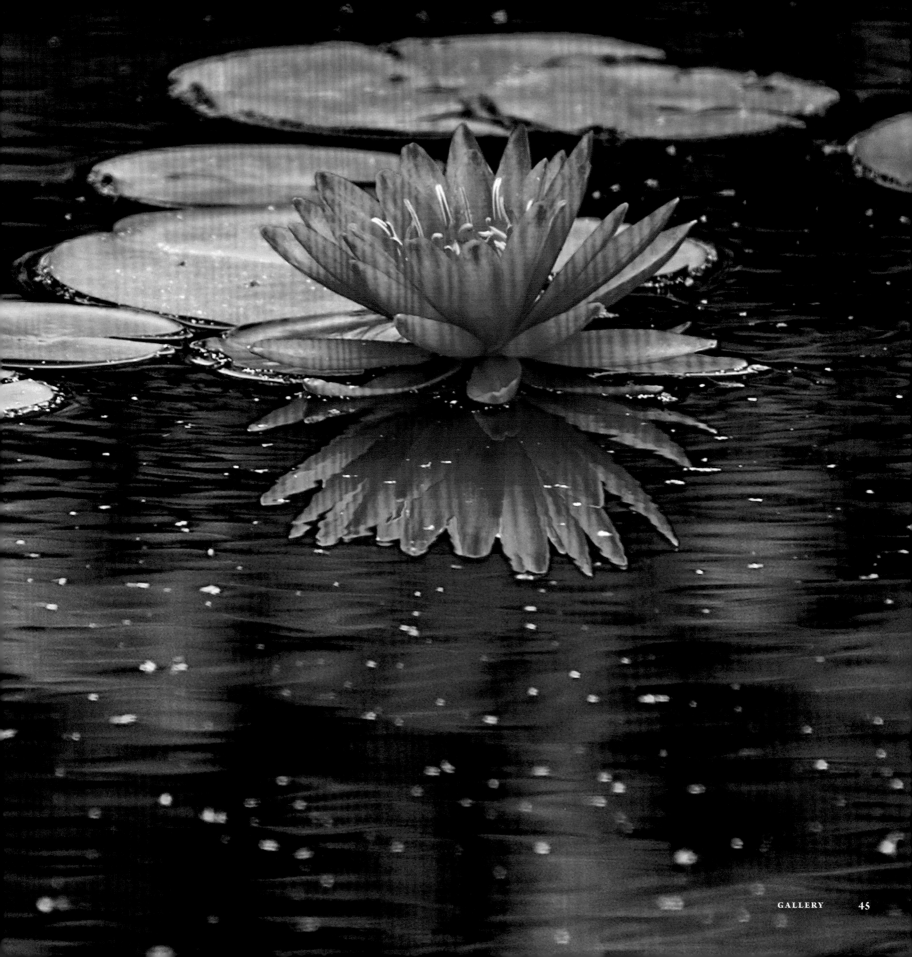

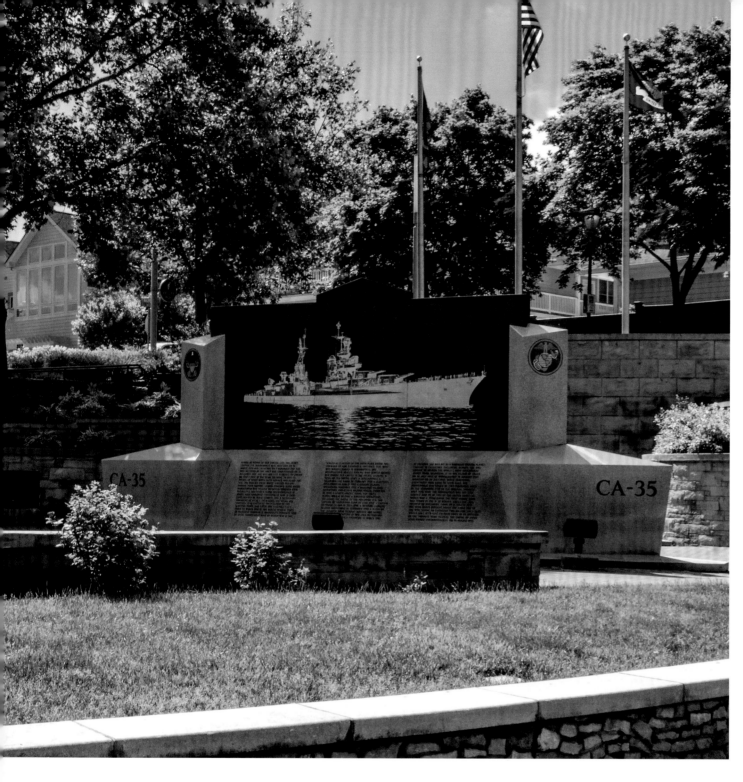

The USS *Indianapolis* National Memorial on the Central Canal

(Facing) The Rotunda Entrance to White River Gardens and the Hilbert Conservatory

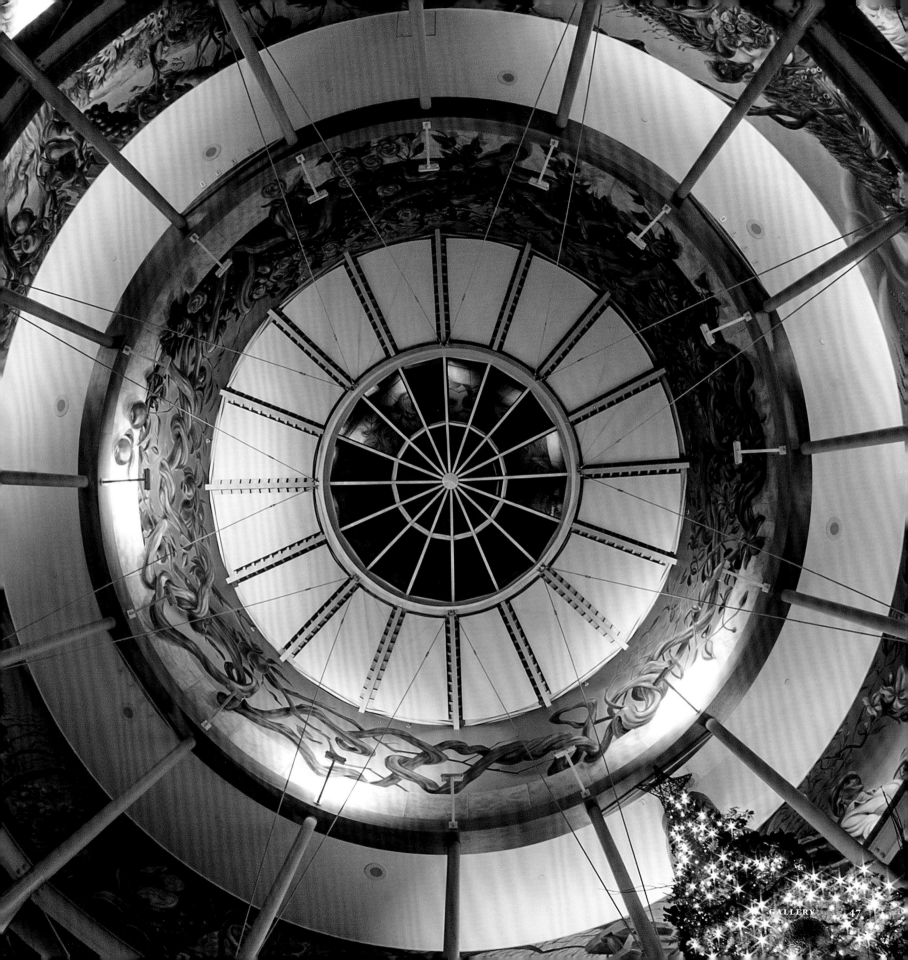

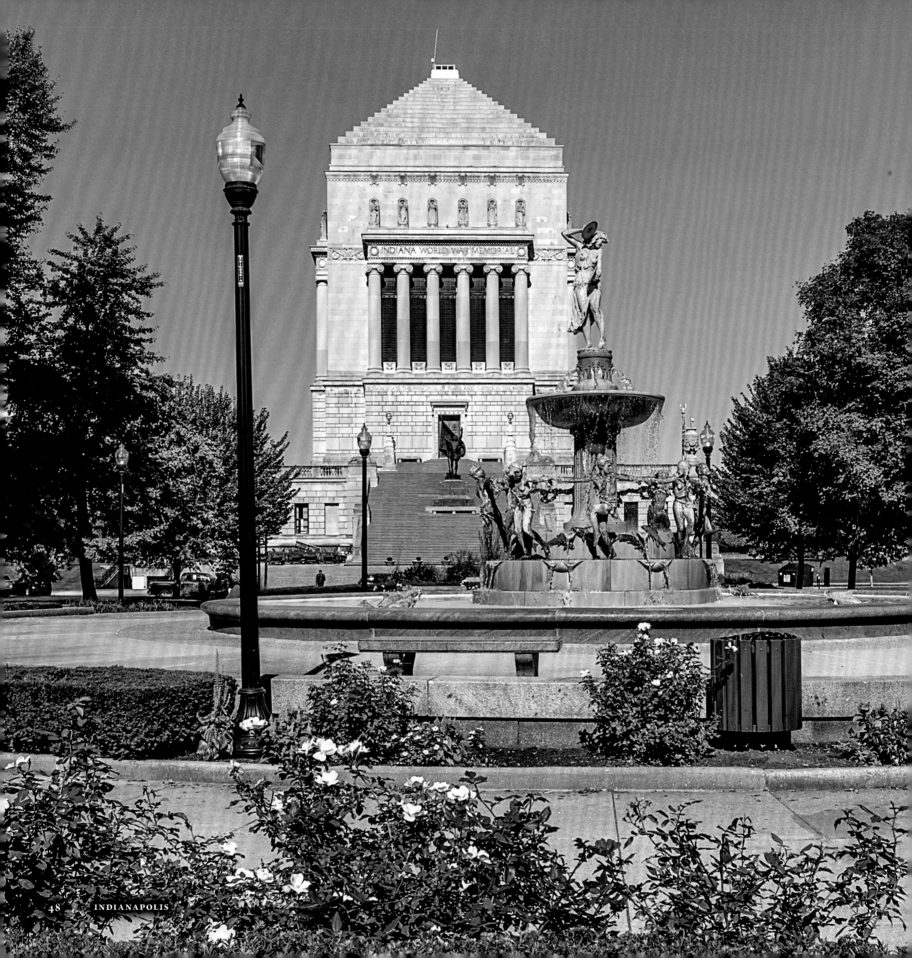

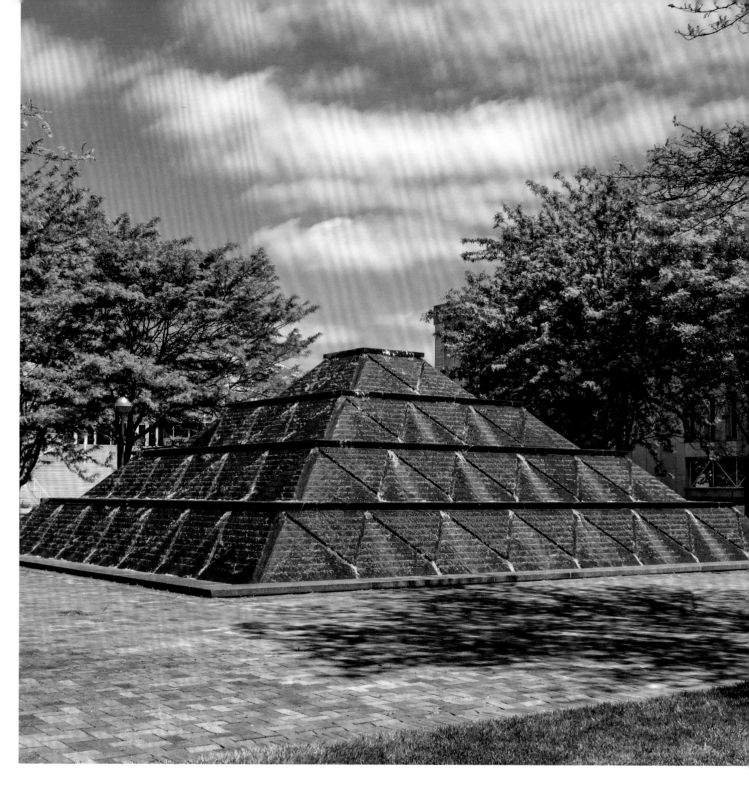

Wood Fountain, IUPUI Main Campus

(Facing) Depew Memorial Fountain as Seen Looking toward the Indiana War Memorial

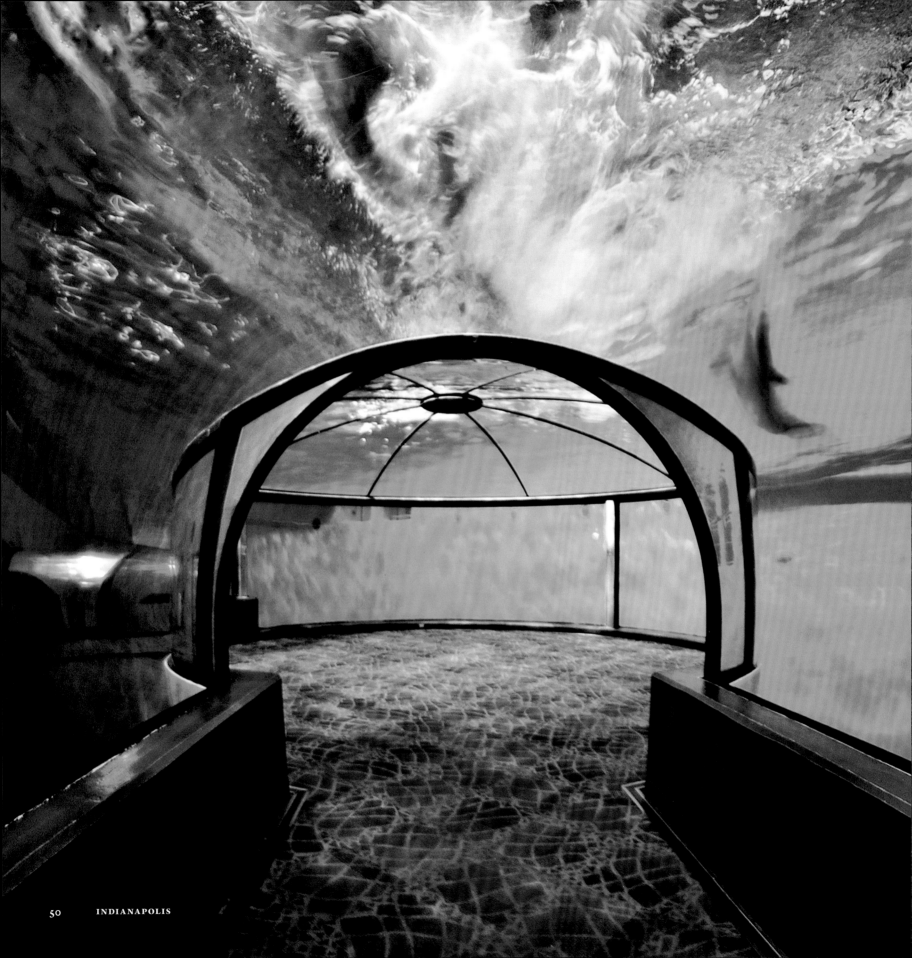

The Firefighters Museum and
Fallen Firefighters Memorial on
Massachusetts Avenue

(Facing) The Dolphin Dome at the
Indianapolis Zoo

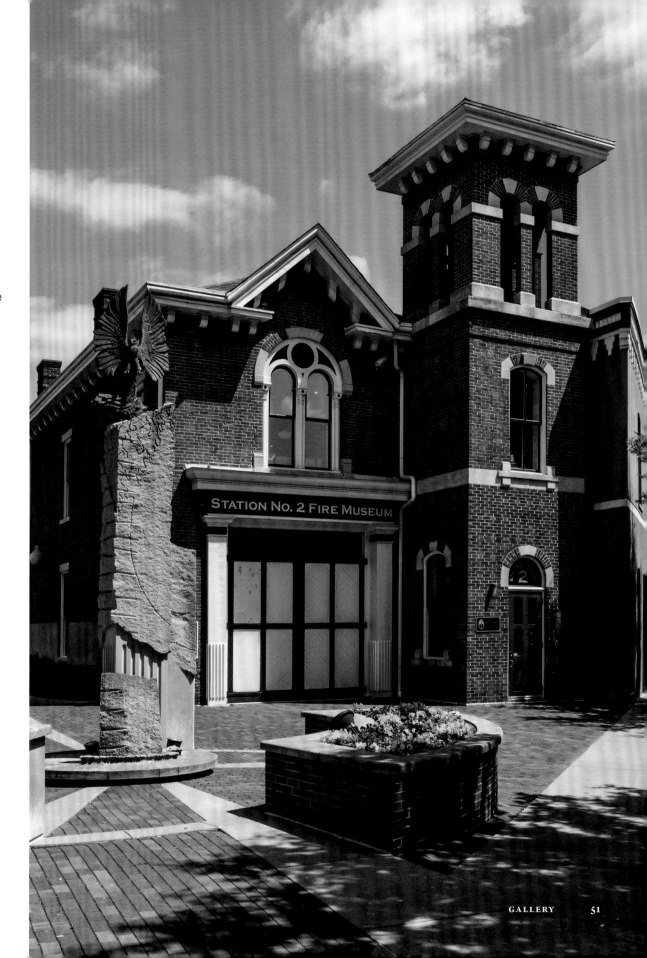

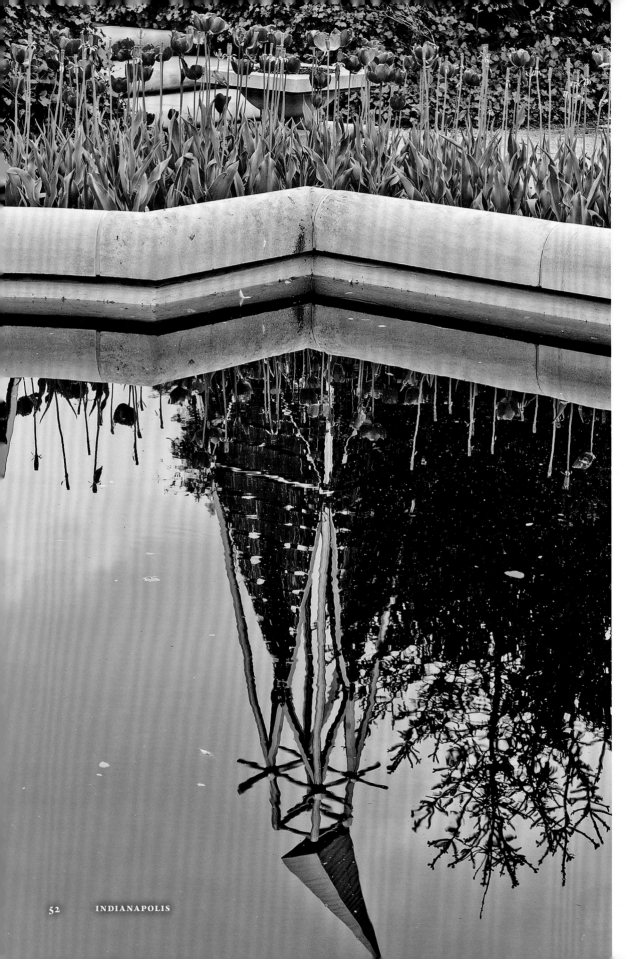

Fountain, White River Gardens

(Facing) Herron School of Art and Design, IUPUI

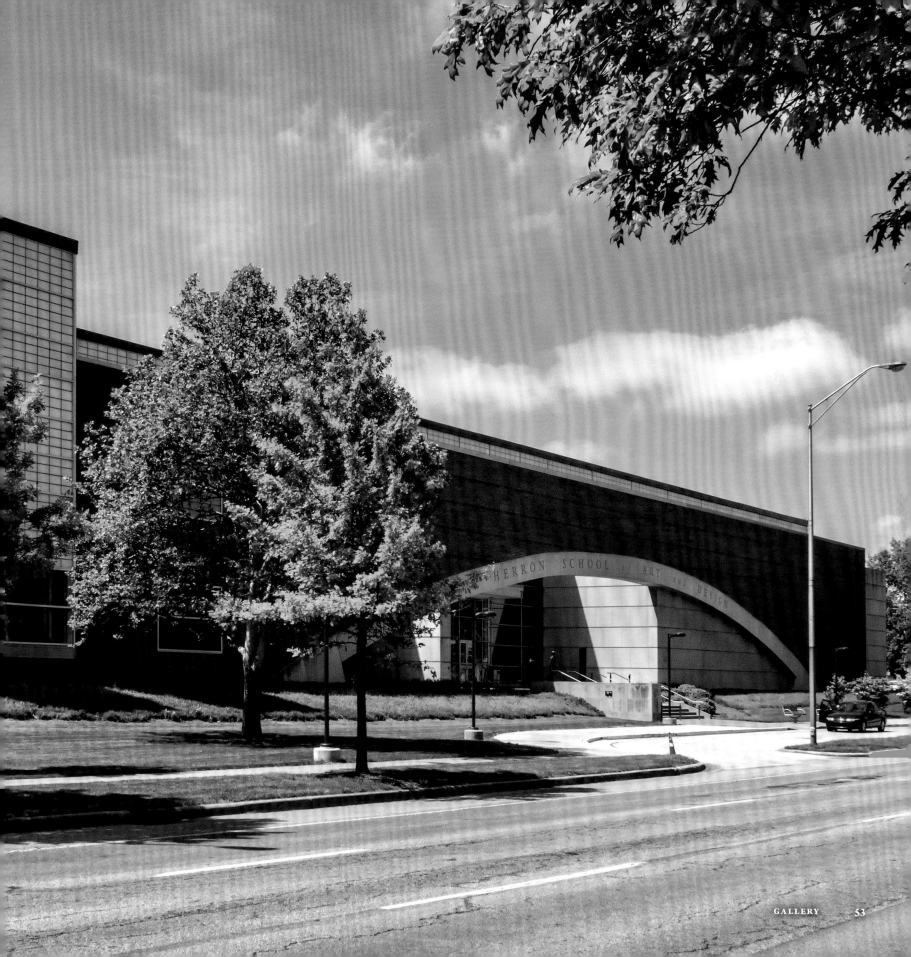

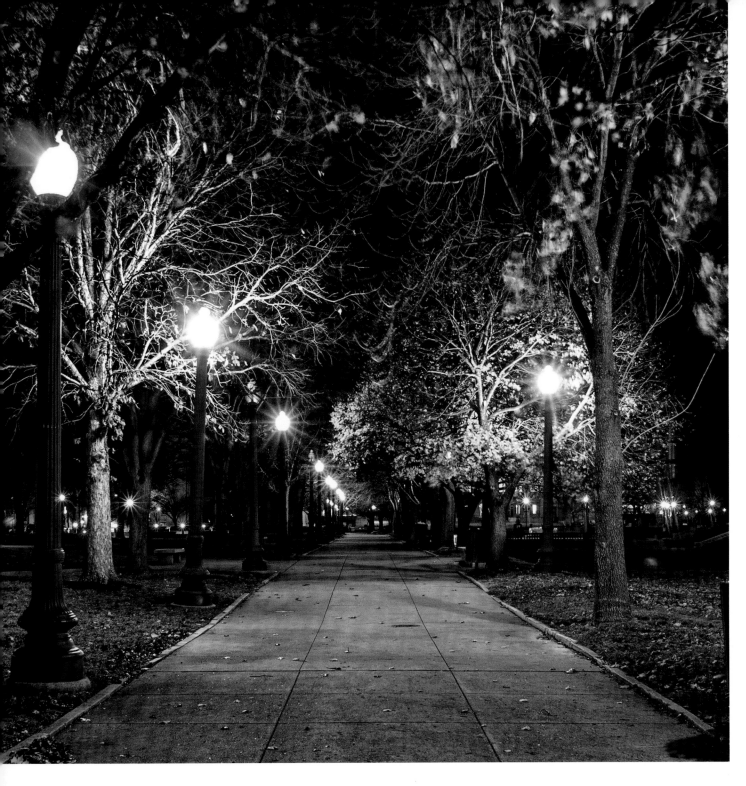

Veterans' Memorial Plaza at Night

(Facing) The Soldiers and Sailors Monument Adorned with Holiday Lights

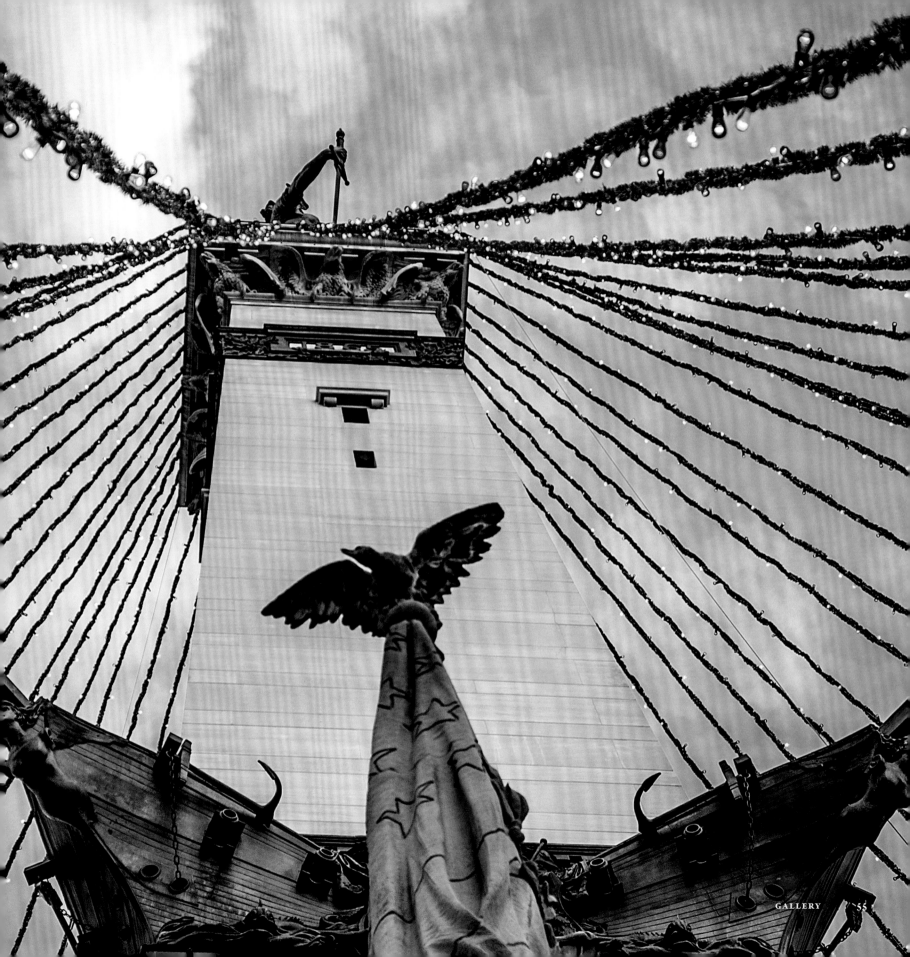

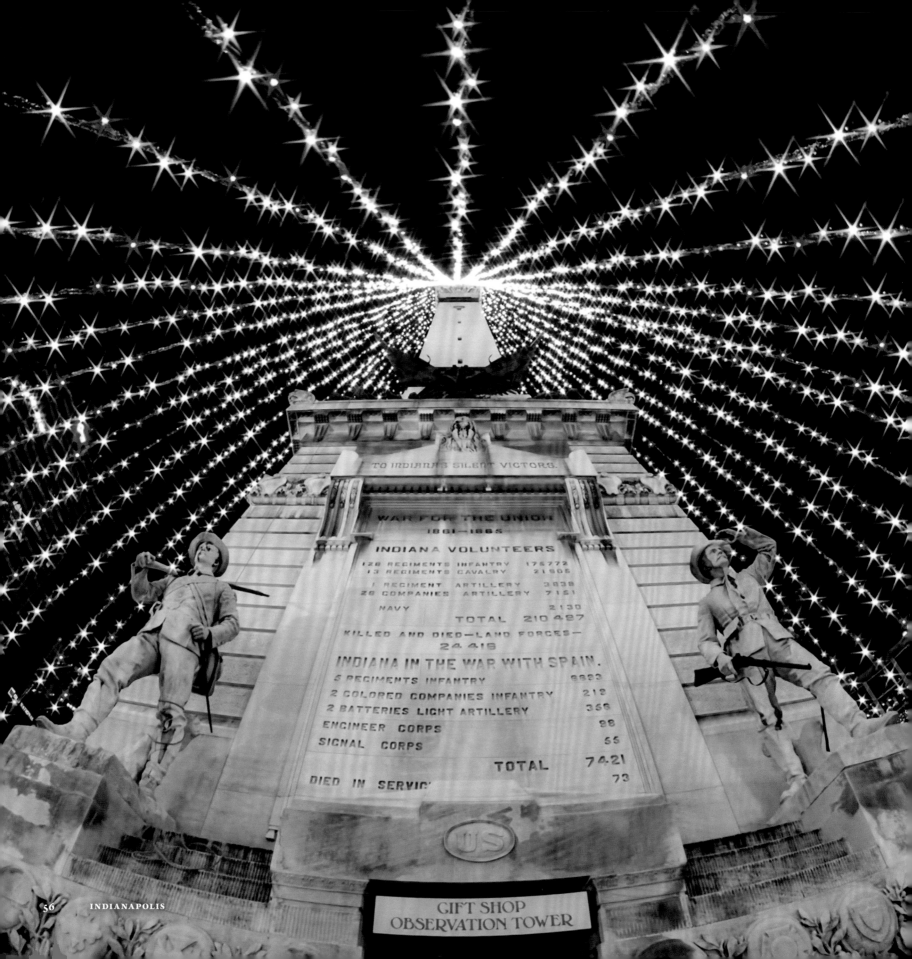

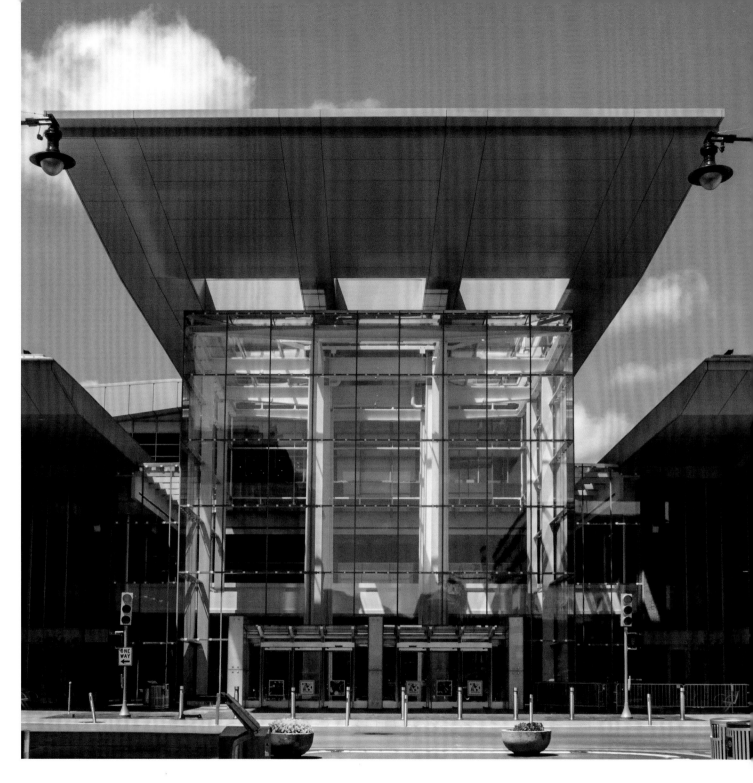

The Indiana Convention Center

(Facing) Looking up at the Soldiers and Sailors Monument

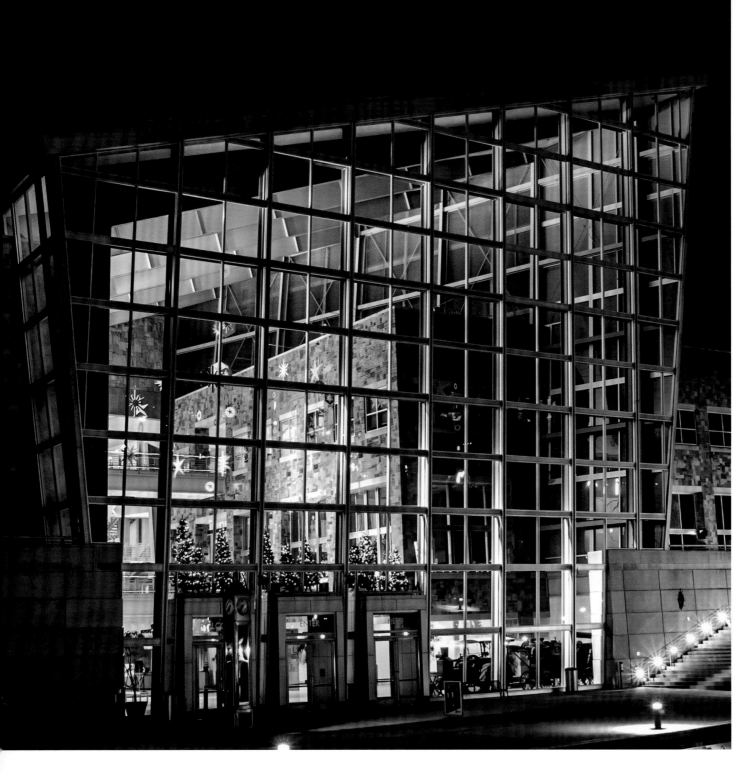

The Indiana State Museum at Night

(Facing) The Indiana State Museum

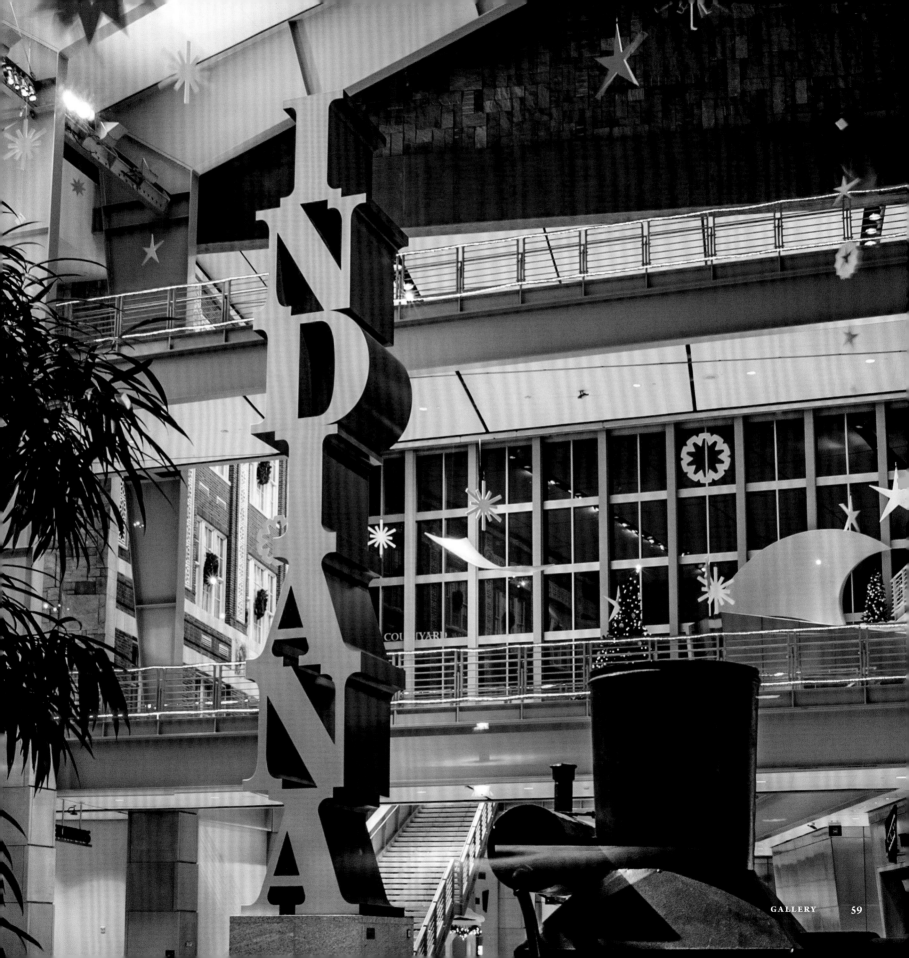

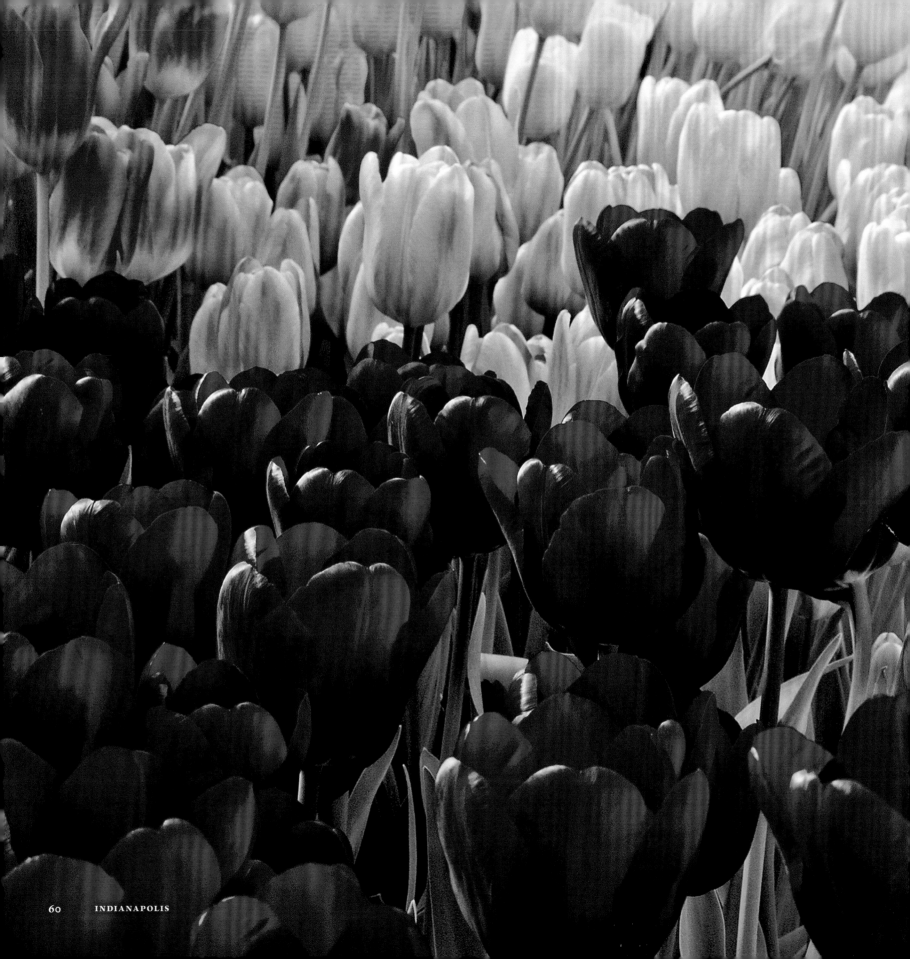

Lilly Gardens at the Lilly House

(Facing) The Annual Tulip Show, Garfield Park Conservatory

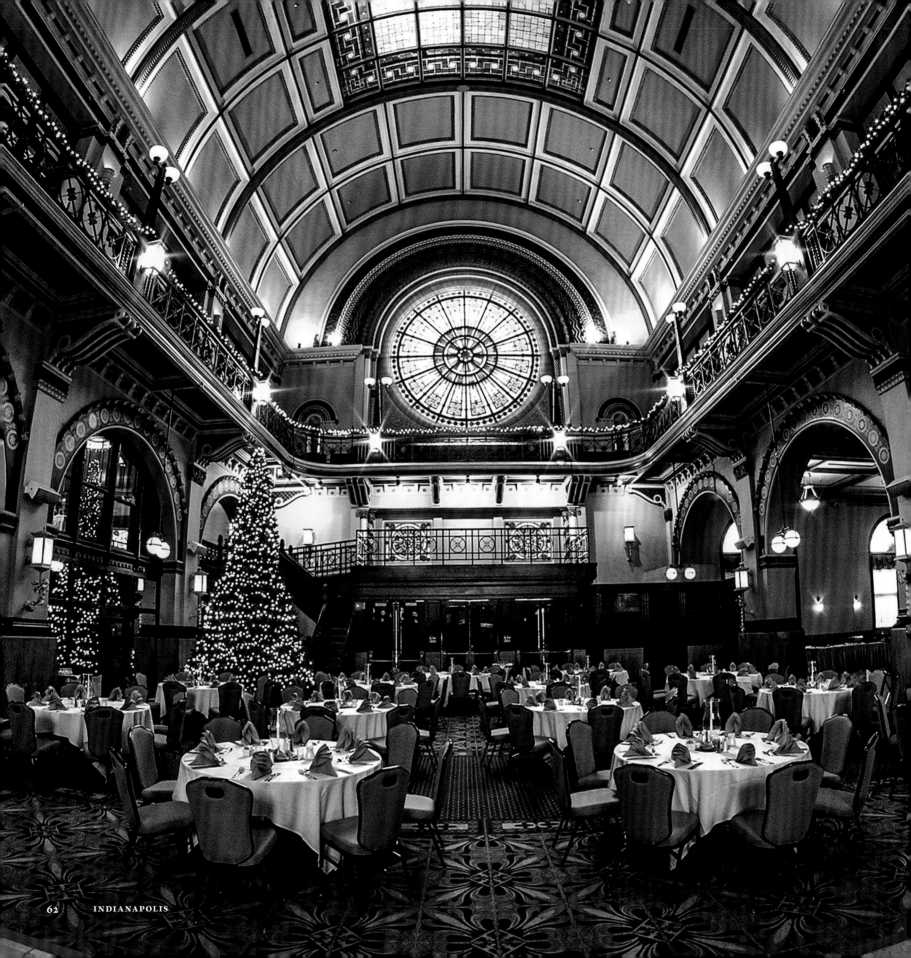

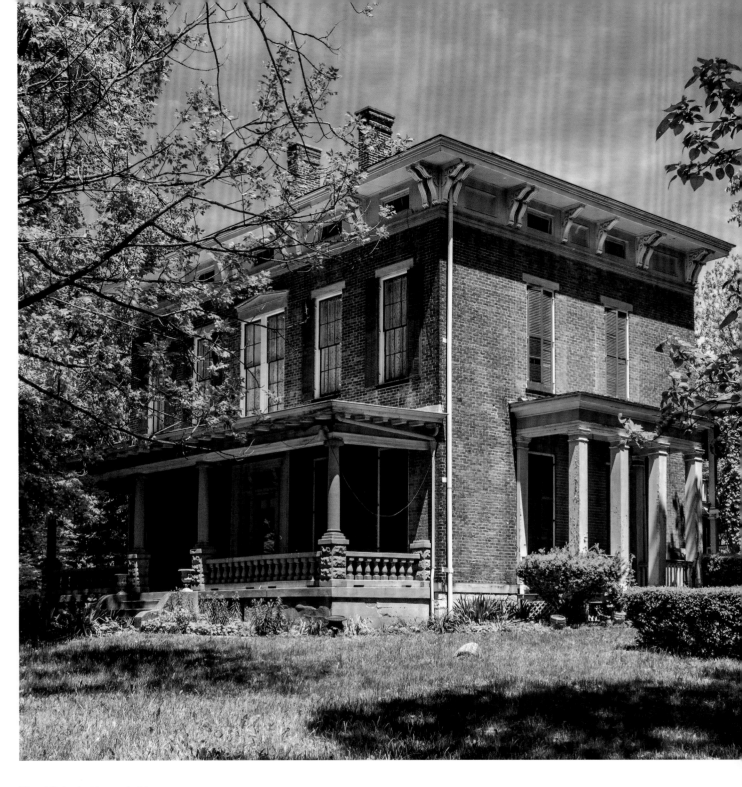

The Historic Hannah House

(Facing) The Grand Hall at Historic Indianapolis Union Station

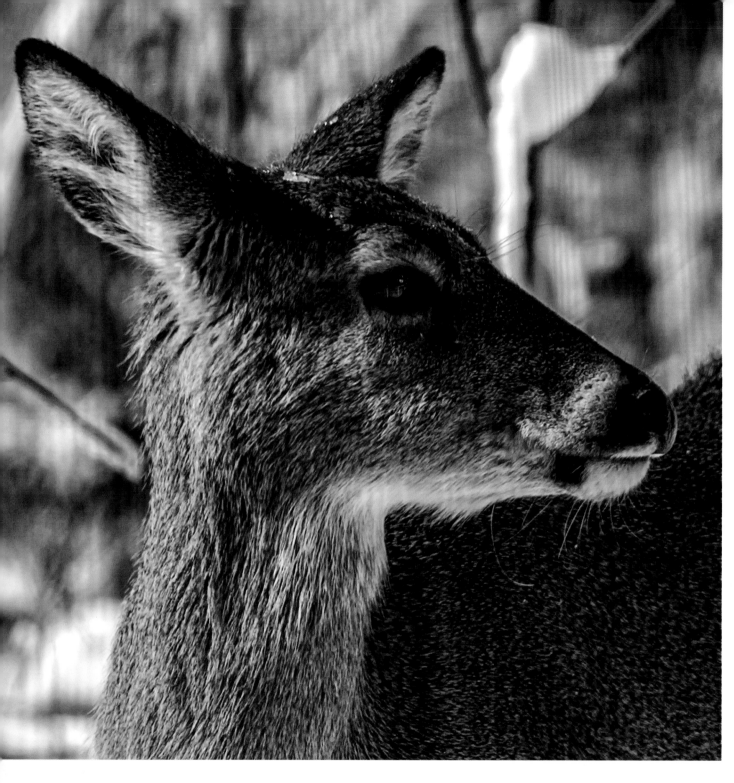

Whitetail Deer at Eagle Creek Park

(Facing) Historic Fountain Square

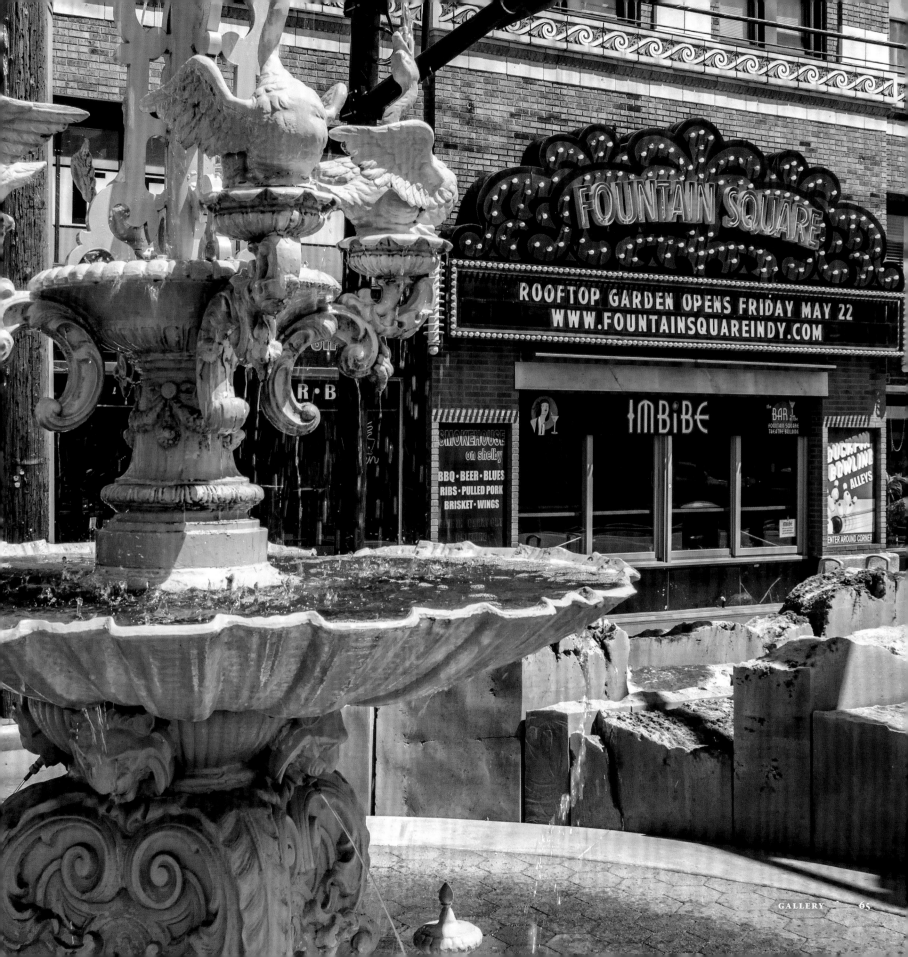

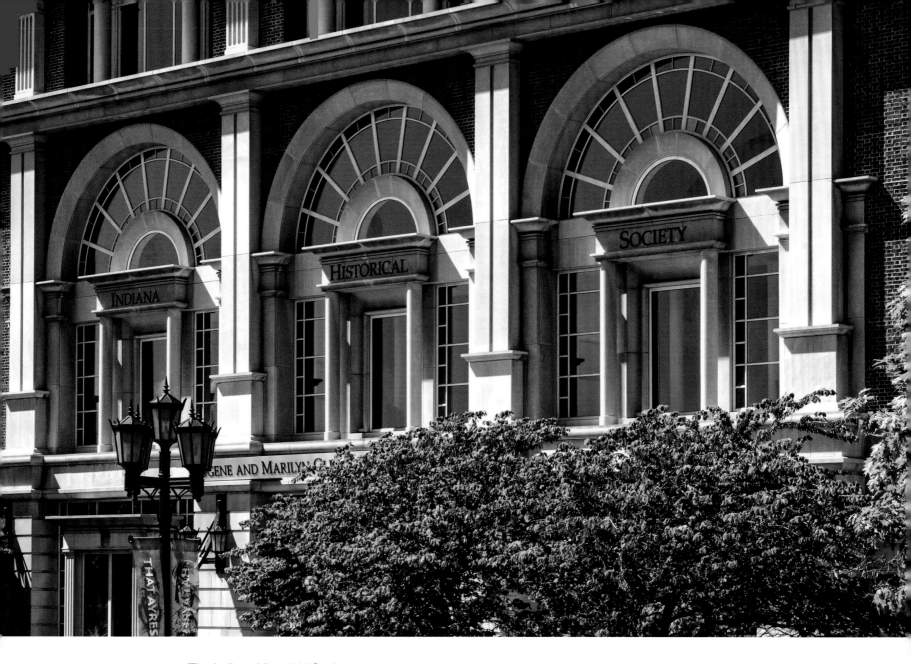

The Indiana Historical Society

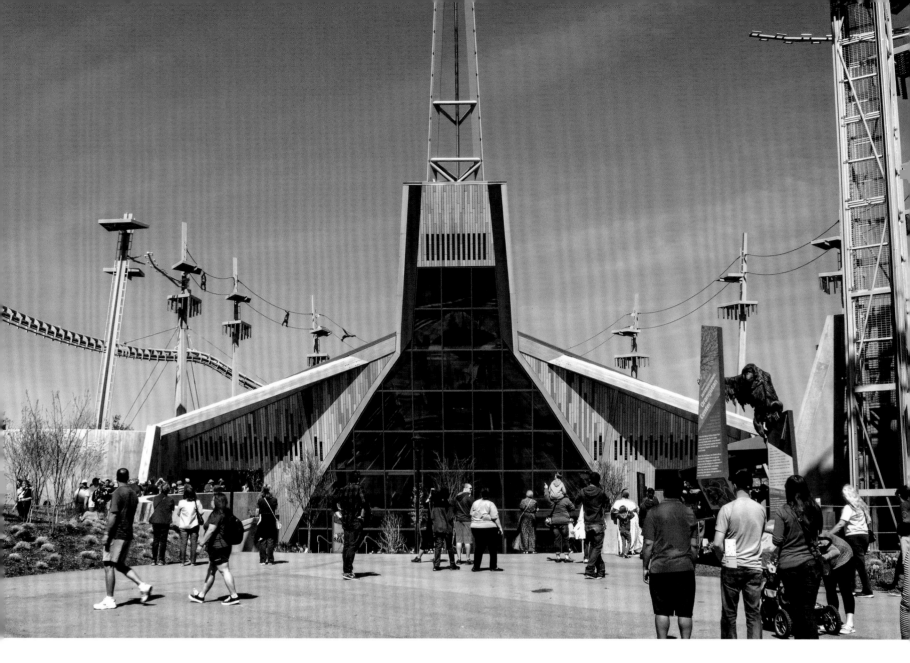

The Simon Skjodt International Orangutan Center at the Indianapolis Zoo

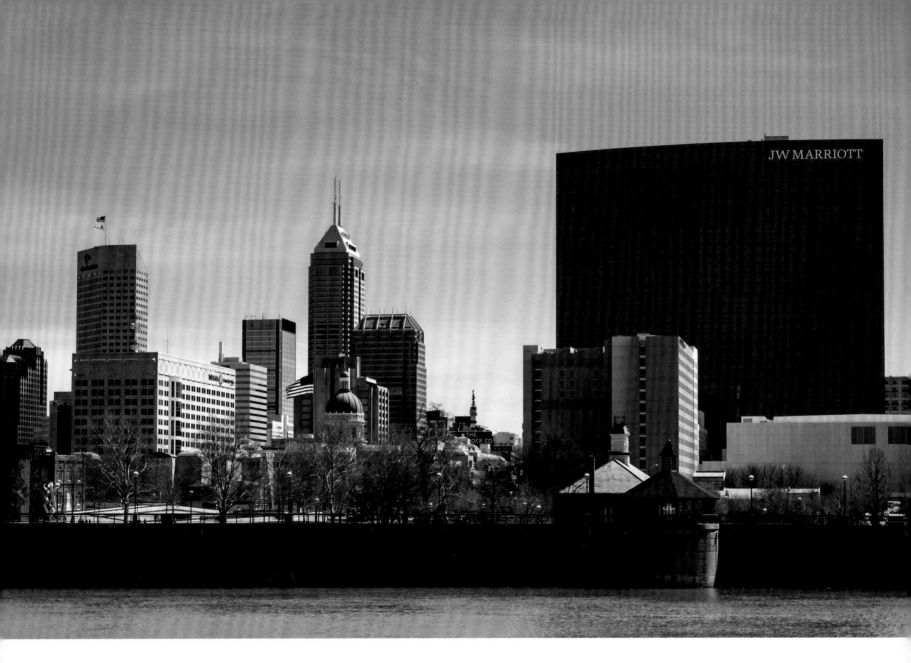

Indianapolis Skyline as Seen from the Indianapolis Zoo

(Facing) The Indiana State Museum from White River State Park

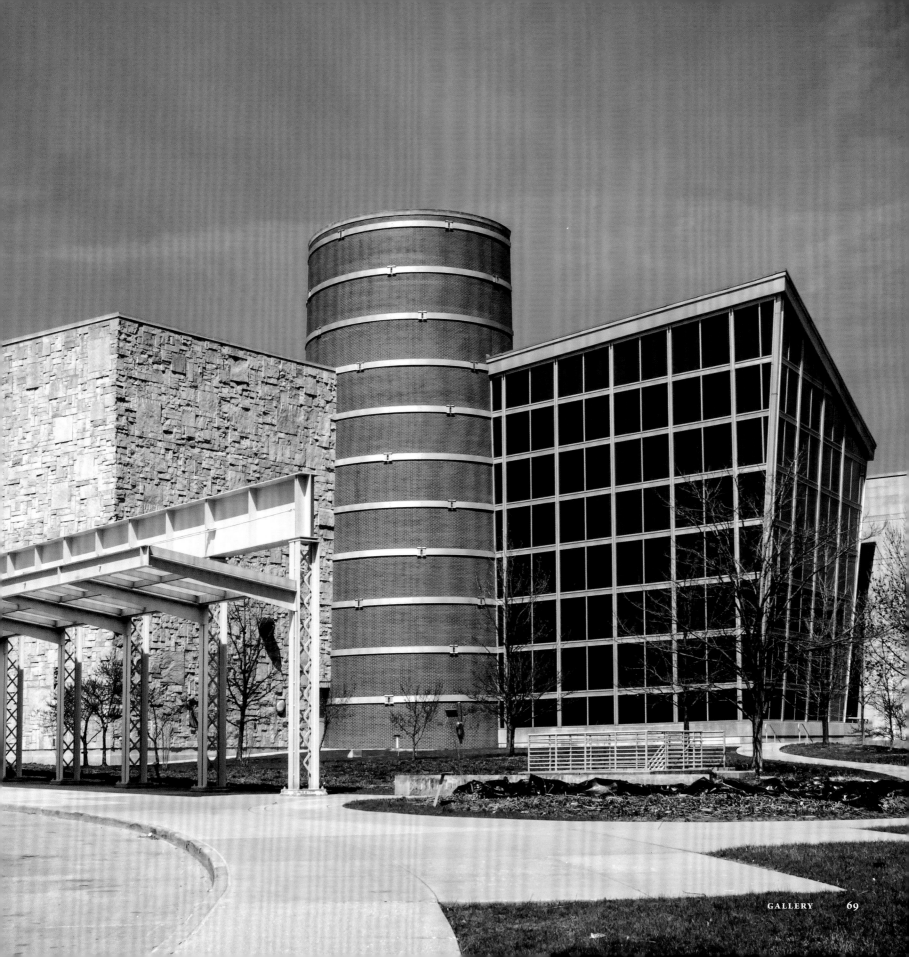

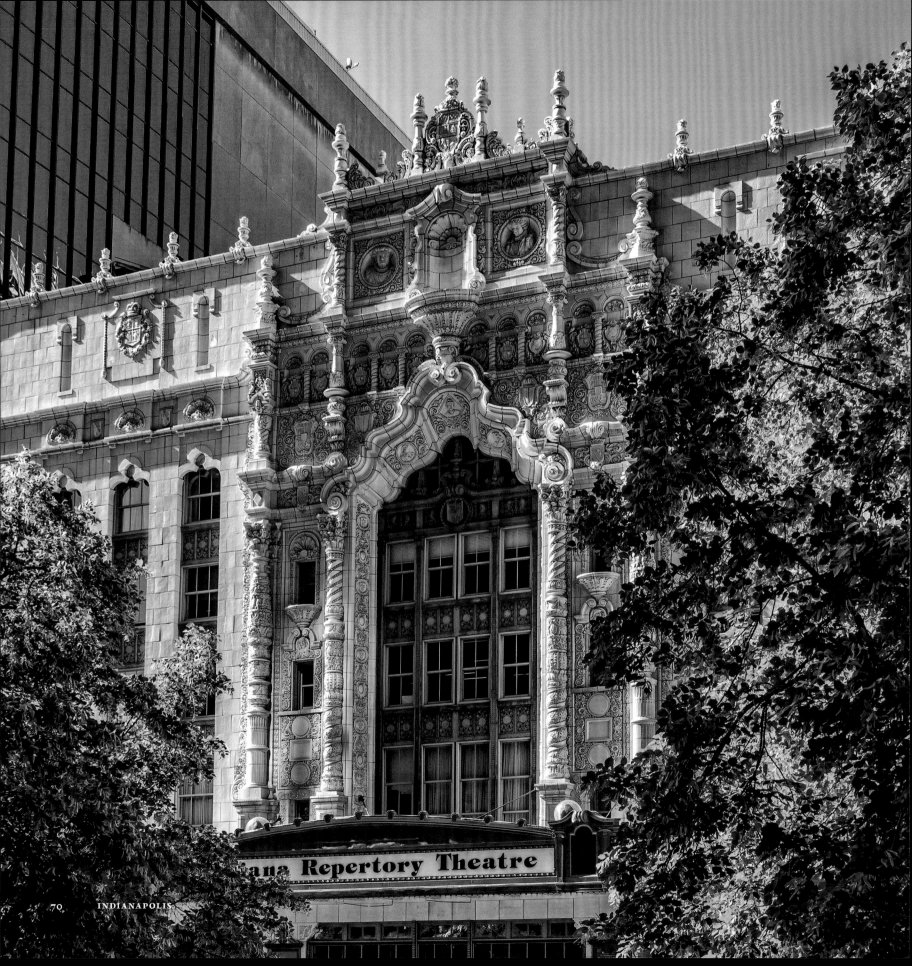

The NCAA Hall of Champions

(Facing) The Indiana
Repertory Theatre

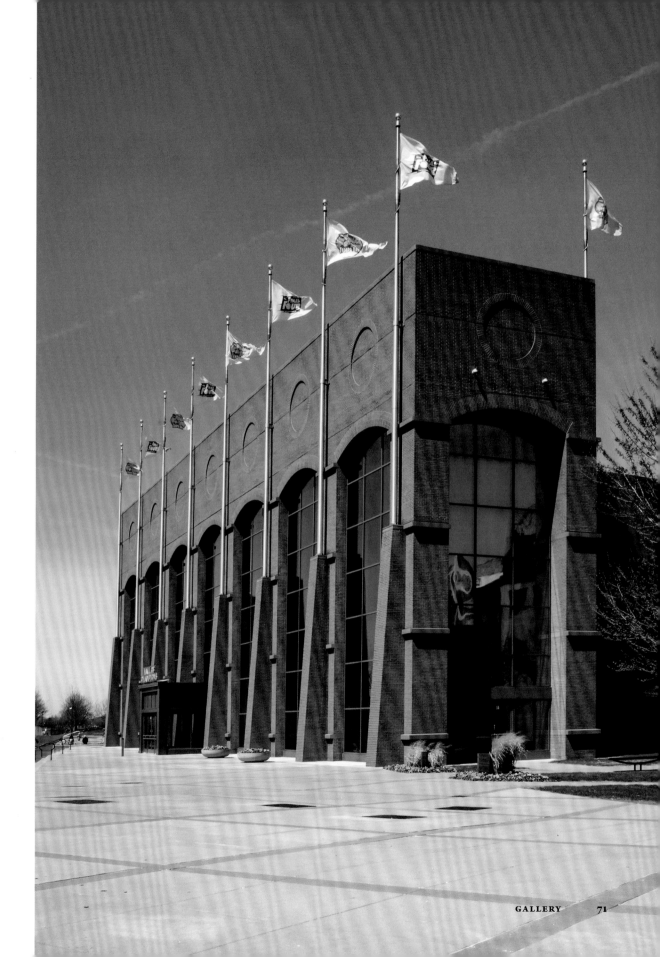

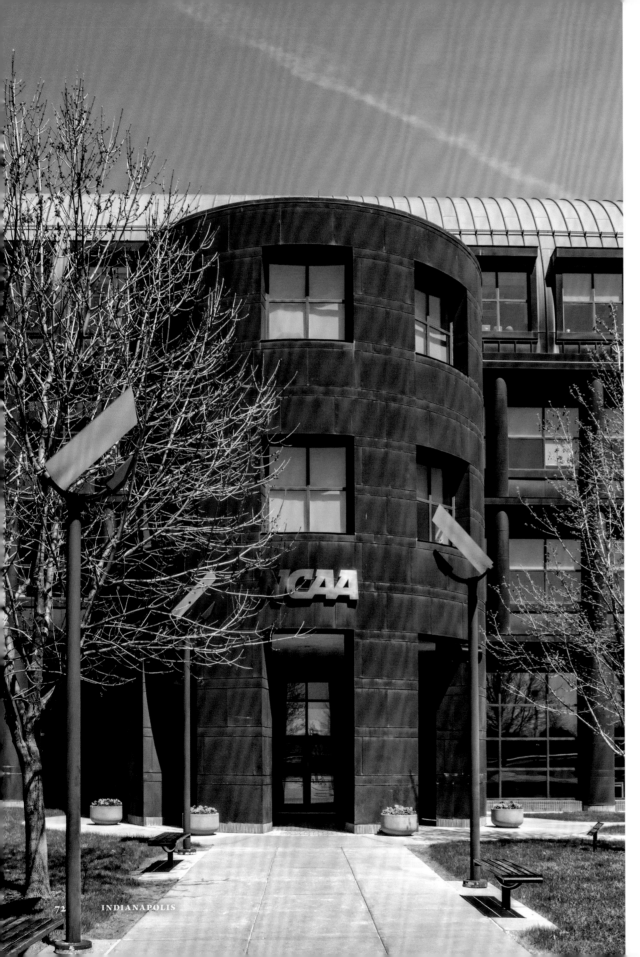

The NCAA Headquarters

(Facing) The Indianapolis Artsgarden

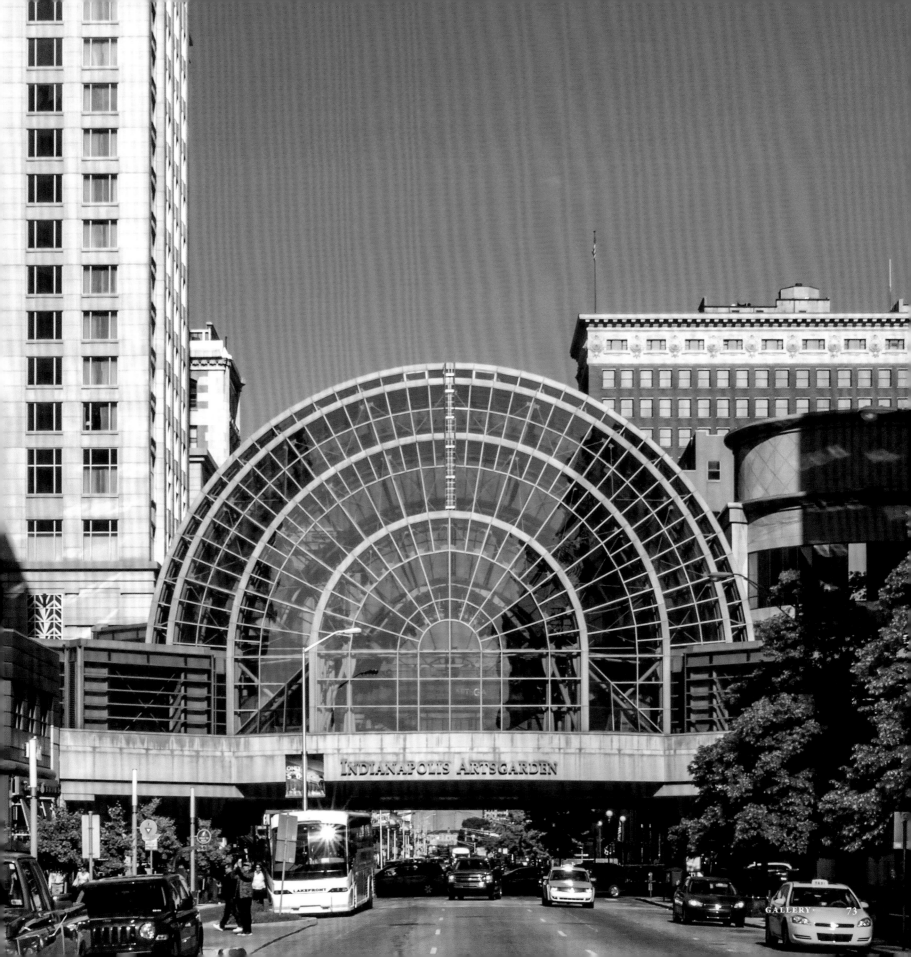

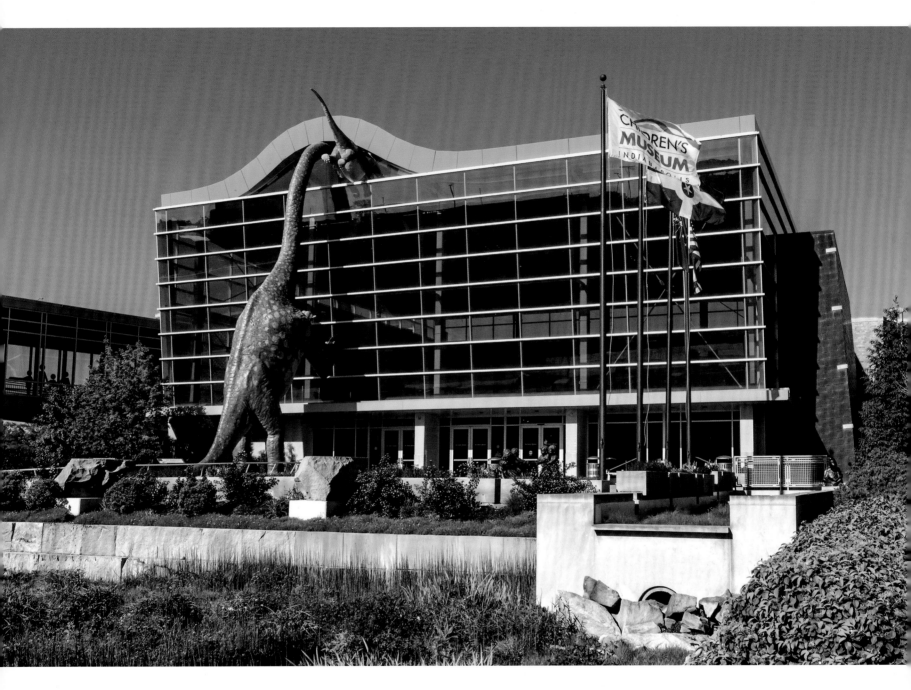

The Children's Museum of Indianapolis

(Facing) The Old National Centre, Formerly the Murat Theatre

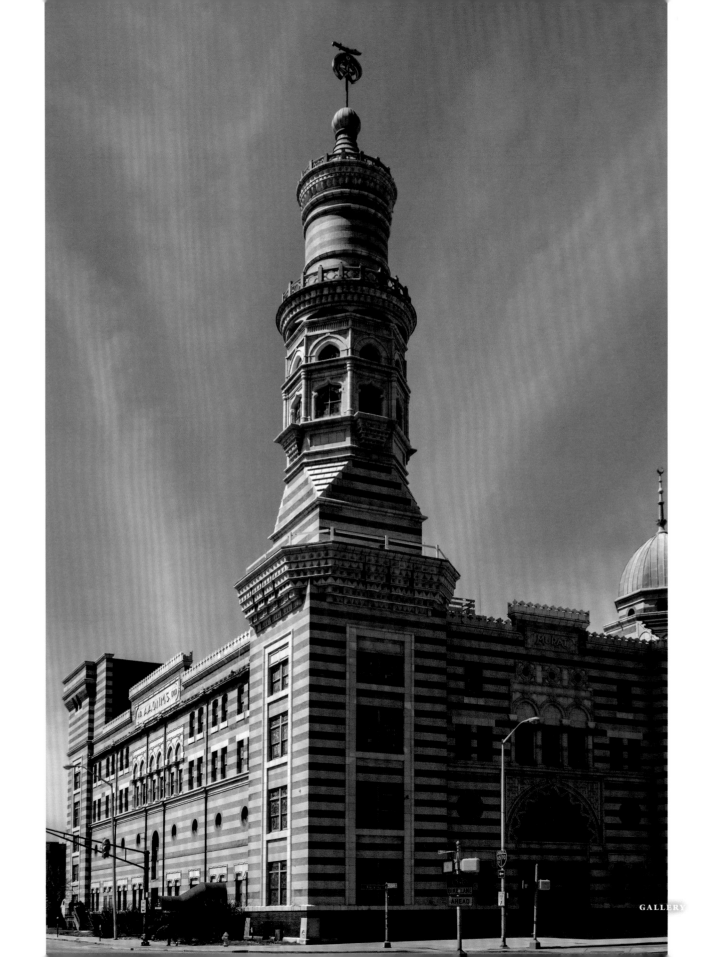

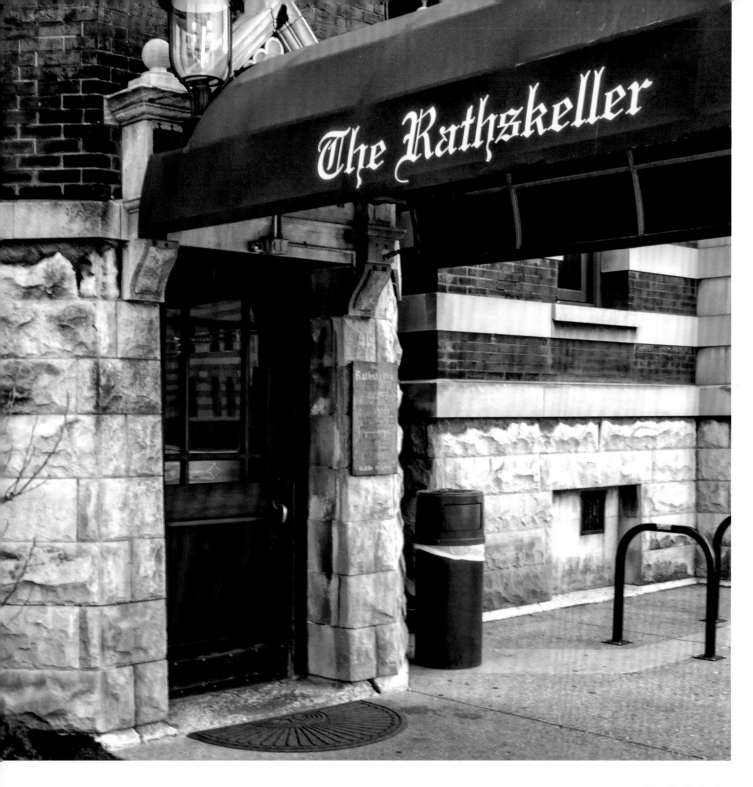

The Rathskeller

(Facing) The Pyramids on Indy's Northwest Side

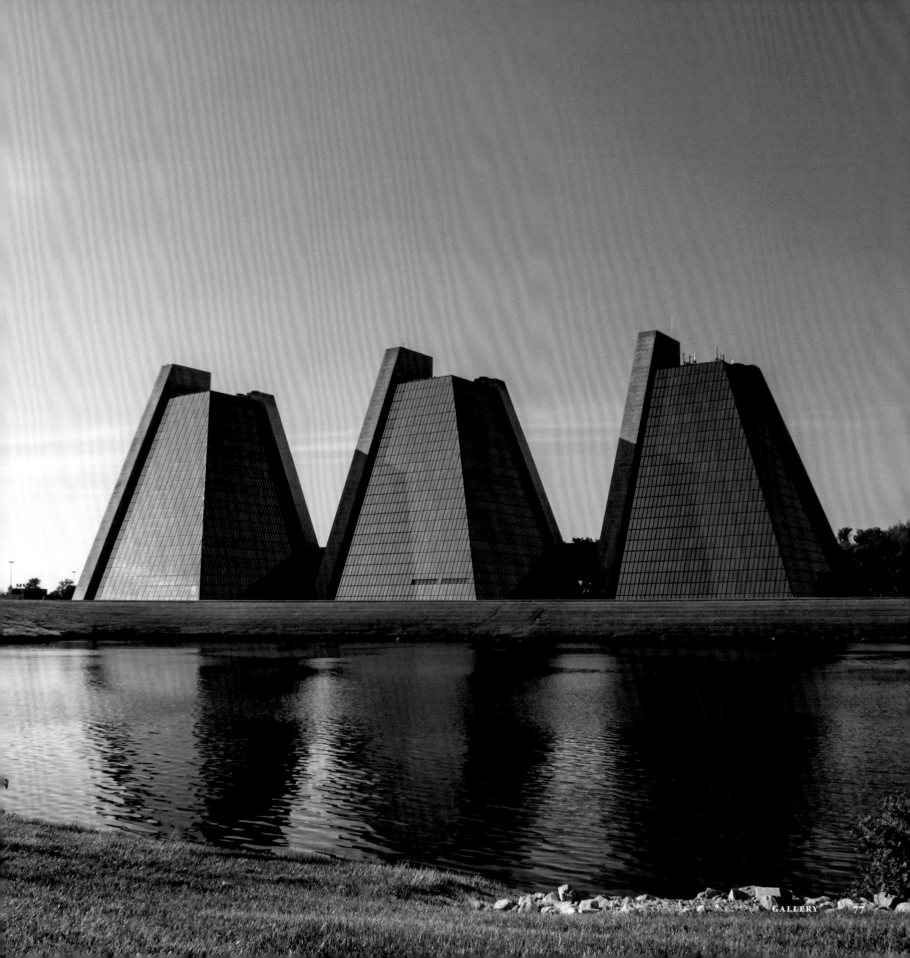

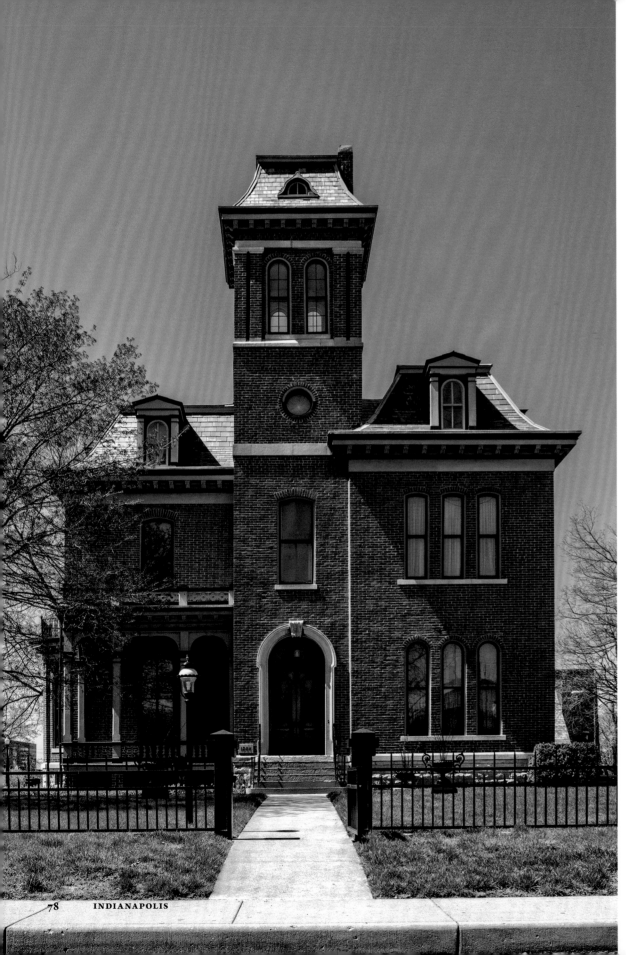

The Morris-Butler House

(Facing) James Whitcomb Riley
Museum Home

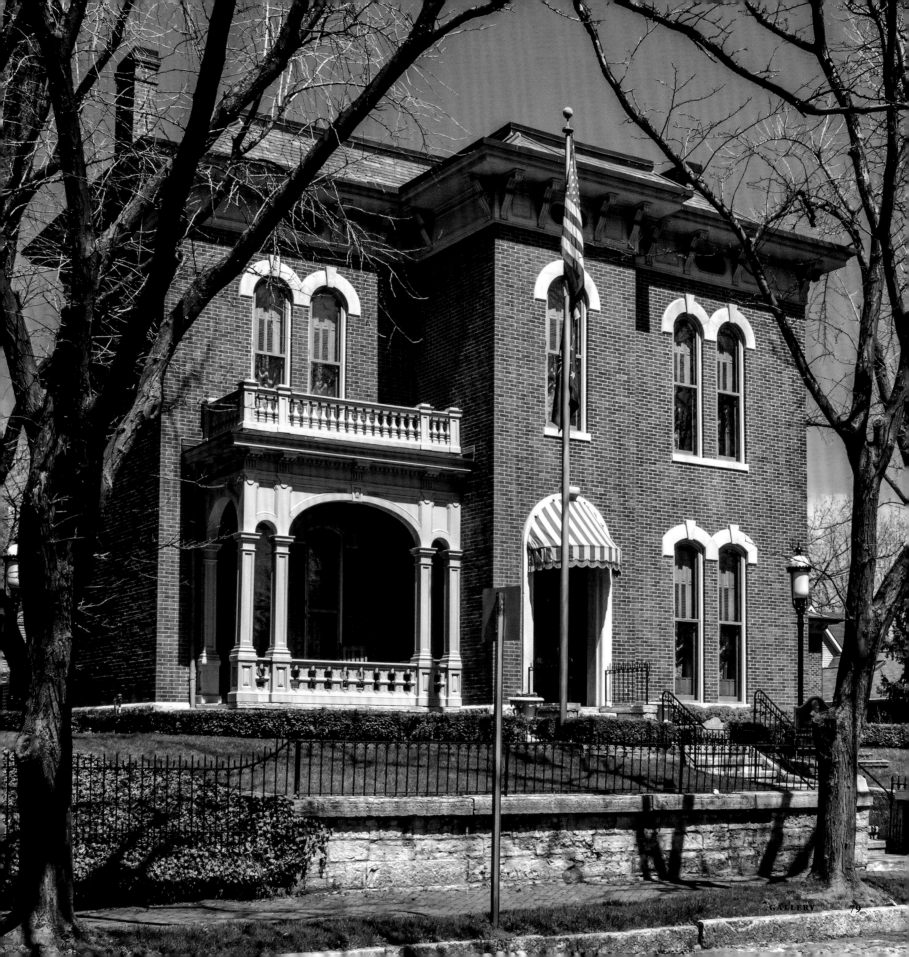

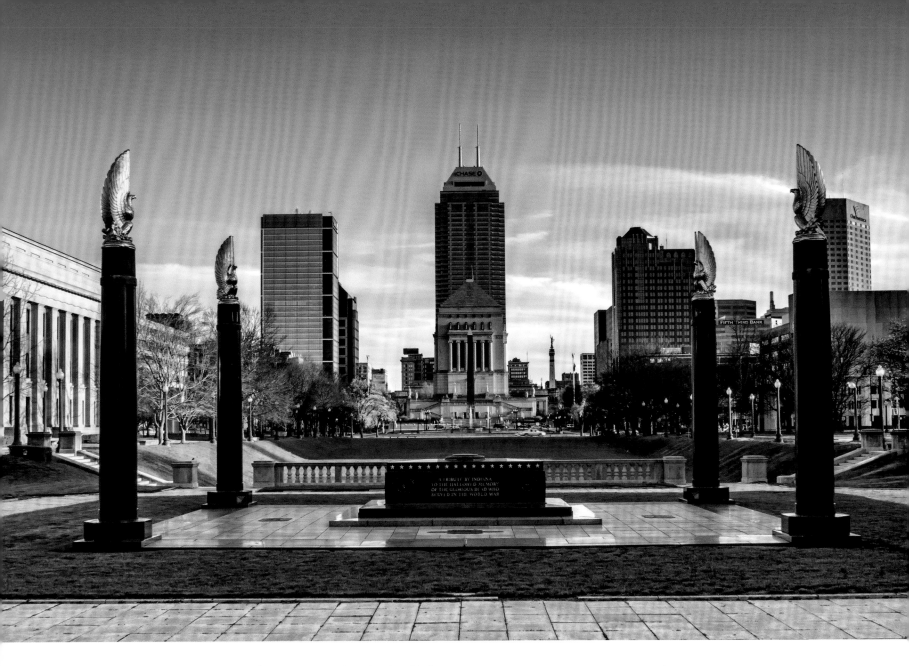

Cenotaph Square in American Legion Mall

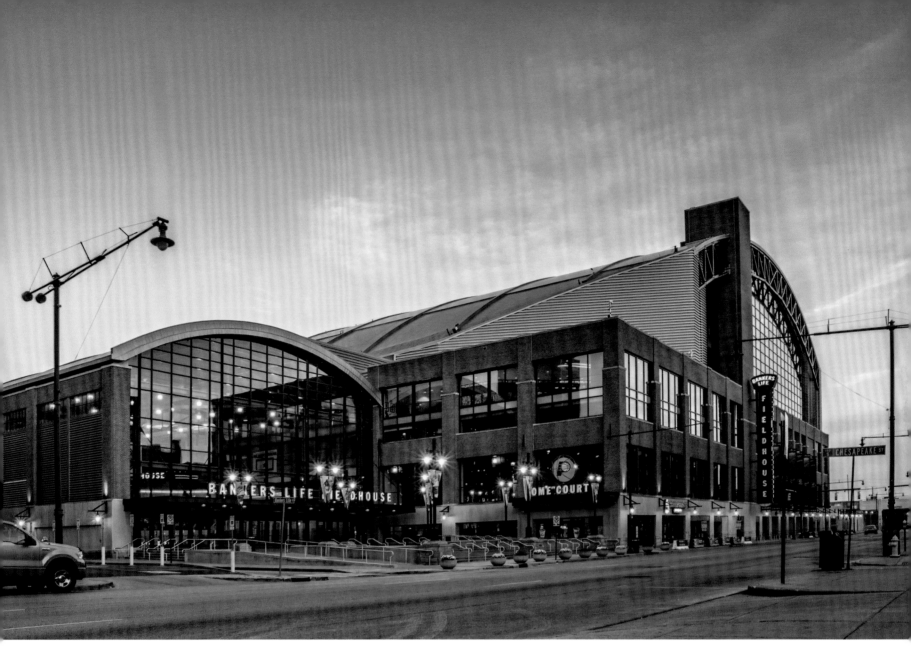

Bankers Life Fieldhouse—Home of the Indiana Pacers

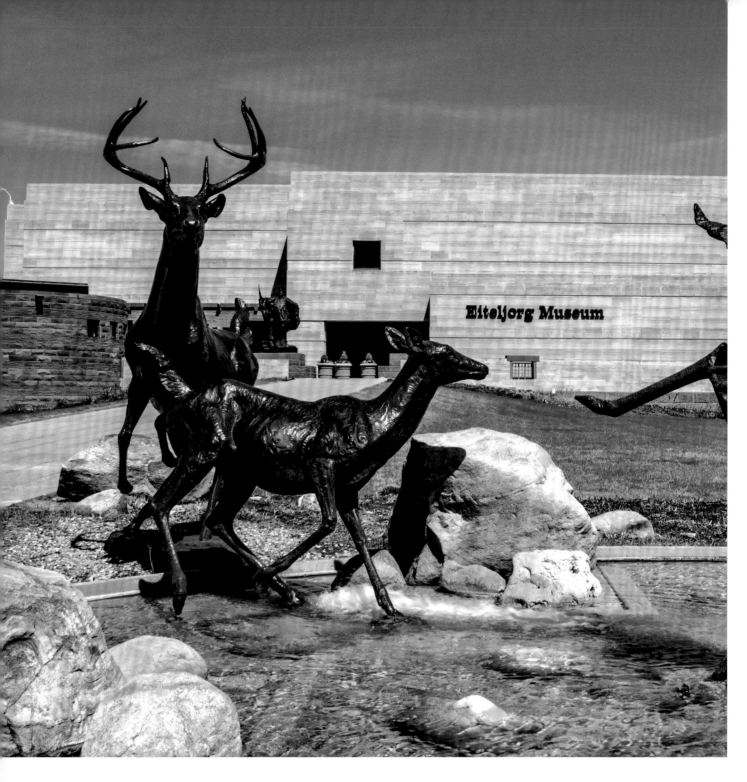

The Eiteljorg Museum of American Indians and Western Art

(Facing) The City Market

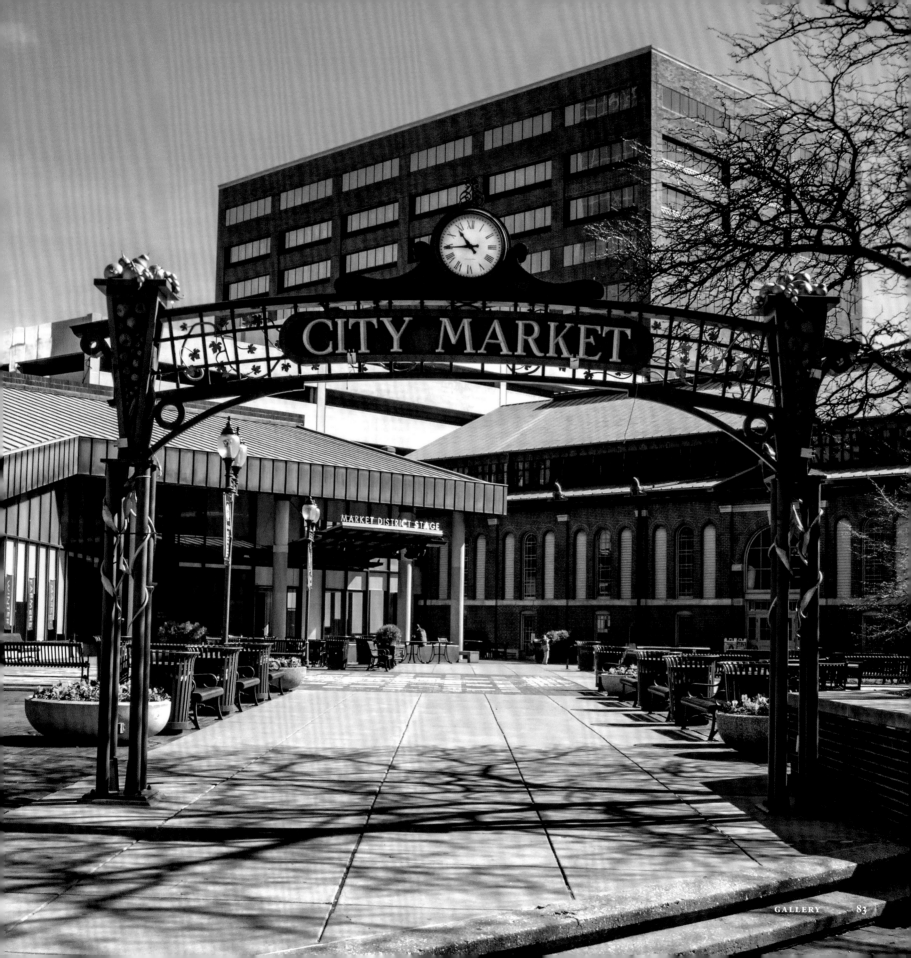

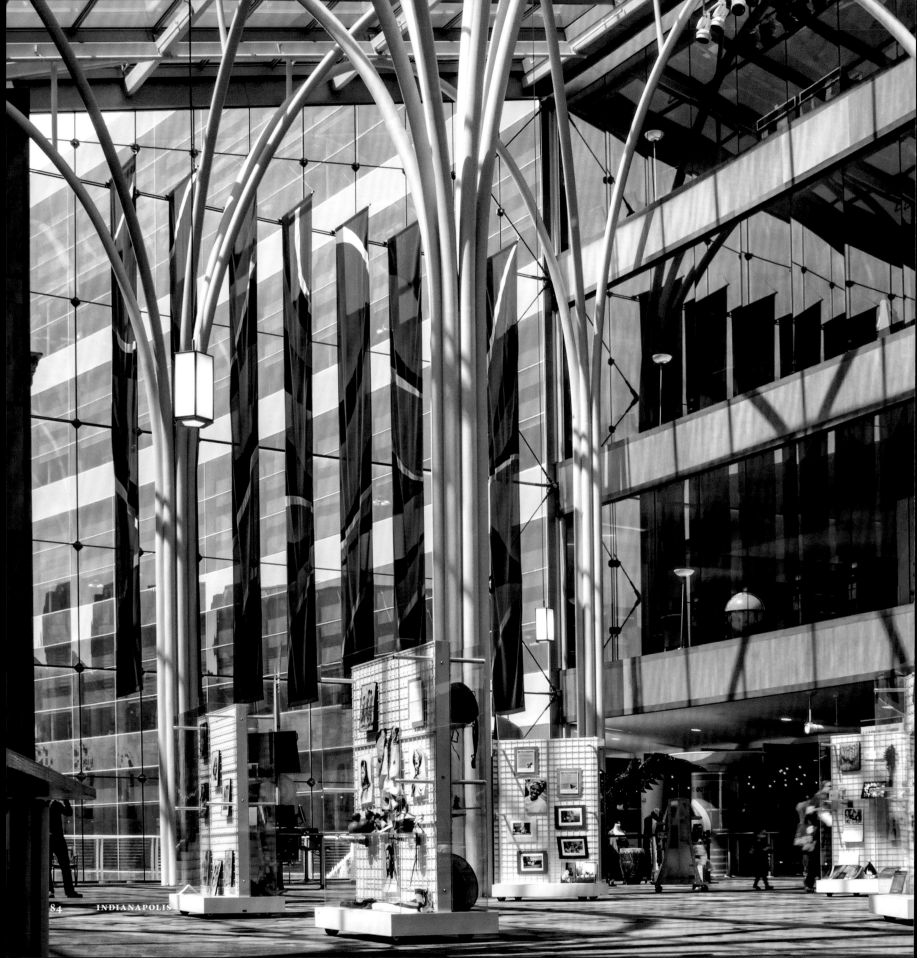

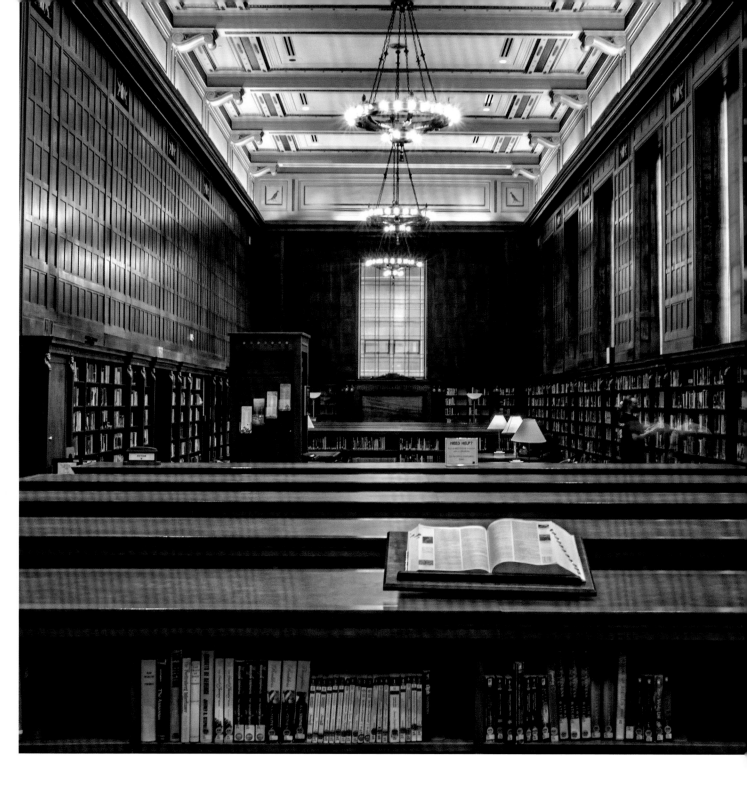

(Above and Facing) The Central Library

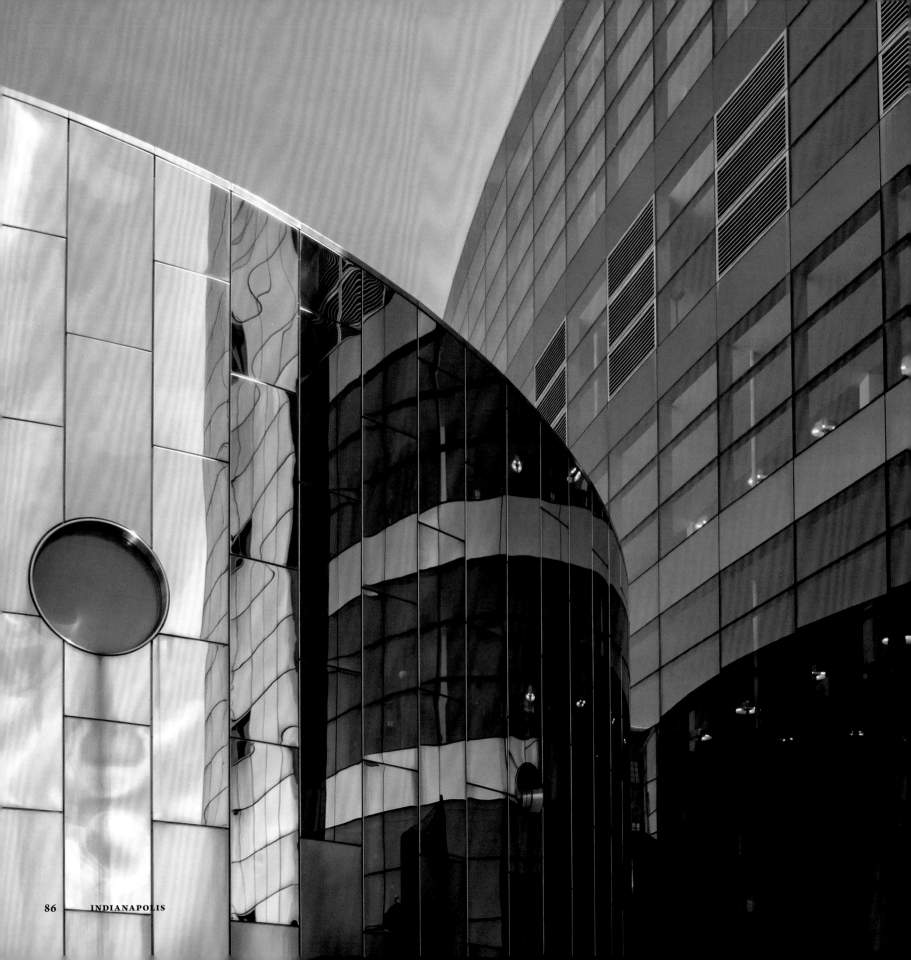

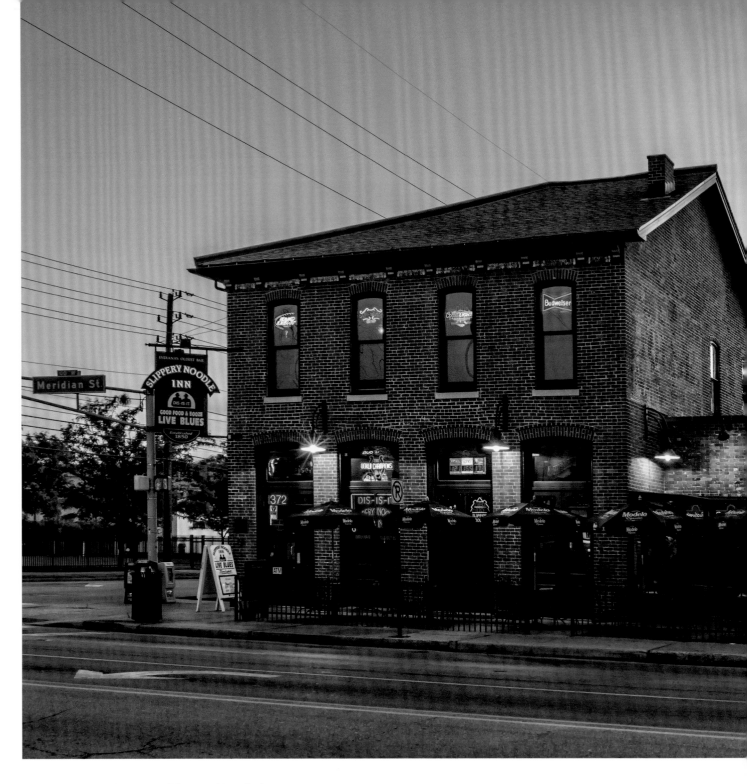

Blues and Nightlife at the Slippery Noodle Inn

(Facing) The Central Library

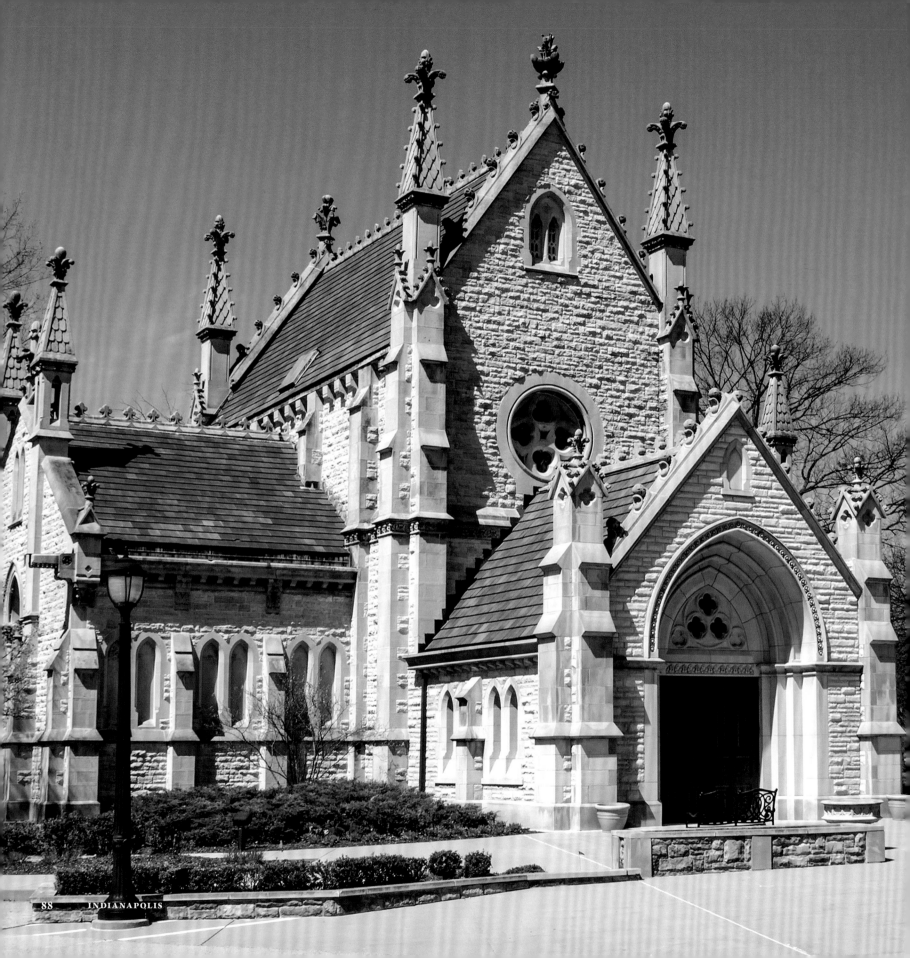

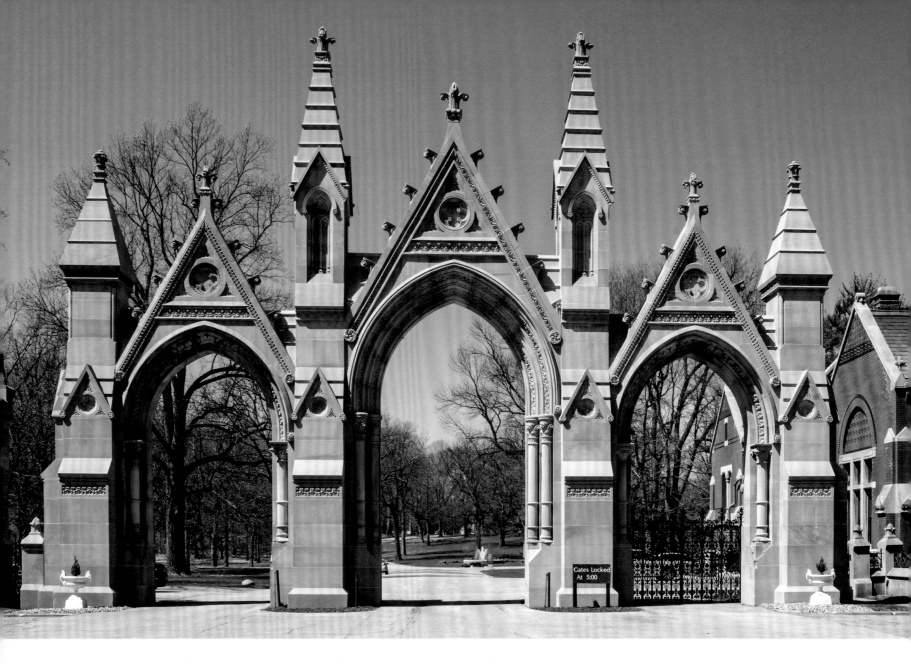

Crown Hill Cemetery, 34th Street and Boulevard Place Entrance

(Facing) The Gothic Chapel at Crown Hill Cemetery

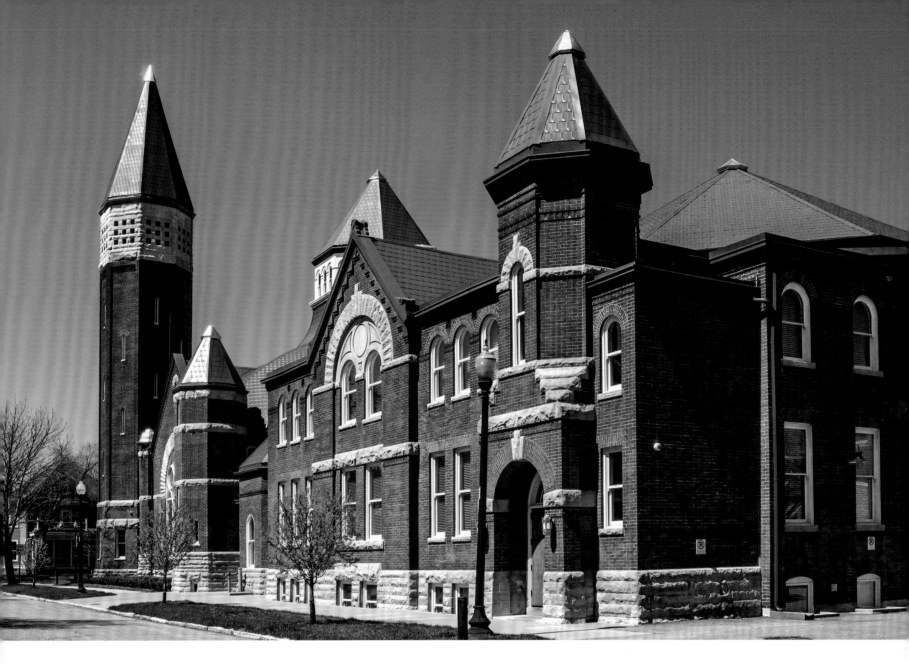

Indiana Landmarks Center

(Facing) Benjamin Harrison Presidential Site

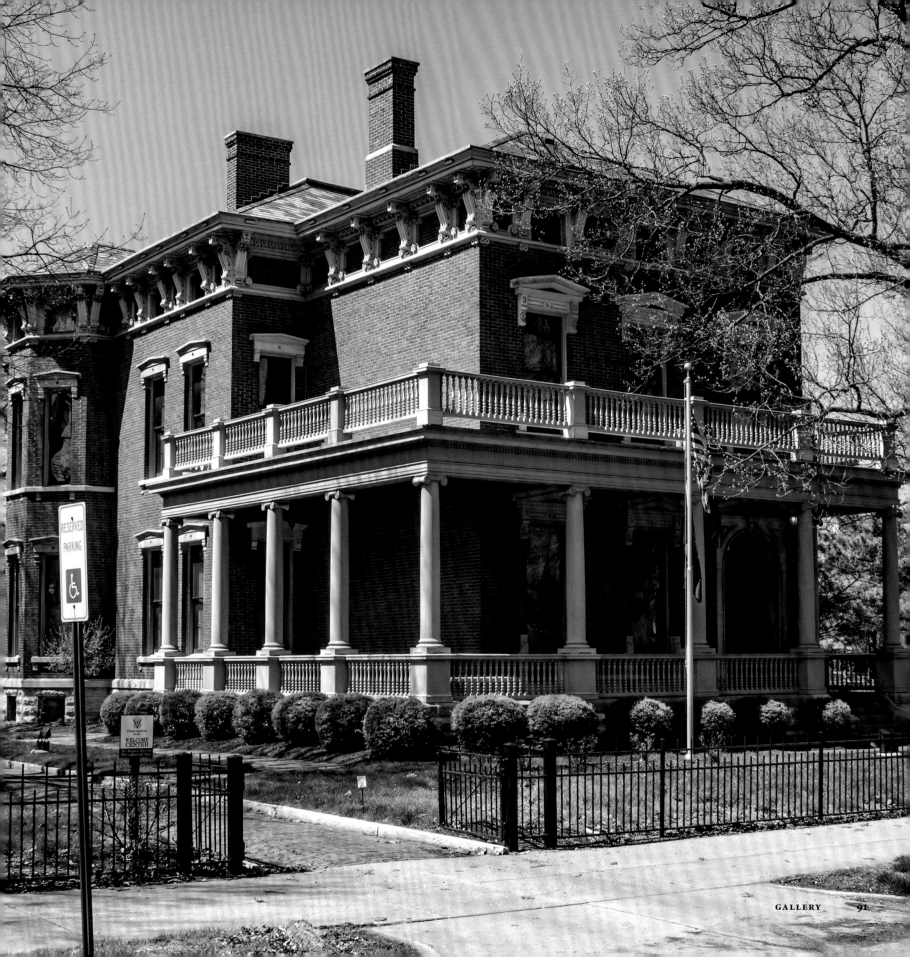

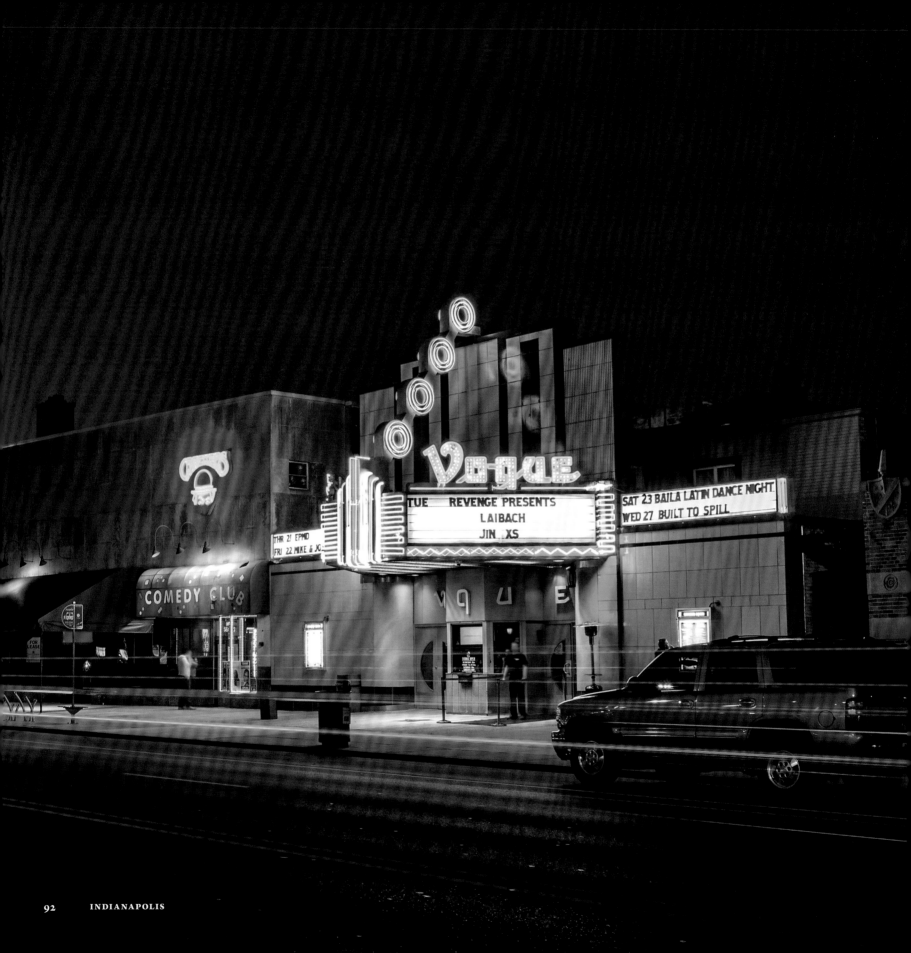

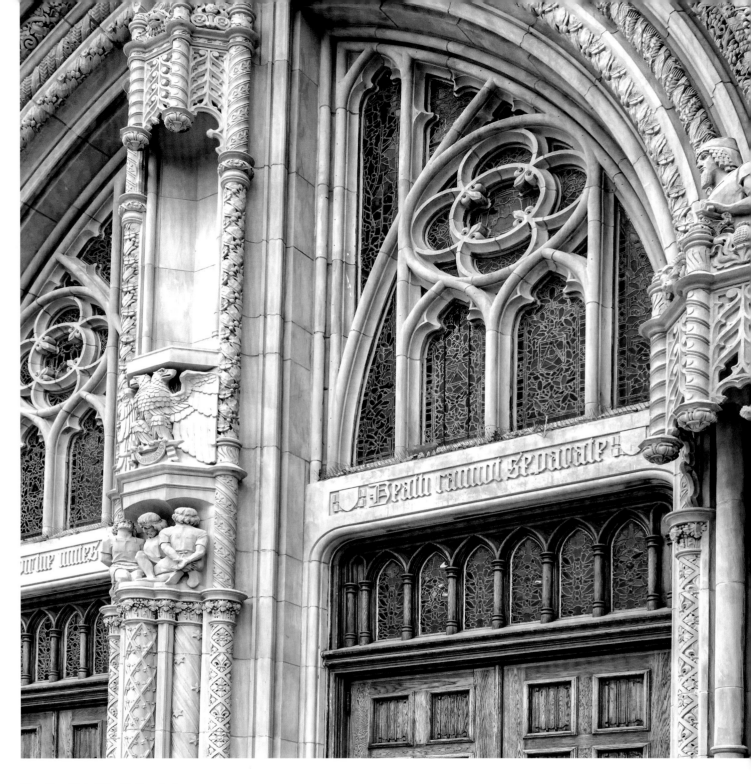

The Scottish Rite Cathedral

(Facing) The Vogue, Broad Ripple

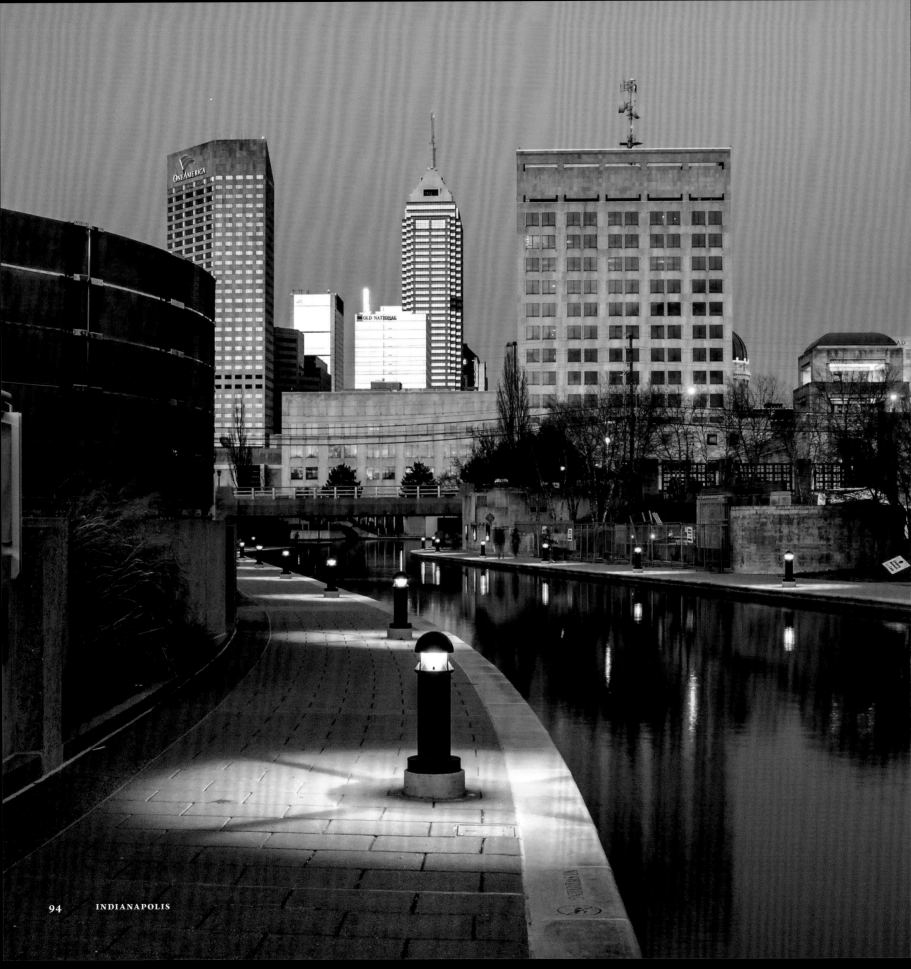

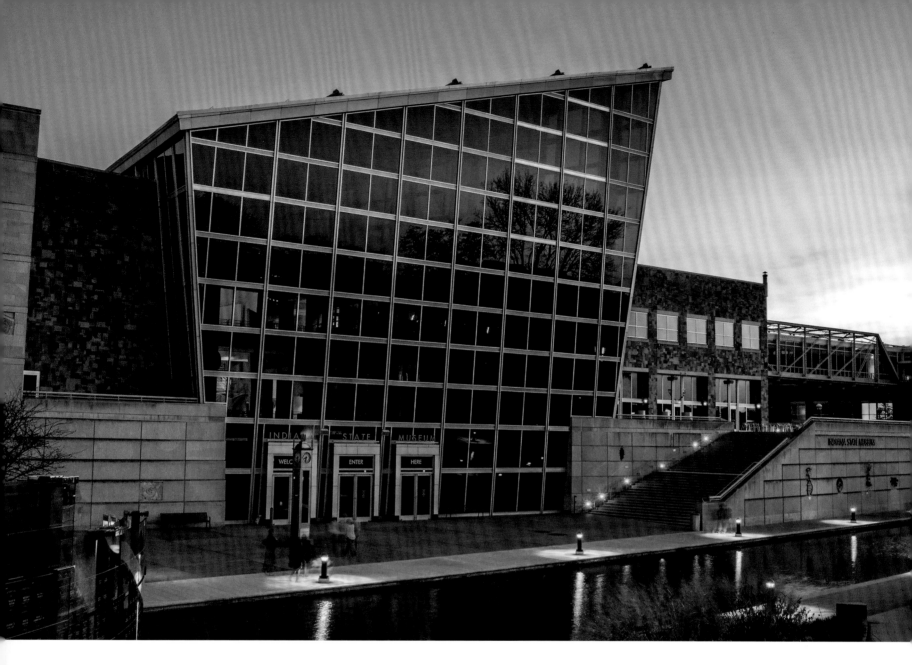

The Indiana State Museum

(Facing) Indianapolis as Seen from the Canal Walk

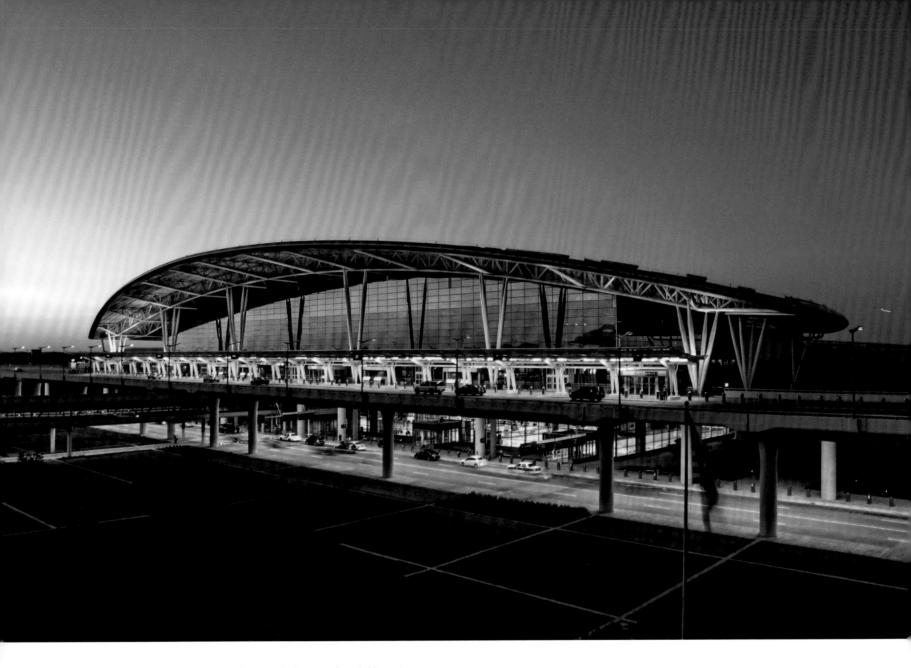

The Indianapolis International Airport

(Facing) The 9/11 Memorial

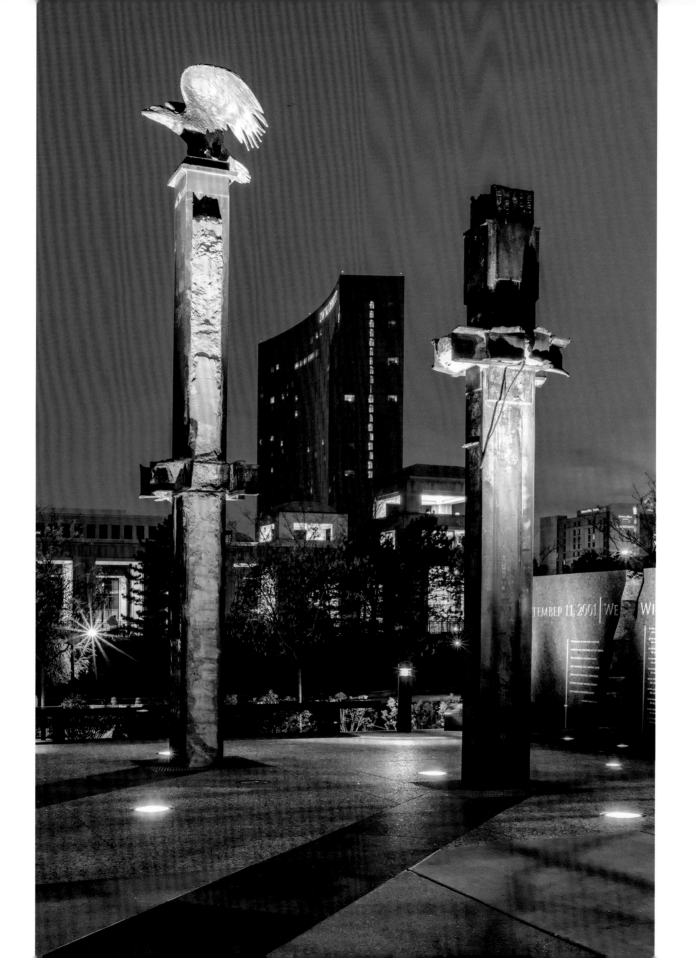

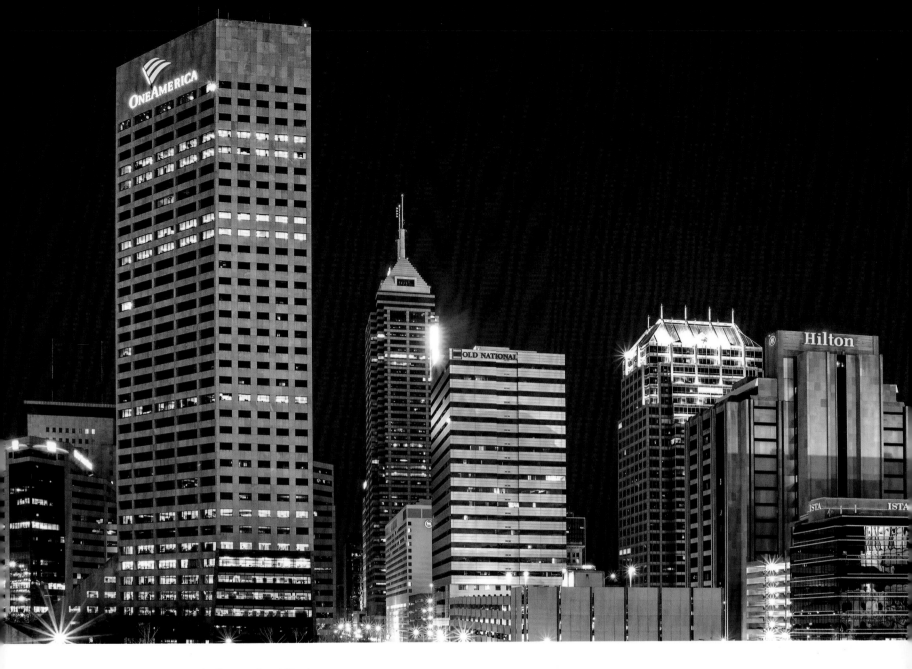

Indianapolis at Dusk

(Facing) Massachusetts Avenue—Part of Indy's Cultural Trail

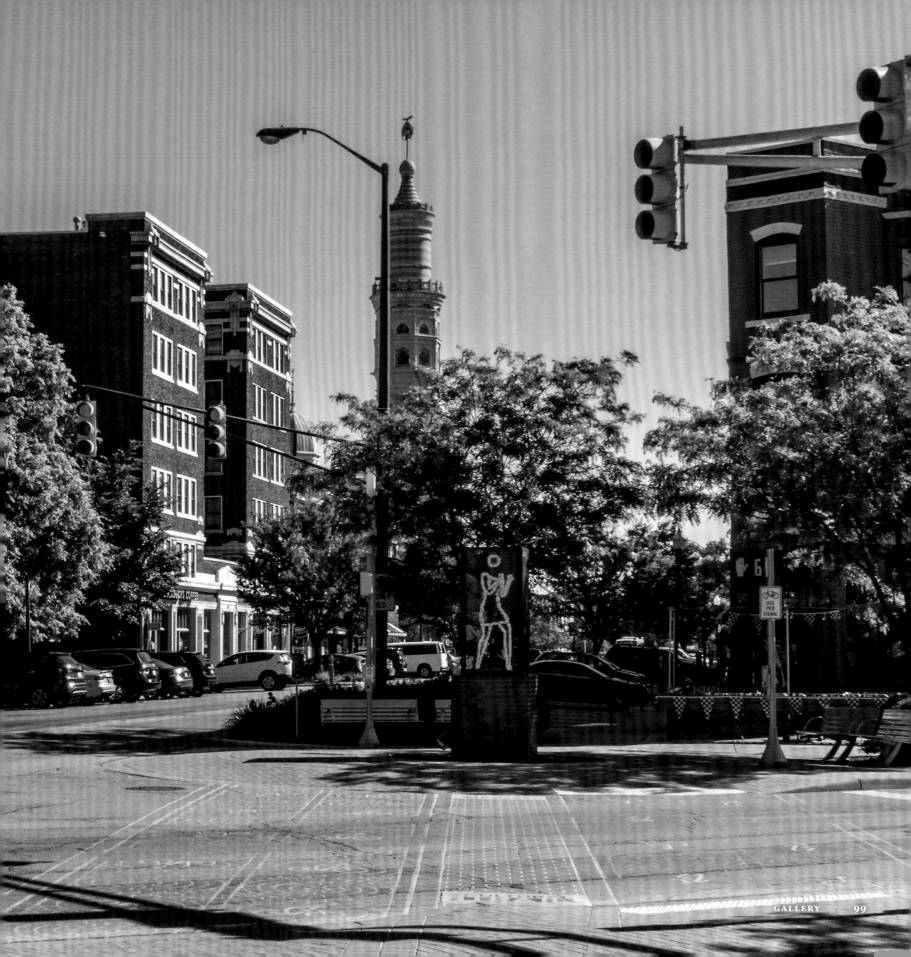

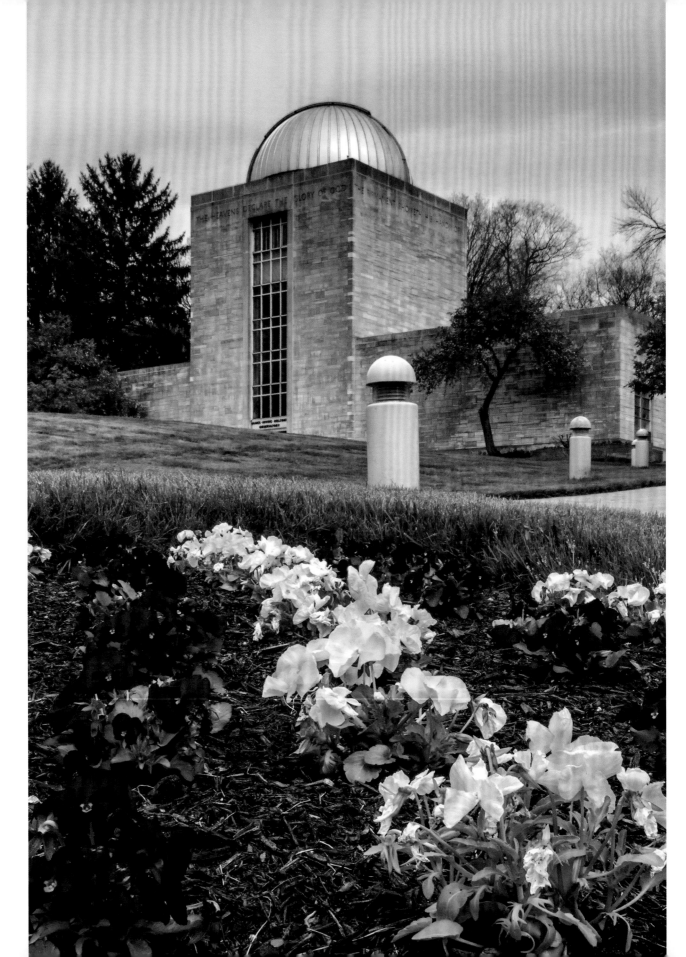

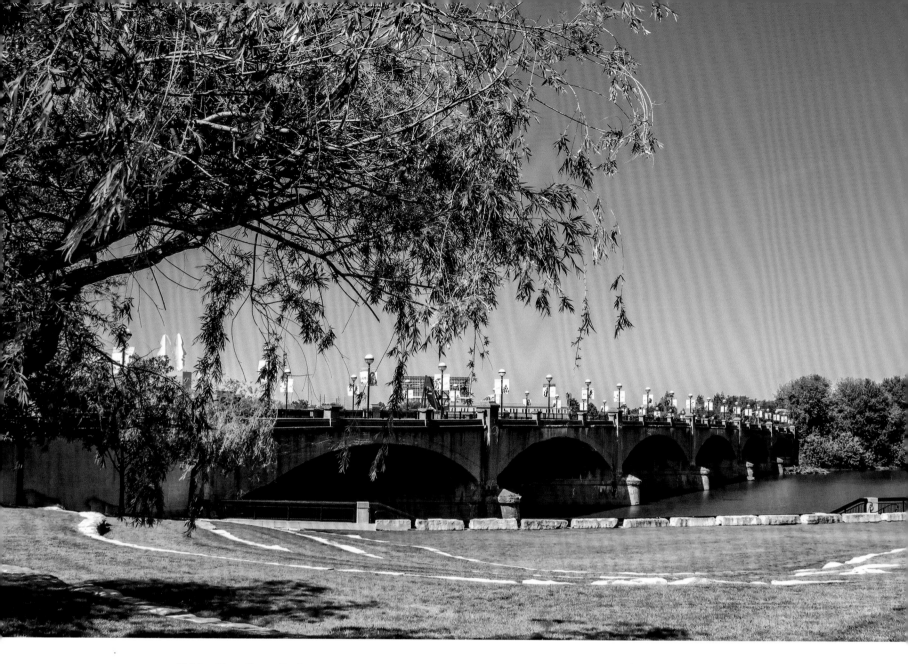

White River State Park

(Facing) Holcomb Observatory and Planetarium, Butler University

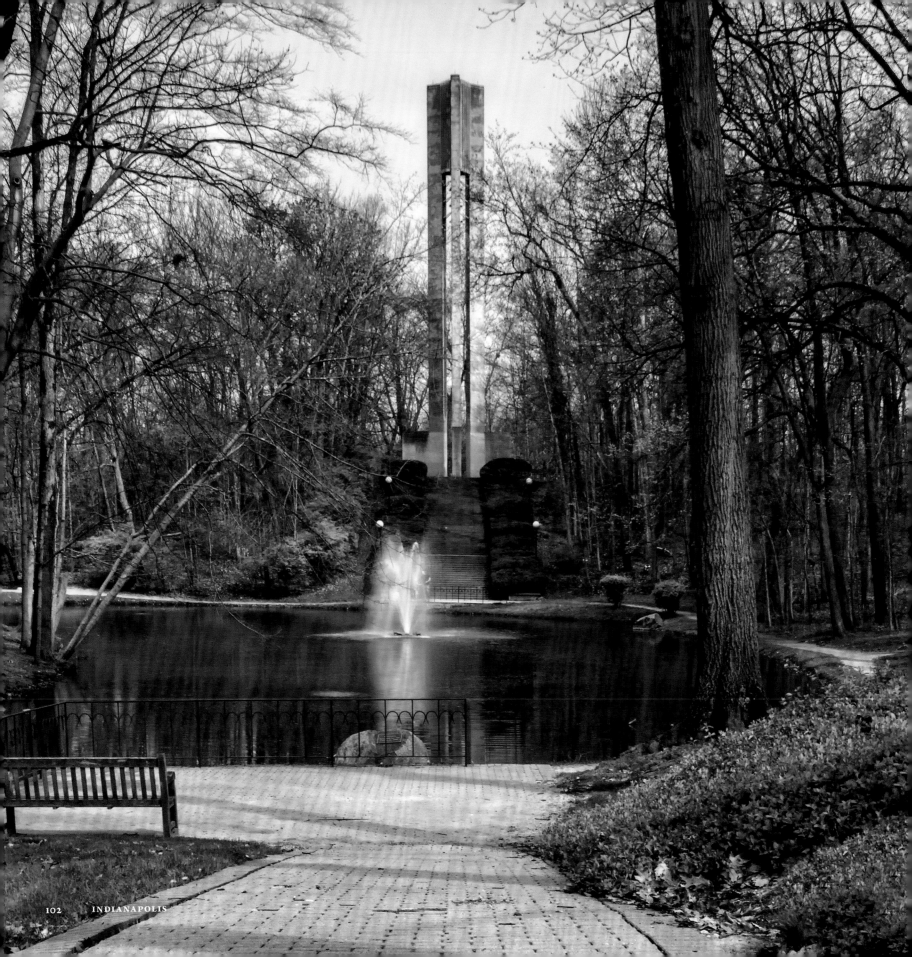

The World War II Memorial at American Legion Mall

(Facing) Holcomb Carillon Tower, Butler University

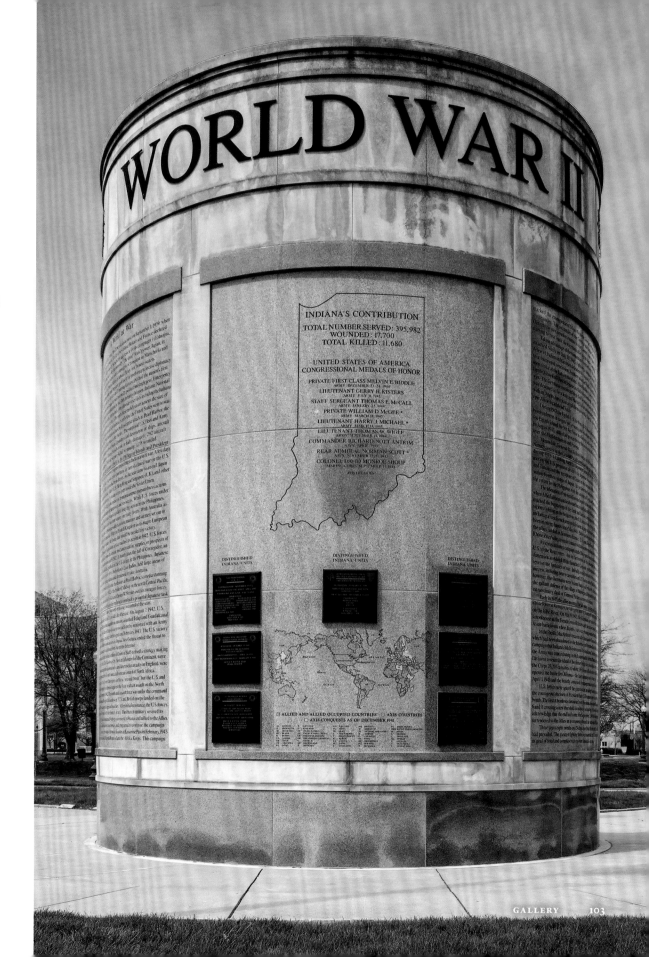

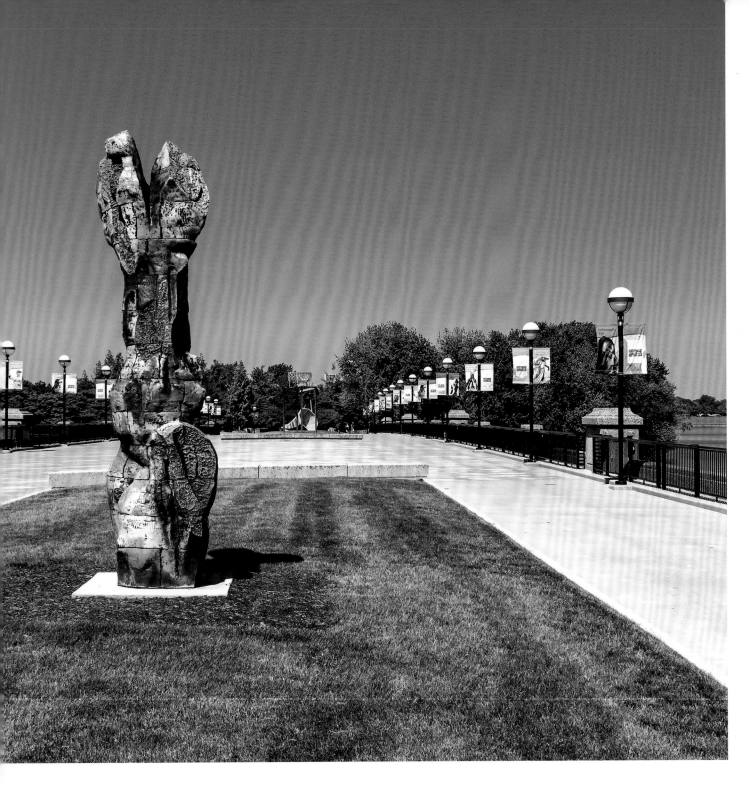

"Ascending" by Robert Pulley in White River State Park

(Facing) The Lilly House on the Indianapolis Museum of Art Grounds

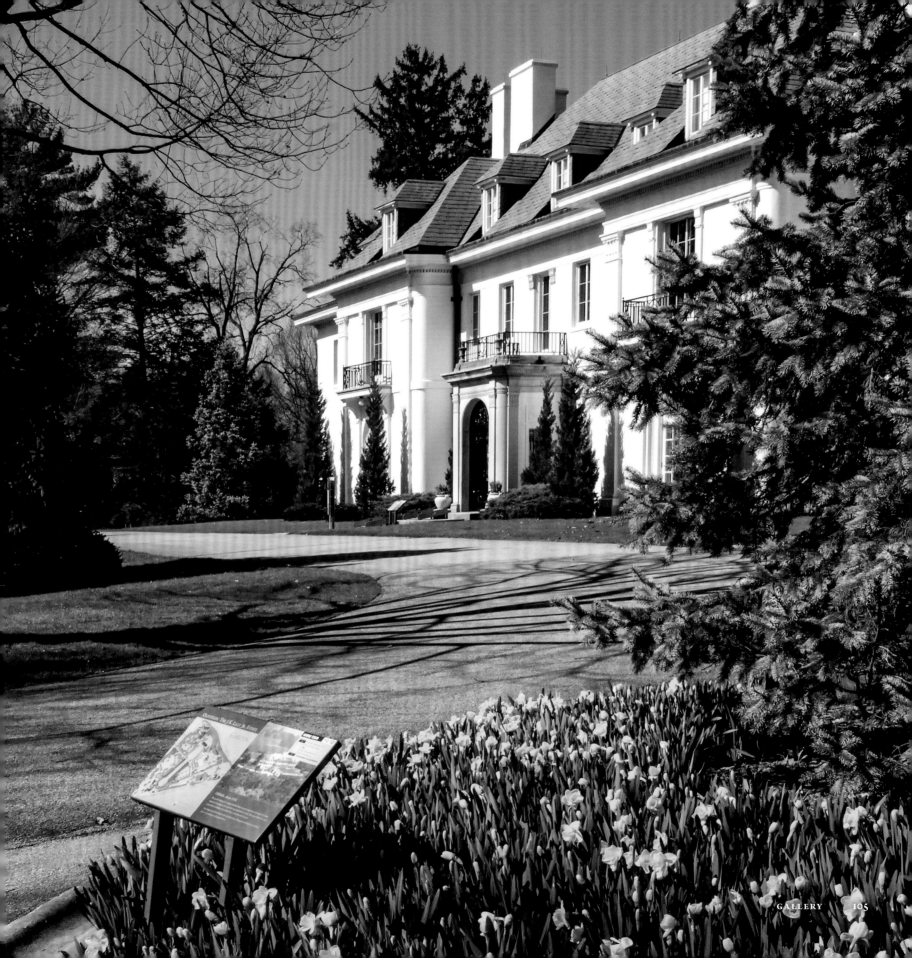

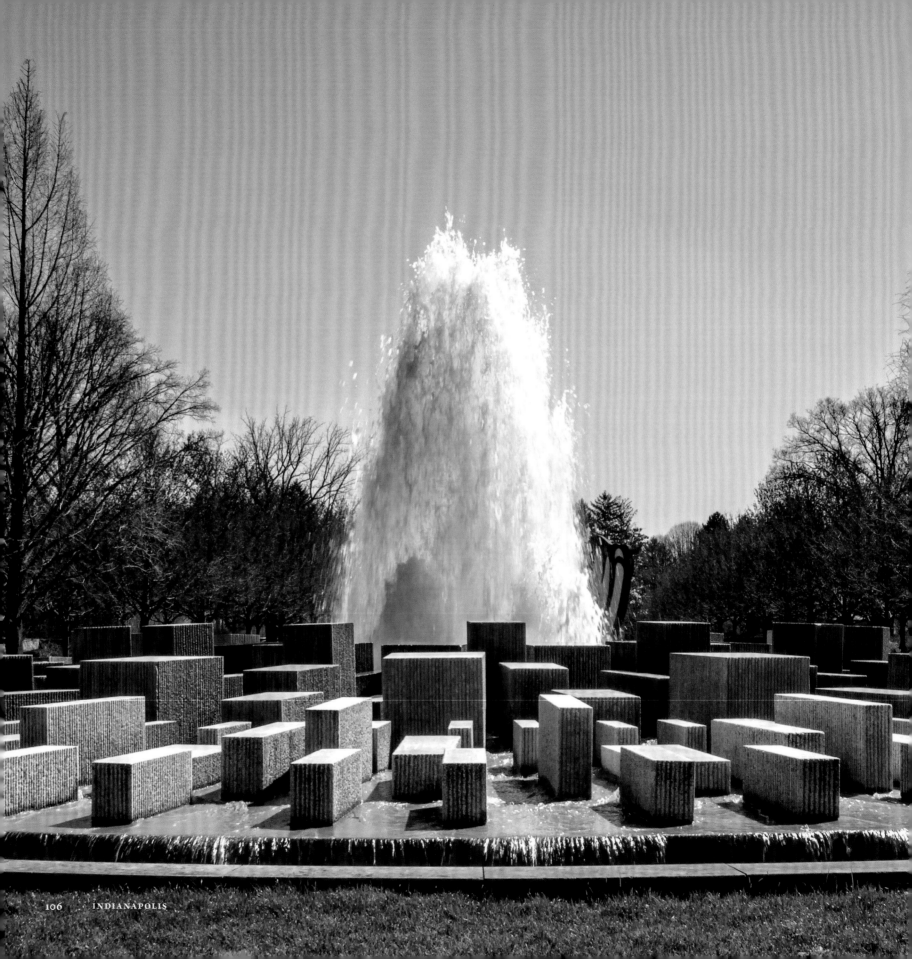

Looking in on City Market

(Facing) Sutphin Fountain at the Indianapolis Museum of Art

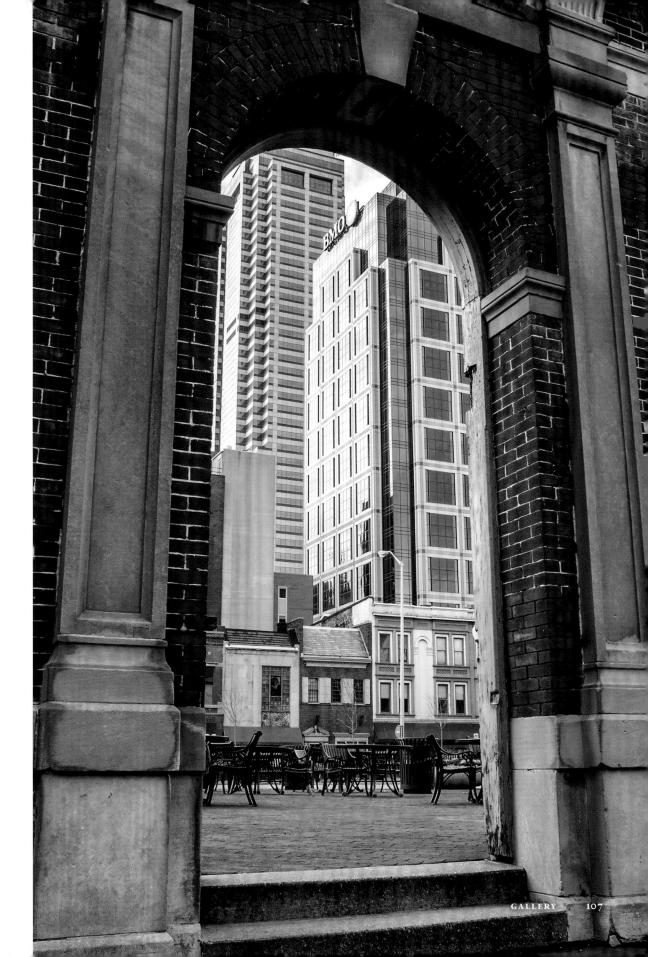

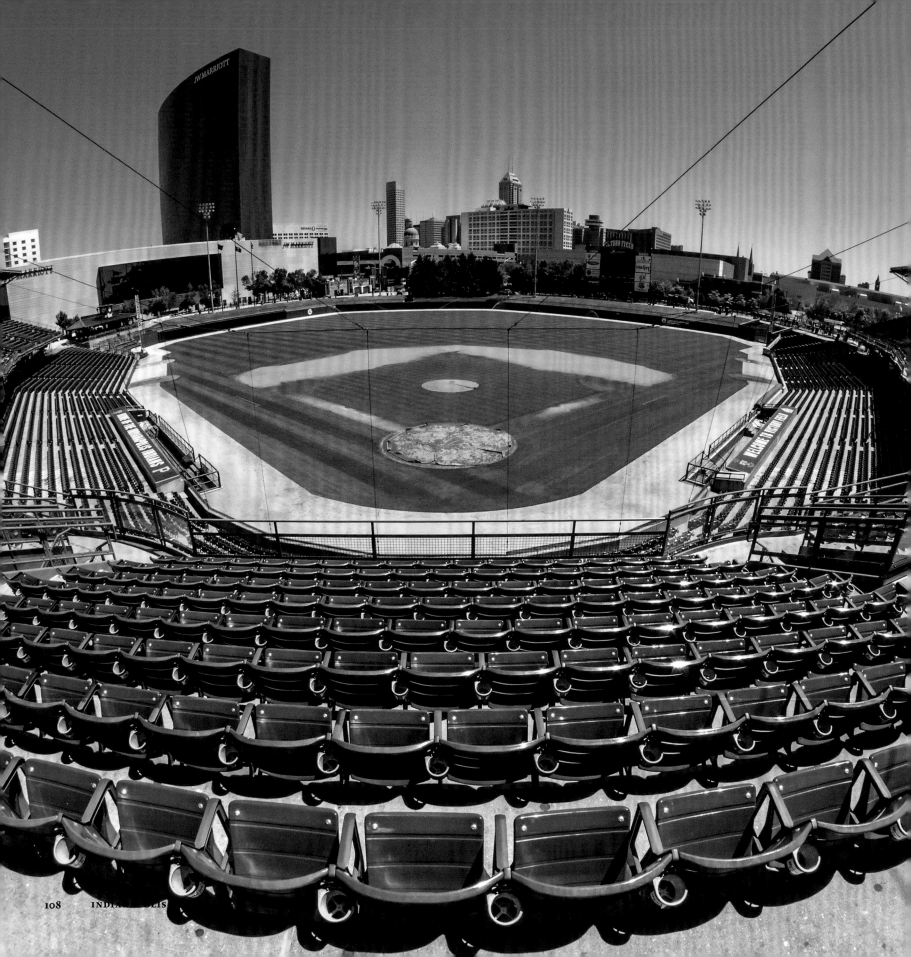

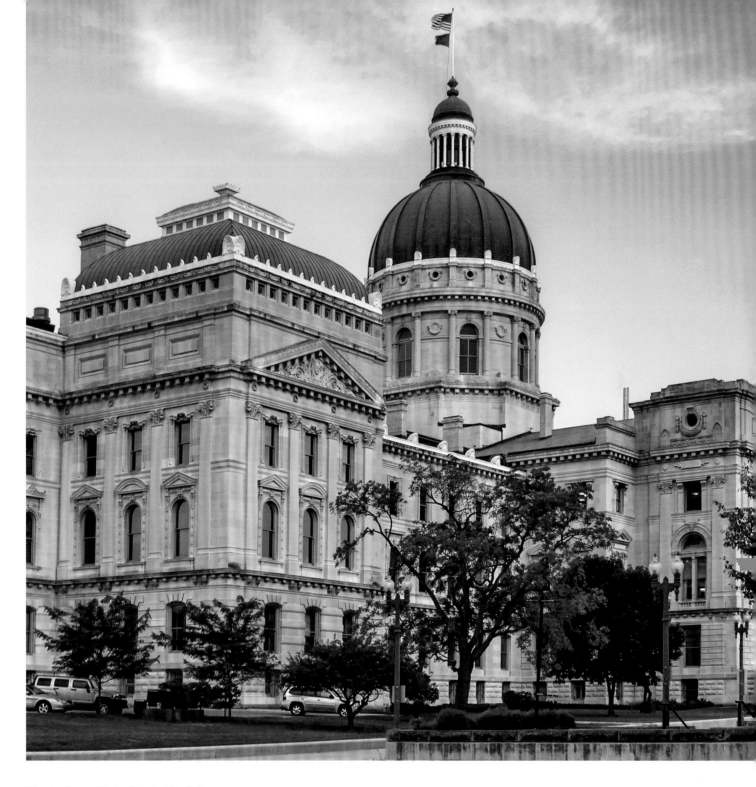

The Indiana State Capitol Building

(Facing) The Indianapolis Indians' Playground, Victory Field

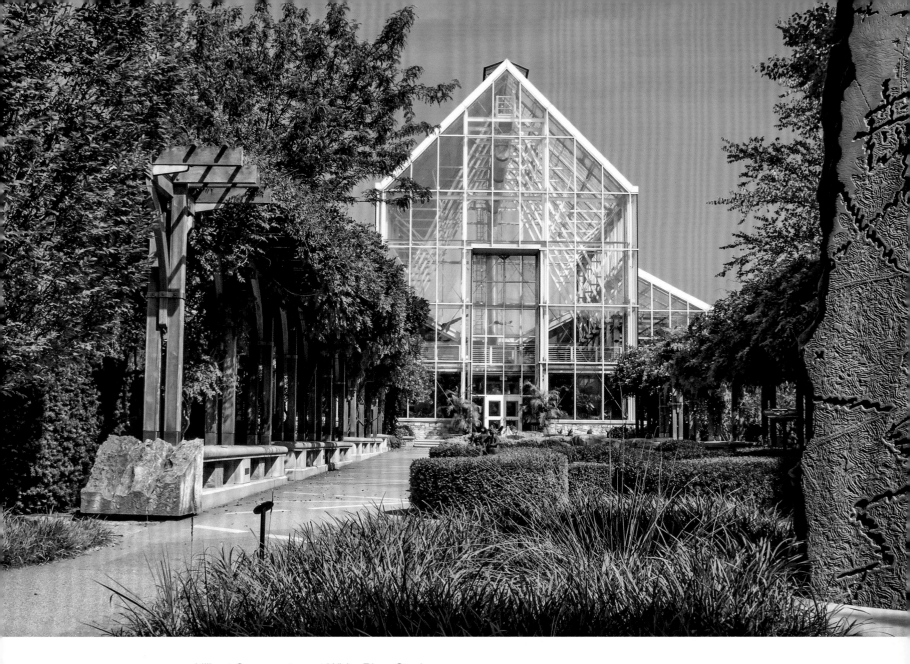

Hilbert Conservatory at White River Gardens

(Facing) The Indiana State Fair

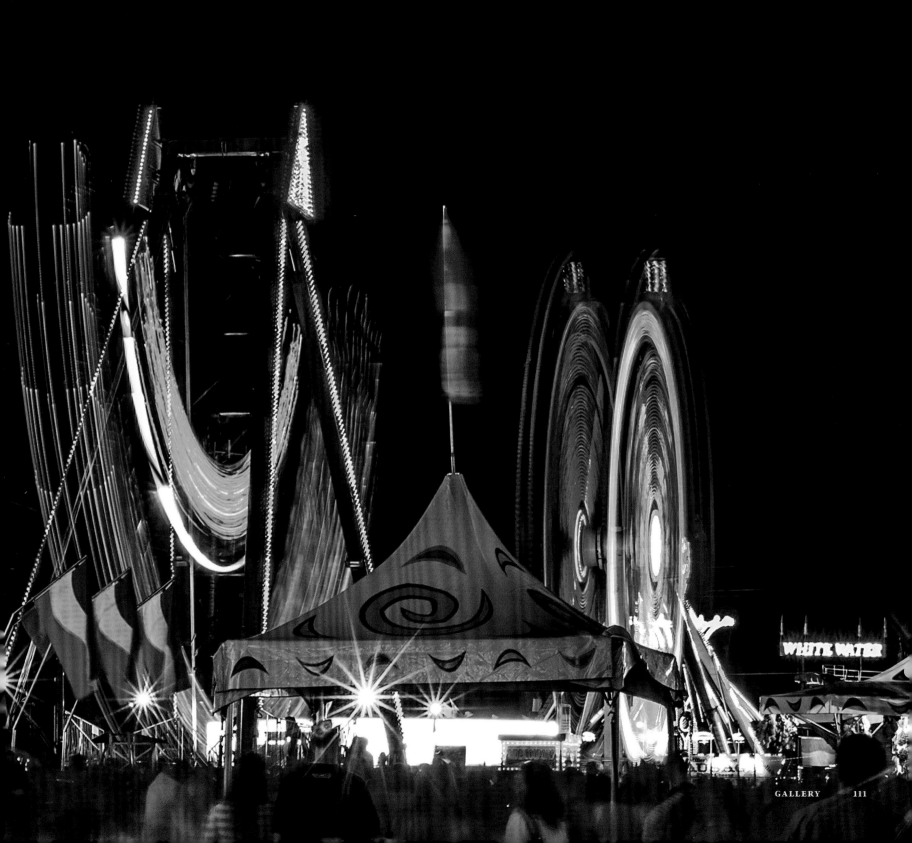

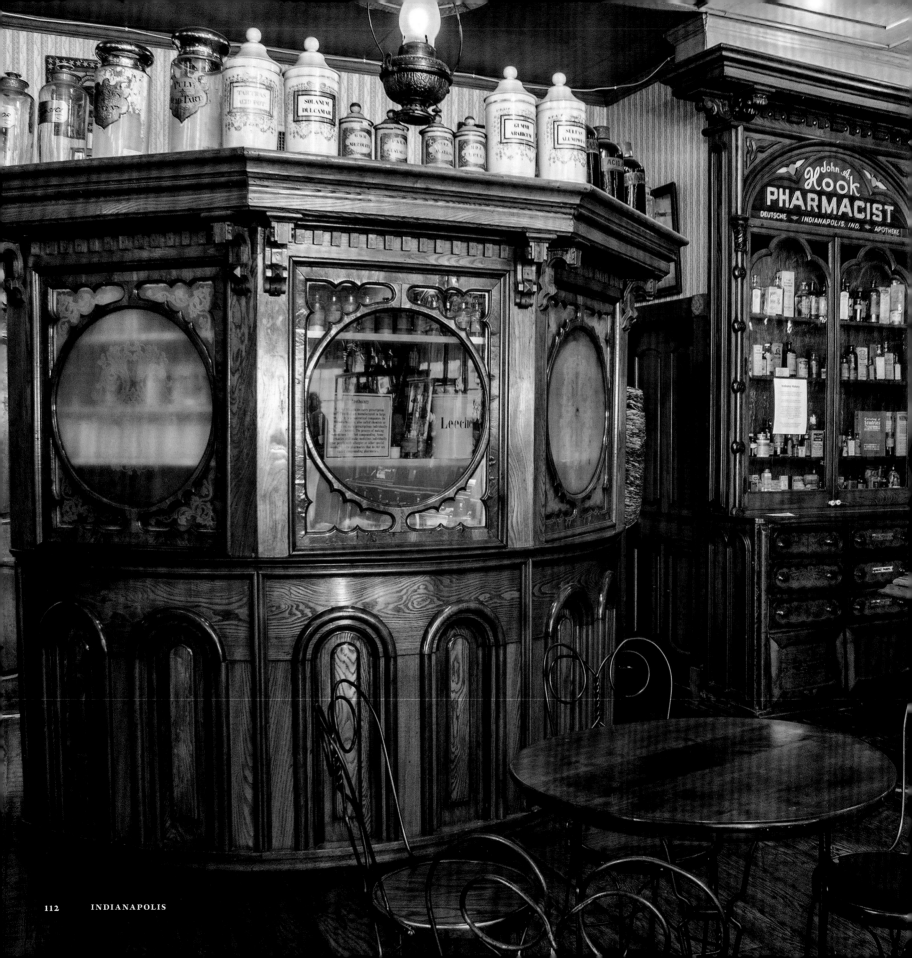

Indianapolis Fireworks

(Facing) Hook's Drug
Store Museum

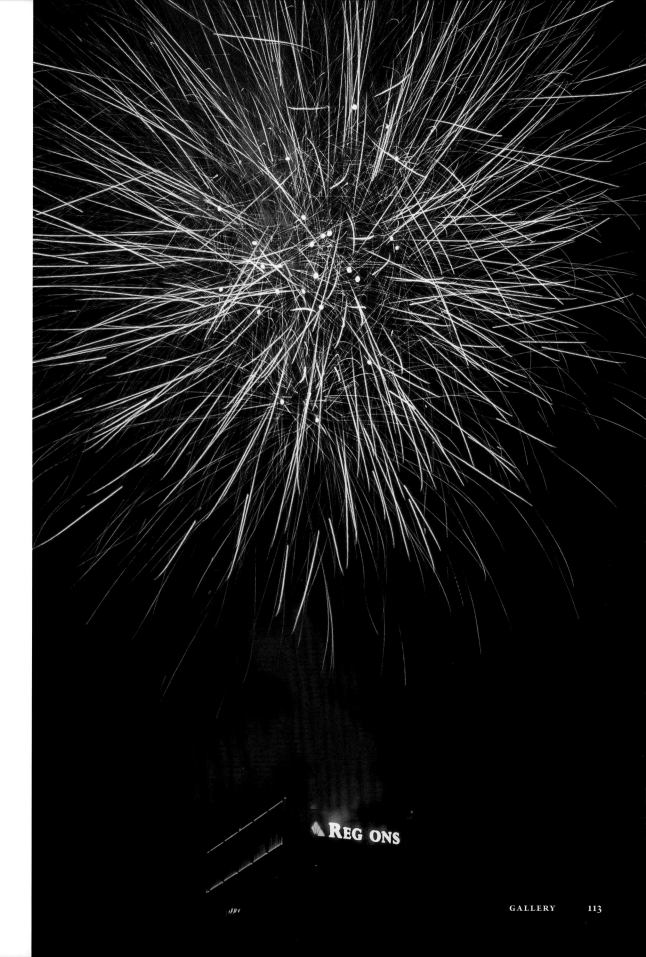

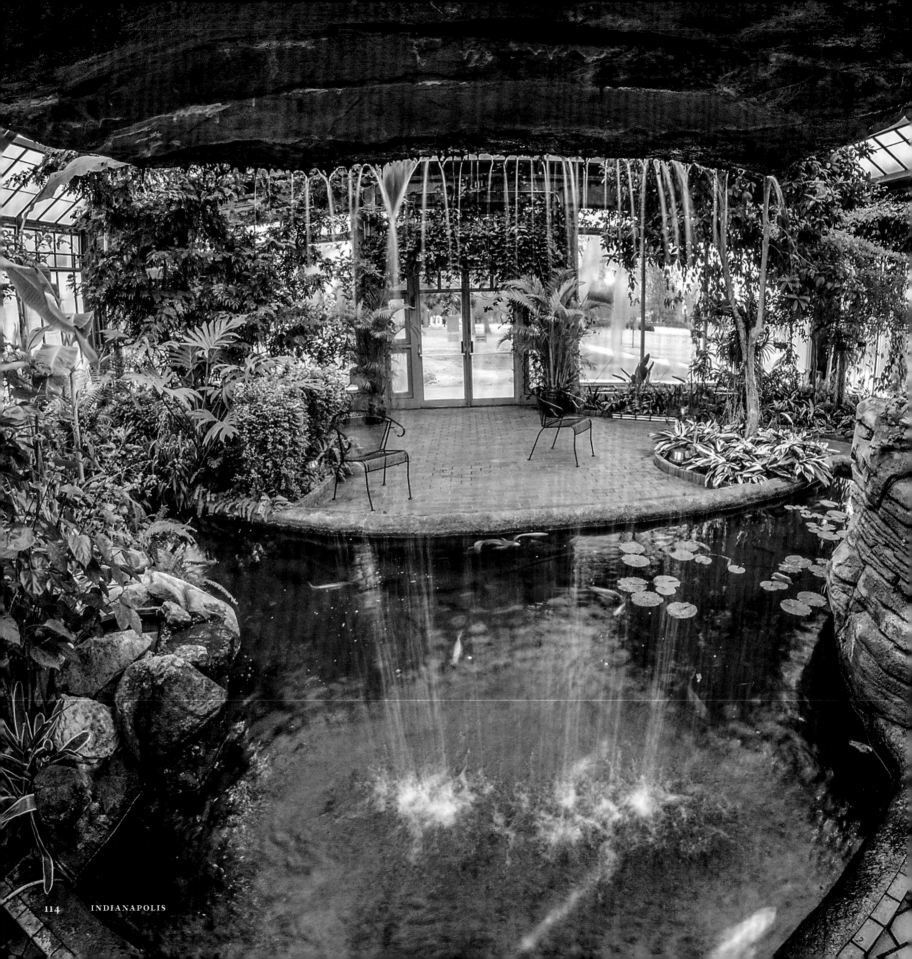

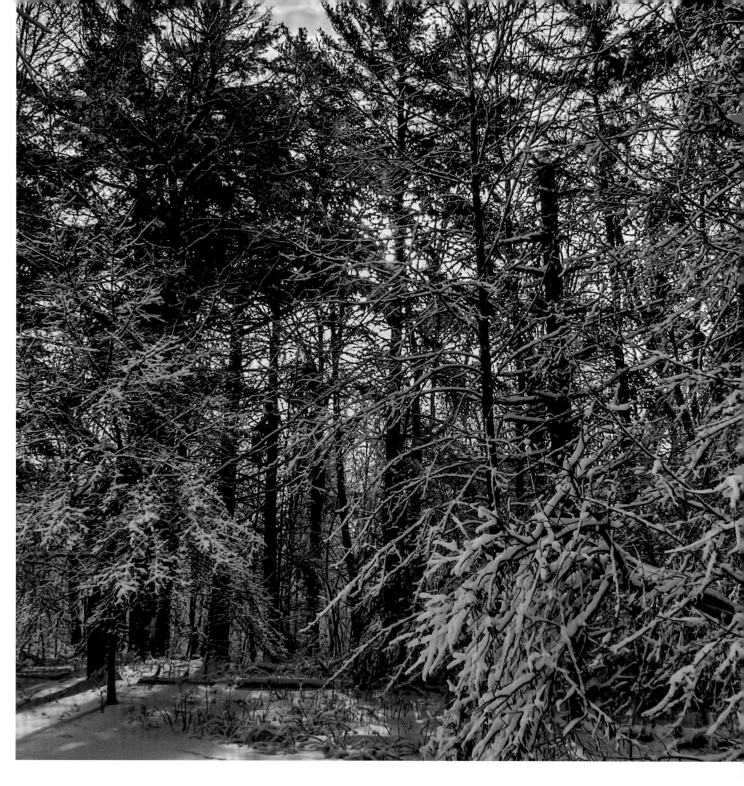

Fresh Snow and Sunrise at Eagle Creek Park

(Facing) Under the Waterfall, the Garfield Park Conservatory

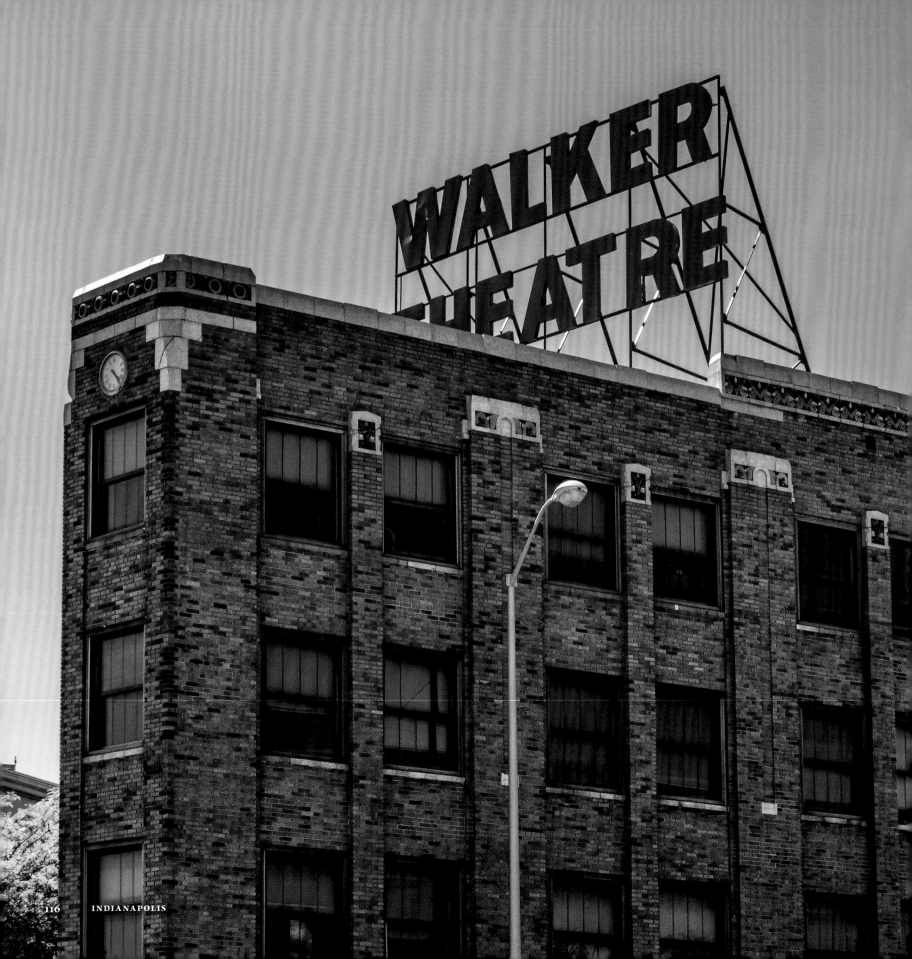

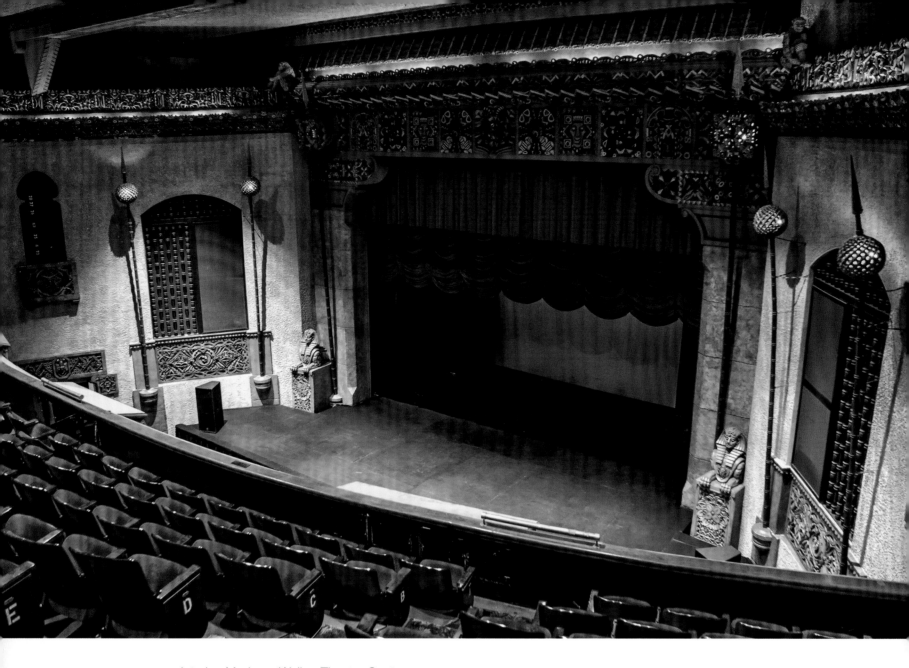

Interior, Madame Walker Theatre Center

(Facing) The Madam C. J. Walker Building

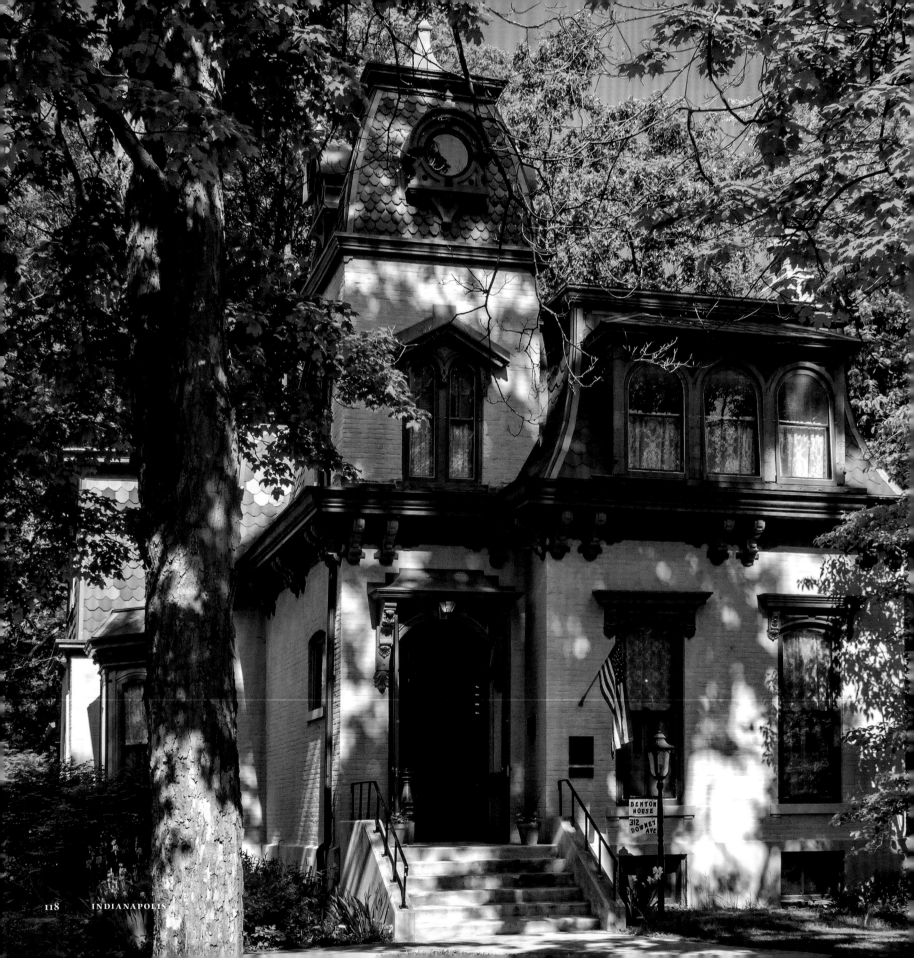

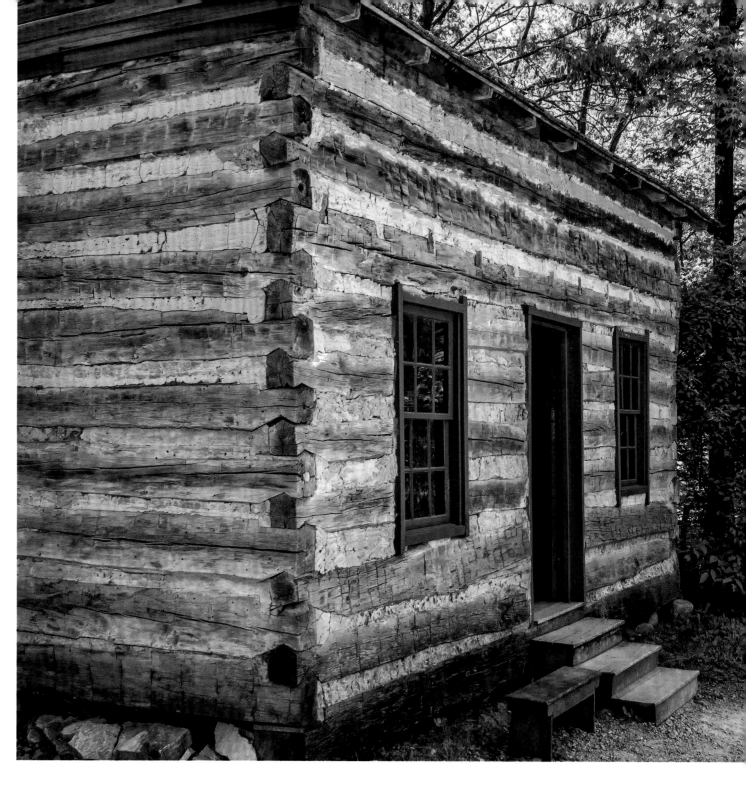

Conner Prairie Interactive History Park

(Facing) The Benton House

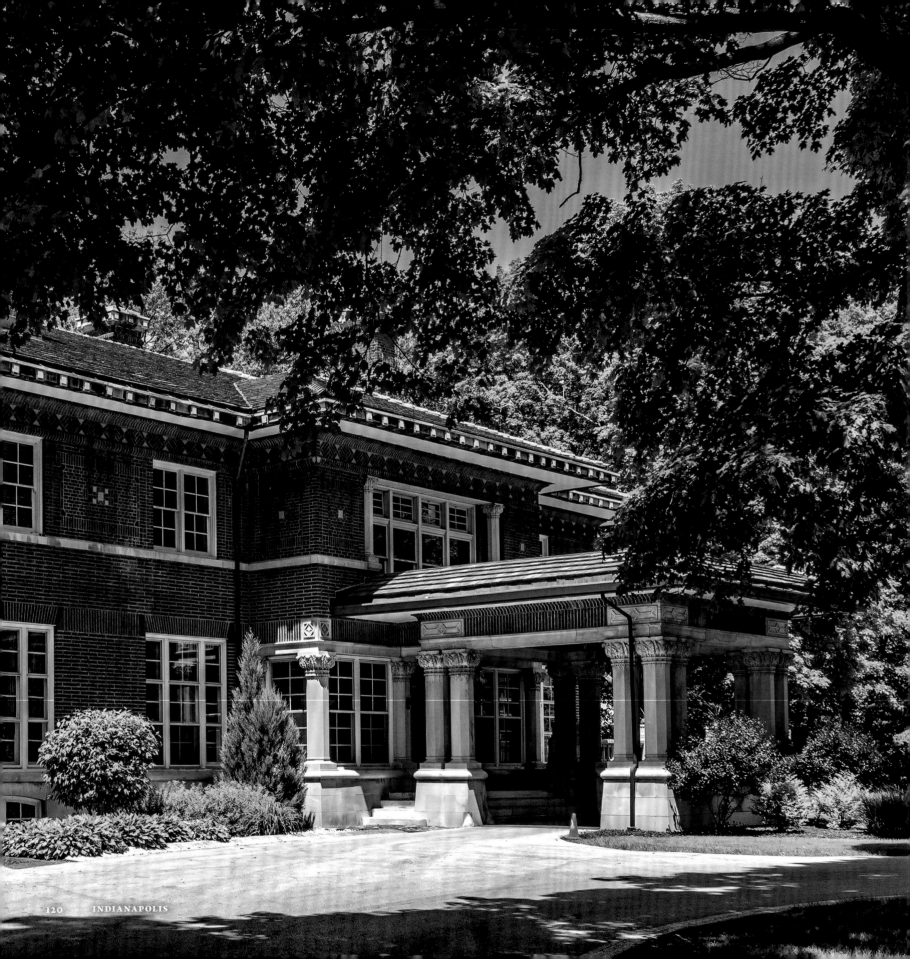

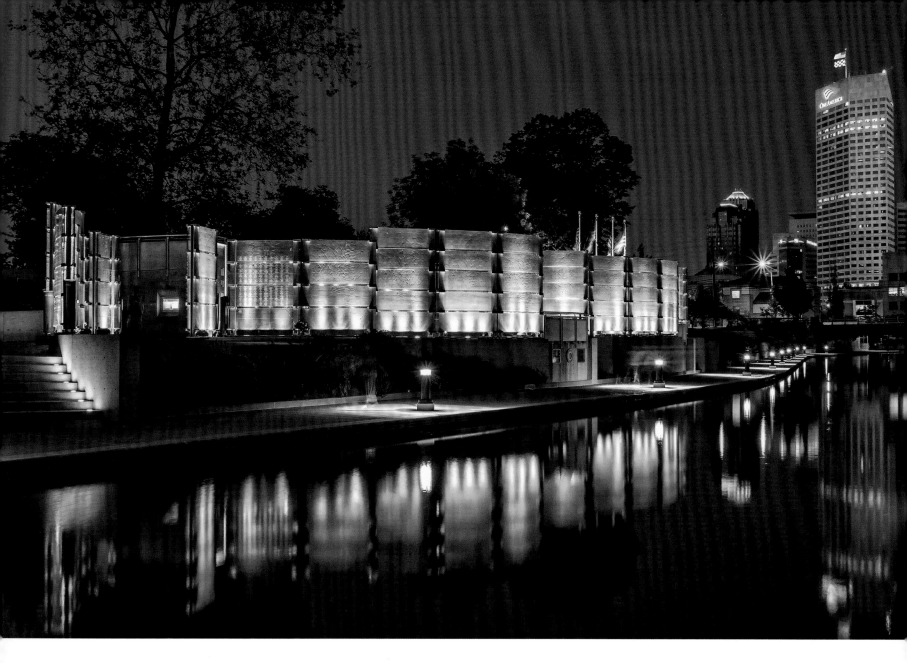

The Medal of Honor Memorial along the Central Canal

(Facing) The James Allison Mansion

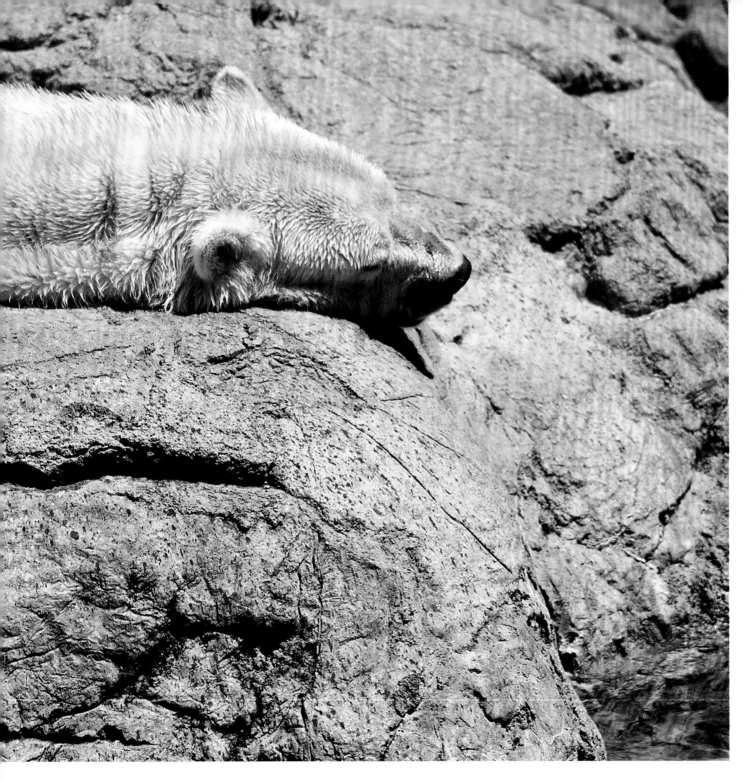

A Local Resident, Indianapolis Zoo

(Facing) A Colorful Flamingo at the Indianapolis Zoo

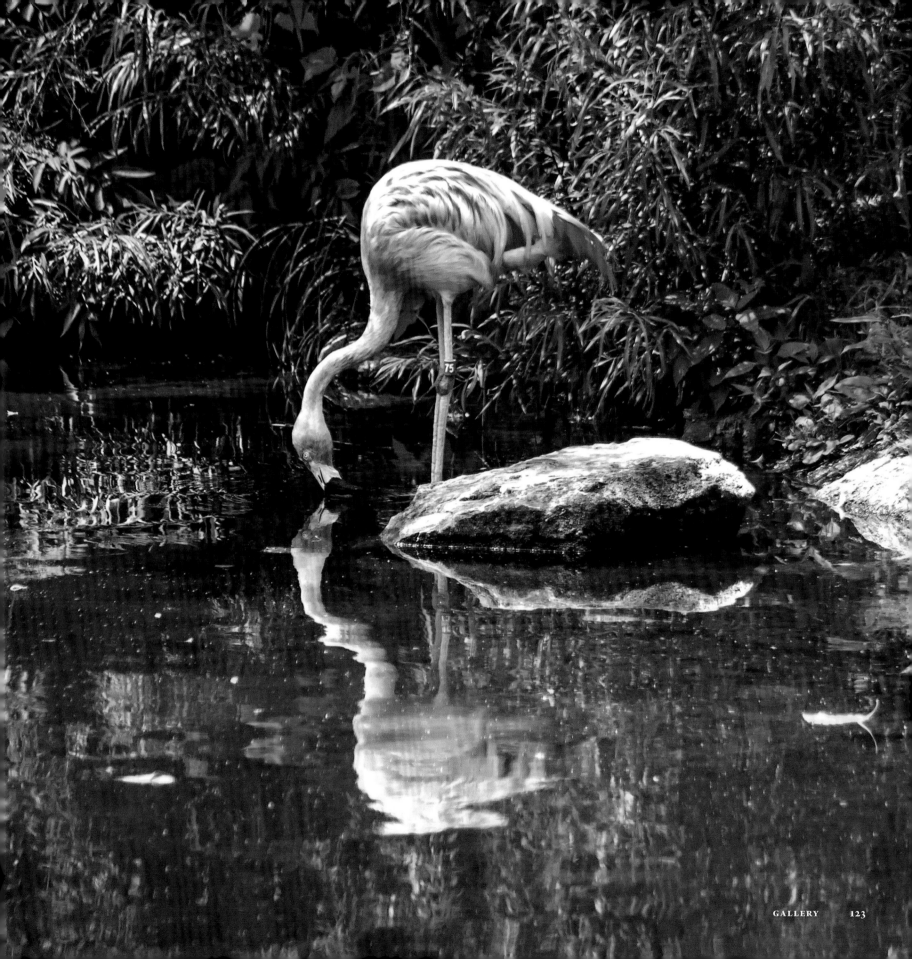

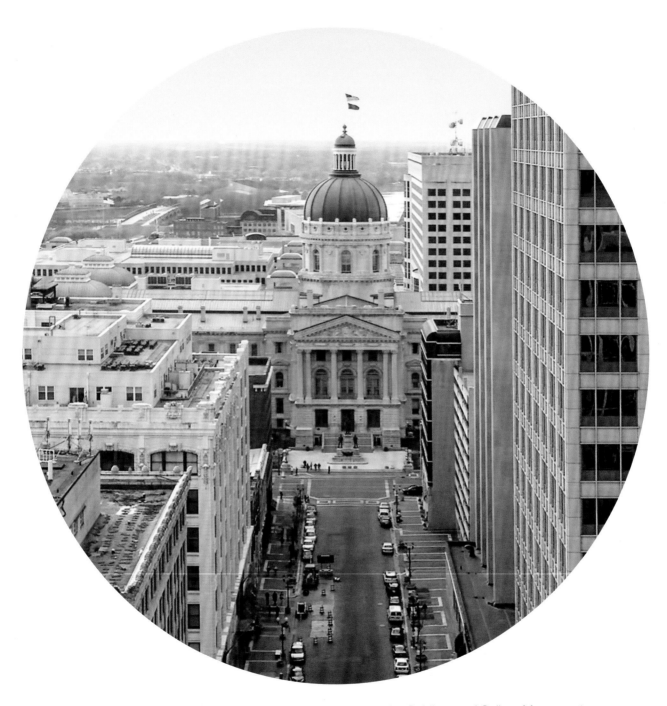

The State Capitol Building as Seen from the Top of the Soldiers and Sailors Monument

Photography has always held excitement and a magical appeal for me from a very early age. Just watching a Polaroid develop is nothing short of mesmerizing and exciting.

I am a firm believer that there is no such thing as bad light. Often we hear photographers say that we should be shooting only during the magic hours and that anything in between is bad light. As most photographers know, "magic hour" is a duration of one hour after sunrise and one hour before sunset. My feeling is that we should look for subjects that fit the lighting conditions and tailor our shots to match the existing light. Wasted time equals missed photographs in my opinion. I love to shoot, so I keep looking for what works with the available light. This also gives me diversity in my photography and forces me to see things in differing lighting conditions.

Photography Talk

I often like to ask people in the course of a "photography conversation" what they believe a camera really does. What is the camera's function? I'm usually amazed at the answer, which is almost always the same: "Well, a camera takes photos." My reply is generally, "Well, that is partially correct, but let's expand on that." A camera, in the simplest terms, is merely a tool, instrument, or device for capturing light, and it is nothing more. A camera, sophisticated as it is, can't reason, think, or compose a shot. It has no cognitive function. It can do only what an operator makes it do. It will only capture the available light based on the settings that you, as the operator, program into it, unless you are strictly an automatic user—but even in automatic you are still required to compose the shot and press the button. The same is true of a work of art. It doesn't paint itself. It takes someone to put all the colors and media together to make an image appear. The person usually shows a look of enlightenment and of thinking in a new direction. This is always exciting for me and makes me smile.

What a person does with a camera is uniquely up to that individual. The years of learning, experience, and skill they have put into honing their craft, their desire to express what they are passionate about, all come together to capture an instant of light that we call a photograph. Keep in mind that there are no magic potions or secret skills to taking good photos and that the next person's better-quality photo is never because they have a better camera. On the contrary, first, it's about learn-

ing the basics and applying those fundamentals each time you shoot. Next, it's all about using that applied learning and your desire to push yourself to the limit and beyond to get better and to learn even more. It's good to challenge yourself and step outside your comfort zone—think outside your own box from time to time. It's one of many ways to make progress and achieve personal growth. A change in subject matter from time to time also keeps us fresh and allows us to see and experience things differently. It becomes definitive, practical knowledge that is priceless and can never be taken away. Our education is an ongoing process. Once you have learned something, it's yours forever.

Truly amazing images are inspiring, and they are everywhere. You can't help but respect and appreciate the amount of learning, practice, field time, studio time, and effort someone has undergone to bring the viewer the photographer's vision of what he or she has seen. As with anything in life, the more you put into it, the more you get out of it, and to me the more rewarding the end result usually is. I personally like to push it as far as I can go, and then some. In doing so, I have often been accused of being a perfectionist. That's okay; I am fine with it. I am continually preaching to people that shoot to take the time to get it right in the camera as much as possible. This advice is good for all of us, from an amateur using a point-and-shoot or phone camera to a seasoned photographer using an advanced DSLR. I find that many of the people I shoot with for the first time seem to be in a hurry. I'm always astonished that so many photographers don't know how or when to slow down. Taking the time to get it right in the camera not only makes for all-around better pics, it also saves you enormous amounts of time in post-editing, thus freeing up more time for shooting. Who doesn't want that? Lots of potentially great pics are missed or ruined because the photographer is rushing. Often my best pics are some of the last ones taken in a series of shots. Choose your location, snap some shots, look at what you have and evaluate it closely, change the composition and any settings slightly if need be, wait for just the right light, and you will find that your patience pays off in big ways. Slowing down will only help take your photography to the next level, I promise you.

My own routine these days first consists of what I call "*Pre-Flighting*" the camera. Upon powering up, I do a quick run through of the ISO, shutter speed, white balance, card formatting, and any other preparations. It's easy to forget to change an ISO back to your preferred range, or not to notice buttons that got accidentally moved around in the bag. It happens. It's an easy step to overlook or forget because we just want to start shooting. Getting in the habit of checking things over first will save you disappointment and ruined shots, some of which can never be retaken.

Once I am satisfied things are where they need to be, it's time to start shooting. When I am certain of the composition I plan to shoot, I then like to check to be sure everything is as level and square as possible, or just as I want it. Crooked shots really take away from a photo's impact. It only takes a second to be sure it's straight, so why not do it? It also makes it easier in the editing process, particularly when stitching a panoramic. Often times I see these same shots posted, still crooked, and the time wasn't even taken to straighten them in post-editing. I then look for distracting elements, such as branches that detract, or leaves, or rocks or what have you, and take appropriate measures to keep them out of the shot or greatly reduce the impact they may have overall.

I also tell people who don't do this already to train themselves to shoot a little loosely, and then plan for some cropping in the final edited version. I always plan for a bit of cropping when composing my own shots. In my opinion, cropping is something everyone should get in the habit of thinking about and probably planning for. This is something I learned firsthand from my years as a custom darkroom printer. Cropping is almost always necessary whether we think it is or not. It seems there is always a bit of unneeded image, too much negative space, a leaf, a twig, format restrictions or whatever that just needs to go. Oftentimes an average shot becomes a better shot by bringing the focus onto the subject just a little bit more. The leading lines can then do their job a little better, the rule of thirds might come into play a bit better, or the shot simply becomes a bit more dramatic and has more visual impact, just from a small tweak. Remember that sometimes what we take out is just as important as what we leave in. Do an experiment with cropping sometime and judge the results for yourself. You will likely be pleasantly surprised.

In today's world of large storage cards, bracketing should become routine if you don't already practice it. I know of no serious photographers that don't bracket to some degree. There simply is no reason not to do it these days. You never know when the bracketed shot that is a stop over or under will be the perfect exposure, or when new software or a new technique will come along that will make you wish you had other exposures available. People with no real photo training can generally pick out a shot properly exposed from the beginning compared to one that wasn't and required extensive work to correct it. It really does make a visible difference. Now you're probably thinking that a decent raw converter or good photo-editing software can save the shot no matter how good or bad it might be. Well, a good raw converter or photo editor definitely can save a shot when needed, and they are very, very good these days, but I still say the shot that needs the least amount of tweaking

outshines an overworked shot any day. You know the one: the one that has spot-on exposure, is tack sharp, has almost flawless color, and is saturated just right. This type of shot will always need the least amount of work and will always look the best. It almost feels wrong to not have to work on them too much, but at the same time it's rewarding because you know it was done right in the camera. It's confirmation that all of the basic fundamentals are being done properly and that you are on track.

Another mistake I see many photographers make is not taking the time to fully learn or understand their camera. It's important to know the features and create a workflow that's suited to your style. Missing a critical split-second shot is always a disappointment, and it does not ever need to happen. All of us have done this at some time or another. Spend some time here and there reading the manual or watching some how-to videos. If it bores you, put it down and come back to it when you are more receptive to learning. It might be helpful to pick out only one thing at a time, commit it to memory and learn it, then move onto the next feature. Sit at home and explore your camera and all its functions. Go through each menu. Ask yourself, what does this one do? What happens if I press this? You can't hurt it, so play around until you are familiar with it. The ability to make quick adjustments on the fly can make all the difference from an average shot to a great shot. Sunsets, for example, are constantly changing light at a rapid pace; you need to be able to keep up with camera changes as well, and without giving it any real thought. At some point, knowing your camera inside out is going to pay off when you catch that once-in-a-lifetime shot, and you will be glad you took the time to learn!

I also want to talk briefly about getting to a location, the travel time involved. As I reflect back on the many photographic trips that I have taken over the years, I believe the trips have become as important as the photography. Really, they always were, but I only in recent years realized it. The conversations, the bonding, the music, the various foods, and looking for unusual things along the way all add up to some memorable trips. I wouldn't trade those trips for anything. It's amazing how hard photography really is, but at the same time enjoyable and rewarding like nothing else. Rarely does anyone pull up to a location, open the car door, snap off a few pics, and drive off with an epic shot. My wife, DeeDee, calls this "drive by shooting." There are long hikes (some even backbreaking it seems) lugging heavy equipment around, bug bites, waiting for the exact light you want, sometimes even pleading for it, no matter where your location is. But when you confirm that you have a shot you believe to be exceptional, it makes it all worthwhile. Then there are the car rides back home. Everyone is tired, but there are still good conversations and anticipation of the shots you took, or the

"Catch of the Day" as I like to call them. I really cherish it all. Relationships grow and friendships are strengthened.

There is no real secret to great photography, no magic potions or wands, and remember it is never because the next person has a better camera. A camera is a wonderful device! We need to appreciate what it is and what it does for us. It allows us to remember people and events in our lives, even when our minds can't. It allows us to see periods in time and history. It allows us to share what we have seen with others from all over the world and see things we might not otherwise see. For me, it's a trusted companion on any road trip I take. I know I can count on it to deliver what I have seen and allow me to share my visual experiences of the world with anyone who might be willing to look. A camera will do only what I make it do, plain and simple. I do the thinking for it, not the other way around. A camera is a tool to capture light and nothing more. It comes down to how you use it. If you see a shot, or someone's Web site, or a photo somewhere and think, "Wow, that is simply awesome," it's because that person applied lots of simple techniques to making that shot. They took the time to learn and understand what makes a great pic. They put all that applied learning into that one fraction of a second to take a photo that will stand out among the crowd. So why take one hundred average shots if you can take one hundred exceptional ones? Remember, people take pictures. If it doesn't look quite right in the camera, color, composition, and all, make changes until it does. Like anything, you get from it what you put into it. Once all of this has become second nature to you, you will be glad you took the time to get it right in the camera. Your photos will improve, as will your love of photography. Anyone can do it, and that includes you!

Index

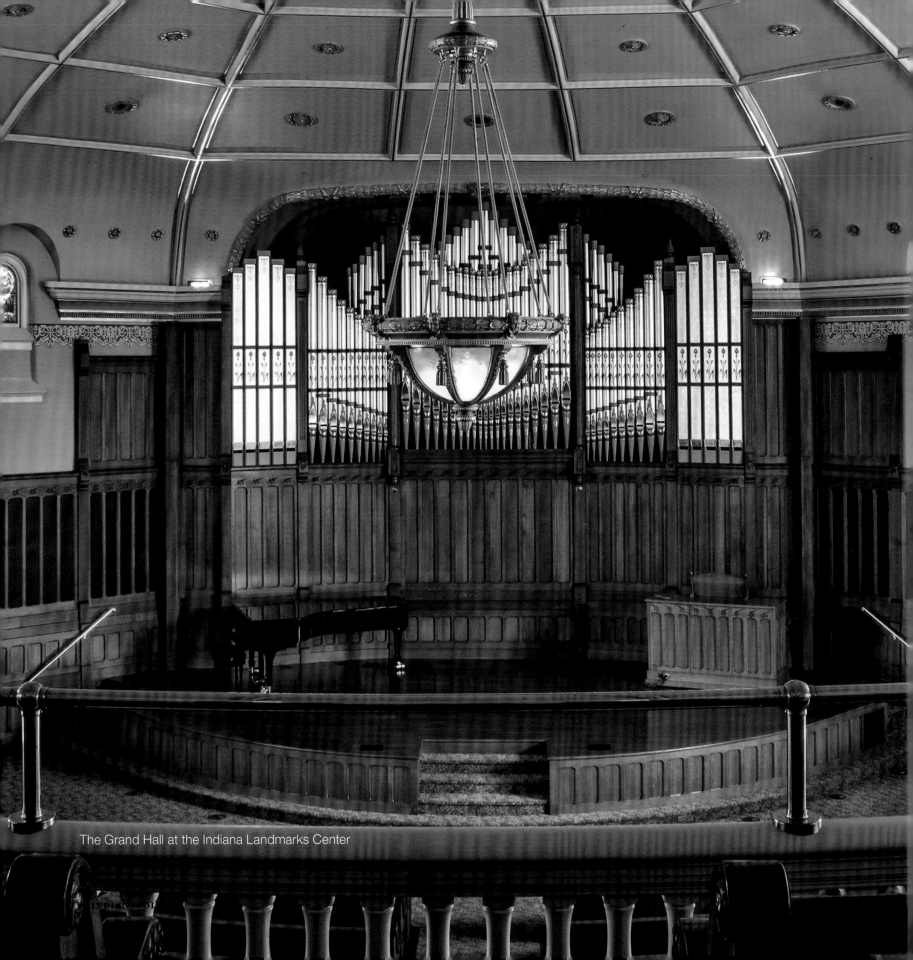

The Grand Hall at the Indiana Landmarks Center

Lee Mandrell

For **Lee Mandrell**, photography started out as a hobby that quickly ignited into a fiery passion and then into a lifelong career. He started out at age fourteen with a secondhand Minolta Hi-Matic E rangefinder. Mandrell worked as a custom darkroom technician in a pro lab for years and was eventually promoted to production manager. An early adopter of both digital technology and Photoshop, he is still actively involved in all current photography techniques and practices.

Matthew Tully is the political columnist for the *Indianapolis Star*. His columns on public schools have helped drive the debate over education reform in Indiana. He is the author of *Searching for Hope: Life at a Failing School in the Heart of America* (IUP, 2012).